# *Enactments*

EDITED BY CAROL MARTIN AND RICHARD SCHECHNER

To perform is to imagine, represent, live and enact present
circumstances, past events and future possibilities. Performance takes place
across a very broad range of venues from city streets to the countryside, in
theatres and in offices, on battlefields and in hospital operating rooms. The
genres of performance are many, from the arts to the myriad performances
of everyday life, from courtrooms to
legislative chambers, from theatres to wars to circuses.

ENACTMENTS will encompass performance in as many of its aspects and
realities as there are authors able to write about them.

ENACTMENTS will include active scholarship, readable thought and en-
gaged analysis across the broad spectrum of
performance studies.

# PERFORMING THE NATION

## Genocide, Justice, Reconciliation

Ananda Breed

Seagull
BOOKS

LONDON NEW YORK CALCUTTA

**Seagull Books, 2014**

© Ananda Breed, 2014

ISBN 978 0 8574 2 108 1

**British Library Cataloguing-in-Publication Data**
A catalogue record for this book is available from the British Library

Typeset by Seagull Books, Calcutta, India
Printed and bound by Hyam Enterprises, Calcutta, India

# CONTENTS

## ACKNOWLEDGEMENTS

This book is a result of over ten years' engagement with the politics and practices of performance in Rwanda, starting with an initial scoping visit in 2004 and ending with this book in 2014, launched by doctoral research and my involvement as a member of the In Place of War project.

The names of individuals interviewed and quoted have been reproduced with their permission. Wherever possible, reconfirmation of permission has been sought before publication. Those who gave permission to be quoted but not to be named have been referred to as 'survivor', 'perpetrator', 'witness' or simply 'member' of an association, as the case may be. At other times, names have been omitted or an alias provided owing to sensitivity of material. Individuals often stated that they regarded the necessity to be named as an act of agency, which should be read as a positive progression towards freedom of speech (particularly following gacaca). Names of public figures and government officials have been retained where integral to the discussion in the knowledge that their official positions and roles played in Rwanda before, during and/or after the genocide are facts in the public domain. As political and sociocultural settings are in a state of flux in Rwanda, every effort has been made to treat individuals and the information shared in confidence during my research with due respect. I want to extend my deep gratitude to each and every individual cited (and uncited). This book would not have been possible without your dedication and generous support of the project.

Acknowledgement and appreciation goes to colleagues of the In Place of War project including James Thompson, Jenny Hughes, Michael Balfour, Alison Jeffers, Charlotte Hennessey, Rachel Finn and Ruth Daniels and PhD supervisory members Amelia Jones, Maggie Gale and Viv Gardner. I have benefitted from the generous support of the National Service of Gacaca Jurisdictions (SNJG) for allowing me to document justice and reconciliation efforts through observations, interviews and access to government documents and

programmes. I am grateful to the National Unity and Reconciliation Commission (NURC) and Fatuma Ndangiza for providing me with an internship in 2005 that gave access to conduct interviews and workshops in the ingando solidarity camps and to gain first-hand knowledge of the diverse strategies and practices of reconciliation in Rwanda.

I am indebted to the numerous individuals who provided insight and knowledge regarding the genocide, justice and the arts in Rwanda including Hope Azeda, Denis Bikesha, Johnston Busingye, Deo Byanfashe, Charles Gahima, Philibert Gakwenzire, Simon Gasibirege, Egide Gatera, Fidel Gatsinzi, Joseph Habineza, Eric Kabera, Frederick Kabanda, Kenneth Kamugisha, Gregory Kanyemera, Carole Karemera, Odile Gakire Katese, Jean-Marie Kayishema, Shamsi Kazimbaya, Julius King, Sam Kyagambiddwa, Silas Mbonimana, Alice Mukaka, Jeanne Mukamusoni, Domitilla Mukantaganzwa, Emmanuel Ngabire, Straton Nsanzabaganwa, John Rubangura, Faustin Rubayiza, Kalisa Rugano, Jean-Marie Rurangwa, Oswald Rutimburana, Simon Rwema, Alfred Tushabe, Aimable Twahirwa, members of the Mashirika Creative and Performing Arts Group, the National University of Rwanda and the Kigali Institute of Science and Technology. Named individuals are not responsible for the content of this book and do not necessarily share the same views. I'd also like to thank the University of Manchester and the University of East London for research support at various stages of the project. Additional thanks to the international research centre Interweaving Performance Cultures where I served as a fellow from 2013 to 2014.

I have benefitted enormously from numerous conversations with colleagues and friends including Awam Amkpa, Andrew Blake, Jan Cohen-Cruz, Giorgia Doná, Laura Edmondson, Erik Ehn, Mitalene Fletcher, Dominic Hingorani, Georgina Holmes, Yvette Hutchison, Sel Hwahng, Astrid Jamar, Bridget Kimball, Kersty McCourt, Christina McMahon, Alpesh Patel, Susannah Radstone and Richard Schechner. Warm regards to Rustom Bharucha for our frequent conversations and the encouragement provided throughout the process. Special thanks to Amita Nijhawan and Lars Waldorf for reviewing initial drafts and the Seagull Books team for the editorial diligence that drove the book to final completion. Finally, I want to express gratitude to my family and George and Patricia Breed for their love and support throughout this project and my beloved James Forrester and Aurora Forrester-Breed for their ceaseless patience, understanding, humour and love.

## RWANDANICITY: THE NEW RWANDAN IDENTITY

Underneath a giant umunyinya tree in the middle of an open dirt expanse, the *gacaca* court[1] in Eastern Province, Rwanda, was about to begin (see Image 1). Gacaca, the post-genocide Rwandan government's solution to address the 1994 genocide against Tutsi, mandated mass participation of the population in local-level courts. The blending of justice and reconciliation took place as the members of Abiyunze Association[2] approached the meeting space where testimonies of the genocide were heard. The association began drumming and clapping and two lead dancers stepping into the centre of the gathering, their arms weaving over and under one another's while footwork patterns (right foot, left foot, left foot, right foot) kicked up dust as they circled one another.[3] The male dancer was a perpetrator who had killed the female dancer's uncle during the genocide in which 500,000 to 1 million Tutsi and moderate Hutu were massacred between April and July of 1994;[4] the female dancer was a survivor.

Following the dance by Abiyunze, a single bench and table were placed in front of the now seated local crowd. Ceremoniously, nine judges walked in single file across the dirt expanse to the table, wearing sashes of the Rwandan flag across their chests, with the label *inyangamugayo* (person of integrity, elected by the local population) written across the national colours of blue, green and yellow. The crowd stood up for a moment of silence. The dance space suddenly became a commemoration space for the atrocities of the genocide. The president of the gacaca began to recite several articles, including Article 34, Organic Law No. 16/2004 of 19 July 2004, that states that the cases to be tried in gacaca courts are solely related to genocide or the extermination of an ethnic group.[5]

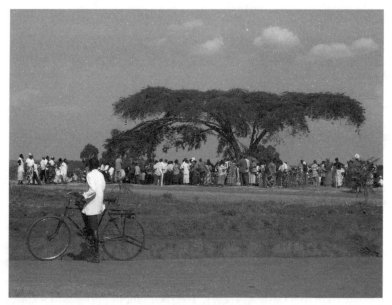

**IMAGE 1** Gacaca gathering, Eastern Province, 2005. Courtesy: Ananda Breed.

Emmanuel, an accused *génocidaire* (perpetrator of genocide), turned to face the crowd of over 600 people. He testified to the crimes committed, including the murder of David Twamugabo.[6] The perpetrator introduced the story by recalling that the *interahamwe* (youth militia)[7] was reluctant to go to the house of David, a giant man who was feared. When they arrived, David stepped out of his house. Several members of the group attacked him but were fought off. The group continued to attack him and threw a grenade. The grenade did not explode. David picked it up, warned them to leave or he would throw it back at them and entered his home. The interahamwe continued their attack from a distance, shooting arrows. Eventually, David was struck. The perpetrator recited the names of accomplices who first hit David with a hammer on his head, then struck his legs with a machete and, finally, sliced his throat with it. At this point in the confession, the perpetrator openly wept. The resident trauma counsellor made her way through the audience to offer him tissues. The crowd dried their eyes with shirtsleeves or collars. Following the gacaca session, the trauma counsellor stated that because the community participated in gacaca and local association activities, people became comfortable round one another, thus providing a space for the possibility of reconciliation.[8]

In this instance, justice and reconciliation were mutually supported through the integration of the arts with the local-level gacaca courts—a model for transitional justice to encourage testimony related to the atrocities of the genocide by fostering trust and building community through the arts. However, the interplay between the arts for healing, post-genocide justice and development aid presents complex performances and performatives that are often contradictory or that limit the espoused objectives of justice and reconciliation. The use of performance in relation to justice includes the performativity of juridical systems themselves; this is particularly important in post-genocide Rwanda where the overarching justice project of gacaca frames any subsequent performance and utterance—one being intricately linked to the other.

Clearly, questions must be considered: How is testimony used to construct collective memories and to build a national identity after conflict? How is theatre used to embed narratives of justice and reconciliation in the post-genocide Rwandan society or to provide alternative spaces for discursive discourses? What narratives are included or left out? In *Performing the Nation: Genocide, Justice, Reconciliation*, I examine varied levels of local, communal and international responses to the reconstruction of post-genocide Rwanda and analyse the interplay between justice, performance, dialogue and memory. I present specific case studies in terms of empirical research I conducted in Rwanda at various stages between 2004 and 2012, and relate the role of theatre to nation building, healing and secondary witnessing.

Theatre is used to 'never forget' as the country undergoes national healing through campaigns of justice, reconciliation and commemoration. Although Rwanda performs as a post-conflict society through a unified and non-ethnically-identified form of nationalism, it has committed ethnic violence in the Democratic Republic of Congo (DRC) against both Rwandan Hutu refugees and Congolese Hutu (see McGreal, Rice and Davies 2010). Human rights abuses in the DRC do not discount or minimize the atrocities of the Rwandan genocide but the fact that there has been warfare based on ethnicity conducted by the government of Rwanda outside its borders while it performs ethnic unification within those borders poses questions concerning enactments of justice and reconciliation.[9] Thus, while the post-genocide Rwanda is performed through international tropes of post-conflict societies (such as justice, reconciliation, forgiveness and truth), competing narratives remain underneath the surface.

This book is about the overall performance of Rwandanicity through varied performances and performatives, primarily concerning the overarching national implementation of gacaca. Here, I provide a context-specific overview of how a nation marred by genocide has sought a unified identity through culture, promoting justice and reconciliation, in relation to other national 'imagining' projects, including the Truth and Reconciliation Commission (TRC) in post-apartheid South Africa. Although Holocaust and genocide studies have established canonical theories related to memory, testimony, commemoration and justice, the re-imagining and re-writing of history and identities in Rwanda are unique and respond to the political and social structures of post-genocide Rwanda. I relate this reimagining and rewriting in Rwanda as a performance, scripting national iterations that shape the post-genocide Rwandan subject (Breed 2008).

While I have researched how post-genocide Rwanda has been reconstructed through a performance studies analysis, noting performative frameworks during the period of gacaca's national implementation between 2005 and 2012, Scott Straus and Lars Waldorf (2011) have remarked similarly on this network of power relations to build nationalism as a 'social engineering project'.[10] An area that has not been significantly addressed in current debates and research is how culture has been crafted to literally script, rehearse and perform the new Rwandan identity. Straus and Waldorf provide a robust account of how and why the currently ruling political party, the Rwandan Patriotic Front (RPF), has pursued a policy of reconstruction and development through an authoritarian military regime that has enforced varied programmes—transitional justice, agricultural reform, villagization, civic education and remapping and renaming regional territories to 'remake' Rwanda (ibid.: 4). Straus and Waldorf state: '[I]t also seeks to alter social identities, cultural norms, and individual behavior' (ibid.). This book seeks to examine these issues.

I use the concept of performativity, or bringing something into being through speech acts, to explore varied performances and performatives, and provide an in-depth analysis of how performative utterances based on nation building are connected to campaigns of justice and reconciliation that are globalized and politicized beyond Rwanda's borders.[11]

The writing of history is inherently problematic at a time when the government is actively rewriting history and working to craft a new Rwandan identity, but to contextualize these performances, I briefly outline critical events leading to the current political structures and international tensions.

Rwanda was colonized in the 1890s by Germany and later ceded to Belgium in 1919 through the League of Nations mandate following the First World War. The hierarchical structure of ethnic identities—Tutsi (pastoralists), Hutu (agriculturalists) and Twa (artisans)—was reinforced and racialized through colonial divide-and-rule tactics.[12] Ethnic identities were rigidified through identity cards in 1935. Tutsi were the elite recipients of colonial favour until the revolution of 1959, in which the Hutu majority overthrew the Tutsi-dominated government and monarchy with the support of Belgium.

The Belgian colonizers, under the authority of Colonel Guy Logiest, thought it was time to grant independence to Rwanda but also felt betrayed by the Tutsi who had fought for independence. The Belgians, therefore, turned over control of the country to Hutu. The optimistic independence movement quickly disintegrated into bloodshed, with victims targeted according to their ethnicity. Thousands of Tutsi were massacred by their Hutu compatriots in the revolution from 1959 to 1962 (Prunier 1995), spurring 400,000 Tutsi to flee to neighbouring countries (Prunier 1998: 119, 121n11). Most fled to Uganda owing to Tutsi ancestral links to the Ugandan kingdom through the Bahima royal family. Following the exodus, Tutsi refugees formed a political and military affiliation with Hima descendant Yoweri Museveni.[13] This collaboration in Uganda would be crucial for Museveni's victory in 1986 and the development of the RPF, led by Fred Rwigyema and Paul Kagame (later to lead the RPF and 2,500 soldiers across the border into Rwanda at the onset of the civil war on 1 October 1990).

Grégoire Kayibanda led the Republic of Rwanda from 1962 to 1973, when he was overthrown by a coup and replaced by General Juvénal Habyarimana who stayed in power until his assassination in April 1994. Across the border in Uganda, Rwandan refugees were faced with mounting concerns based on shifts in land rights. Hence the RPF staged a return to Rwanda (in which theatre played an important role to enlist Rwandan refugees), resulting in several military incursions. The 1990–94 civil war between the RPF and the Rwandan government was mediated by the international community, in which a multi-party system came into existence and resulted in the Arusha Peace Accords. At that time, young Hutu formed the interahamwe, largely responsible for the slaughter.[14]

The genocide began after the plane carrying Rwandan Hutu president Juvénal Habyarimana and Burundian president Cyprien Ntaryamira was

shot down above Kigali Airport on 6 April 1994. During the genocide, neighbours killed neighbours, partners in inter-ethnic marriages were often forced to kill their Tutsi spouses and children. In July 1994, the Tutsi-led RPF stopped the genocide and established the Government of National Unity. Over 2 million people, mainly Hutu fearing retribution, fled to neighbouring countries. Pasteur Bizimungu, a Hutu, became president, while the majority of cabinet posts were given to Tutsi. Bizimungu resigned in 2000 and was replaced by Kagame, a Tutsi leader of the RPF. From 1996, the RPF was involved in insurgencies and counter-insurgencies along the border between Rwanda and the DRC (partly due to the large refugee exodus) that resulted in two wars: one between 1996 and 1997 to overthrow Mobutu Sese Seko and the other between 1998 and 2003 that led to regional control of the DRC's vast mineral resources (see Lemarchand 2009; Prunier 2009). In 2003, Kagame was elected to a five-year term, winning '95% of the vote' (*The Economist*, 28 August 2003), although his landslide victory was marked by irregularities. He won the 2010 presidency with 93 per cent of the votes. As the RPF stopped the genocide, an RPF-led government was given a moral stamp of approval—valid even today—by the international community. Internally, the National Unity and Reconciliation Commission (NURC) was established in March 1999 to foster solidarity and understanding.[15]

> Since its formation in the late 1980s the RPF promoted an ideology of ethnic inclusion, which it called 'national unity'. The RPF emphasized unifying aspects of Rwandan history and culture (i.e. shared language, culture, and religious practices) and blamed the country's 'ethnic problems' on colonialism, arguing that colonialists had created and perpetuated the divisions within Rwandan society [. . .]. When the RPF took power in 1994, it created the Government of National Unity, which purported to follow the power-sharing agreements outlined in the Arusha Peace Accords (Burnet 2009: 84).

However, Filip Reyntjens and Stef Vandeginste (2005) argue that reconciliation, until this point, was not a stated objective of the new government: 'In this context of political elimination of opponents, it is obviously much more "comfortable" for the regime in power to declare that reconciliation is a policy objective. In this move, which is among others intended to please donors and funding agencies, the National Unity and Reconciliation

Commission was established by law' (ibid.: 103).[16] The NURC has used the-atre (among other strategies) as a technique for mobilization of the masses in favour of the RPF government, repatriation and citizenship.

The preamble to the Constitution of the Republic of Rwanda, adopted by referendum on 26 May 2006 and entered into force on 4 June 2006, outlines a common vision for the future: 'We enjoy the privilege of having one country, a common language, a common culture and a long shared history which ought to lead to a common vision of our destiny' (Republic of Rwanda 2008). The preamble emphasizes the importance of Rwanda's precolonial history as the bedrock of the Constitution and the nation itself: 'It is necessary to draw from our centuries-old history the positive values which characterized our ancestors that must be the basis for the existence and flourishing of our Nation' (ibid.). During my research in Rwanda, nearly everyone I spoke to recited the same information about the history of Rwanda: 'We are all Rwandan. The colonizers divided us. Prior to colonization, we lived together in peace.'

After genocide, the government is constructing a new Rwandan iden-tity devoid of the former ethnic labels, producing a subject before (and within) the law. I use the term post-genocide to delineate the framing of history, through government narratives constructed and propagated since the events of 1994, as a performative from which history is written and Rwanda is imagined. The reconstruction of Rwanda is much like a per-formance, in which concepts of unity and reconciliation are staged and the subject of the new nation is inculcated (Lemarchand 2009: 69).

Rwandanicity is the performativity of the new Rwandan identity. The Rwandan newspaper *New Times* described it as 'an idea and philosophy that guided the people's conduct and perceptions. As an ideology, therefore, it is what the people of Rwanda understood themselves to be, what they knew about themselves, and how they defined and related to each other and their country as a united people (*Ubumwe*)' (Rusagara 2005).

Here, I also explore the creation and performance of Rwandanicity in *ingando* solidarity camps, theatre performances, gacaca courts, grassroots associations and memorials and commemorations.[17] Although the objective of the government has been to create justice and reconciliation through the new Rwandan identity, the fact that the current government consists primarily of RPF, and Tutsi members, fosters potential conflict by estab-lishing a single Tutsi narrative and erasing counter-narratives.[18]

## SCRIPTING AND PERFORMING IDENTITY

'I can take an empty space and call it a bare stage,' says Peter Brook (1968: 9). Contesting the notion of an 'empty space', prominent Kenyan author and postcolonial theorist Ngũgĩ wa Thiong'o asserts that 'the performance space, in its entirety of internal and external factors, may be seen in its relationship to time, in terms, that is, of what has gone before—history— and what could follow—the future' (1998: 41). wa Thiong'o analogizes the nation to a stage, directed by a political dictator, with entrances and exits at the borders. Applying this analogy, the whole of Rwanda might be conceptualized as a performance space. What is allowed inside the space? Who enters and exits? Where is there blocking of political movements? What remains hidden or buried? What is being excavated? The performance space is never empty. It is the site of social, mythical and economic forces in society.

Contrarily, Michel Foucault (1977: 150) argues that place is a void, a space that divides, a concept that can be applied to space in Rwanda as a contested area of power. This contestation more often than not implies violence. Frantz Fanon (1963) argues that violence is necessary to break down some of the spatial and psychological boundaries established in ethnically divided societies. René Lemarchand applies ideas expressed by Fanon and quotes: 'Violence is a cleansing force [. . .]. It forces the native from his inferiority complex and from his despair and inaction; it makes him fearless and restores his self-respect. [. . .] For the native life can spring up again from the rotting corpse of the settler [. . .] Violence unifies the people' (1970: 496). He goes on to state: 'That violence did help unify the Hutu is undeniable; but whether it did succeed in "freeing [the peasant] from his inferiority complex", in "making him fearless" and in "restoring his self-respect" is what remains to be seen' (ibid.). These comments were made in relation to the bloody revolution of 1959, when Hutu opposition forces toppled the Tutsi government and monarchy functioning under the Belgian colonial rule and Rwanda gained its independence with the establishment of the Republic of Rwanda.

The quotes by Fanon and Lemarchand raise the issue of how violence has been used for both liberation and oppression in the transition from colony to self-rule. While Lemarchand directly relates violence to the political and social states of Rwanda and Burundi, Fanon presents a general theory about the postcolonial subject in Africa. Both qualify the

general use of violence to the destruction and reconstruction of the self and the nation in postcolonial societies.

Lee Ann Fujii (2009) too reflects on the notion of violence as a unifying force that produced identity groups during the genocide. She compares the politics of genocide to performance, positioning 'state-sponsored ethnicity' as a 'script' for violence that was performed: 'The most powerful technique for constructing ethnicity in radical terms was through violence. Political actors created a form of ethnicity that was constituted by violence' (ibid.: 121). While clan or kinship ties were passed down orally through family histories, ethnic identities of Hutu, Tutsi or Twa were regulated by the state's construction of ethnicity, reinforced by colonizers and rigidified through identity cards. Fujii argues that ethnicity has been permeable historically, depending on the political and social context at the time. There were two primary paths to change ethnic identities: through the acquisition of cattle and material wealth or by modifying identity cards to reflect the desired identity. Thus, individuals were able to navigate ethnicity and their responses to state-imposed scripts. Fujii states: 'National-level power holders created the script and gave their backing to local-level power holders who directed the script in their local communities. It was this hierarchy of power that linked local productions to centre politics; local productions nevertheless reflected local interests and conditions' (ibid.: 124).

While the aforementioned scholars have noted the significance of the construction of national identity through 'performed' violence, Eugenia Zorbas (2009) borrows James C. Scott's (1990) notion of 'public and hidden transcripts' to propose how iterations and performances are controlled in post-genocide Rwanda through scripts. Zorbas cites the RPF version of reconciliation as public transcripts mandated by the RPF's 'national unity and reconciliation policy':

> From its first days in power, and despite initial lack of donor support, the RPF has most consistently associated this shifting policy with the prosecution of *all* people accused of genocide-related crimes. However, the RPF has also cited the imperative of reconciliation to justify a wide array of other actions: in no particular order, these have included an ongoing mass civic re-education exercise, a programme of (some have argued, forced) population resettlement into government-constructed villages, a decentralization programme, controversial legislation on land ownership, two

military campaigns into neighbouring Zaire / Democratic Republic of Congo, and the aggressive pursuit of Rwandan economic development via the promotion of higher education and Internet and Communication Technology in particular (2009: 128).

I further the notion of scripting national performances and performatives by the evocation of the post-genocide Rwandan subject through national iterations controlled by the aforementioned public transcripts alongside laws that promulgate Rwandanicity.

## PERFORMATIVITY AND JURIDICAL SUBJECTIVITY

The new Rwandan subject is in the process of being created through enactments across a range of venues, involving a host of implementers, including theatre, juridical systems and grassroots associations, each of which exemplifies a different form of performativity. The new Rwandan identity is thus performatively encoded through citation, recitation and reiteration of various aspects of Rwandan mythology and history posed in relation to the contemporary Rwandan nation state. Judith Butler (1993) theorizes the role of repetition in the performative construction of identity:

> [T]hink about the performativity as *that aspect of discourse that has the capacity to produce what it names*. [. . . T]his production always happens through a certain kind of repetition and recitation. So if you want the ontology of this, I guess performativity is the vehicle through which ontological effects are established. Performativity is the discursive mode by which ontological effects are installed (emphasis in the original).

In terms of Rwandanicity, to state 'I am a Rwandan' creates the new Rwandan subject who is tied to a precolonial form of unity and collective cohesion. The utterance, or in Butler's terminology the recitation, of 'I am a Rwandan' is linked to power relations associated with a particular period of precolonial history that communicates its meaning. Unlike John Langshaw Austin's speech acts, in which a particular social order is maintained (i.e. wedding vows or the naming of the sex of a child), Butler's speech act resurrects a particular narrative connected to precolonial times.

To perform 'I am a Rwandan' presumes the existence of a subject but it could also bring into being a subject that has not yet formed. As Butler (1993) notes, drawing on Foucault:

Power works in part through discourse and works in part to produce and destabilise subjects. But then, when one starts to think carefully about how discourse might be said to produce a subject, it's clear that one's already talking about a certain figure or trope of production. It is at this point that it's useful to turn to the notion of performativity, and performative speech acts in particular—understood as those speech acts that bring into being that which they name.

The precolonial past is the image or 'imagining' used to envision the future. Although an understandable pursuit in the wake of genocide, the use of culture to promote a legendary past is problematic because of historical power imbalances among Hutu, Tutsi and Twa.[19] The reimagining itself is a rewriting of history and a reworking of culture to promote current political and social aims. Today, however, culture is being manipulated to create and support a state-mandated singular conception of Rwandan identity, that pivots on the avowed erasure of ethnic differences. This erasure is causing the entire system to court the dangers of potential conflict because ethnicity remains a predominant fixture of how power is distributed—an aspect not being addressed at a political level.[20] As an example, the ethnic labels Hutu and Tutsi eventually became synonymous with perpetrator and survivor, which will, in the long run, have a grave effect on Rwandanicity (Pottier 2002: 130). Ethnic fissures threaten to become deeper if predominantly Hutu families are forced into community service or prison sentences, economically burdening a large portion of the community.[21]

In addressing *how* Rwandanicity is performed in contemporary Rwanda, it is useful to examine the two forms of reiteration mentioned: from a position of power (e.g. a Tutsi who holds a government job) and by a subject who is disempowered (e.g. a Hutu in prison). The latter repeats but cannot fully become what he or she names. As a reiteration, Tutsi refugees and artists who have returned may state 'I am a Rwandan. There are no ethnic divisions,' but at the same time may support the dominance of the RPF in the government, thus bringing into being what they enunciate while also glossing over their own access to power. The released Hutu prisoners may say the same phrase at the ingando solidarity camps but often because they are coerced into doing so to be released. A gap opens between the saying and the subject's relationship to this idealized Rwanda. Repetition of the phrase may eventually create a unified Rwandan subject even for

the Hutu but at this stage in history—perhaps still a little too soon after the genocide—the iteration may come before an actual belief in the phrase (and the Rwandanicity or the Rwandan subject it proposes to narrate).

That the use of ethnic terms in Rwanda can be criminalized under the law against divisionism and genocide ideology points to the government's explicit control of speech acts and to the dangers of the utopian view of reiteration the government promotes. The government enforced Law No. 47/2001 of 18 December 2001, entitled 'Instituting Punishment for Offences of Discrimination and Sectarianism', the motivations behind promulgating which are complex, but it is important to know how it contextualizes the power of speech in my research. As Article 1 of this 'ethnic divisionism' law states: 'Discrimination is any speech, writing, or actions based on ethnicity, region or country of origin, the colour of the skin, physical features, sex, language, religion or ideas aimed at depriving a person or group of persons of their Rights as provided by Rwandan law and by International Conventions to which Rwanda is party' (Government of Rwanda 2002). A revised draft law was approved by the National Assembly and Senate in mid-2013 but it still contains language that could criminalize free speech.

This law is addressed to citizens of Rwanda but includes foreigners too, thus restricting how researchers or journalists (potential theatre-makers) can or cannot write or speak about Rwanda in relation to ethnicity. The law is problematic for it can be misused to wield power. Hypothetically, an individual who claims that Tutsi dominate positions of political power and that power is shared unequally among ethnic groups may be tried under this law for 'any speech, writing, or actions' as the claims are based on ethnicity. The law does not define what might be considered an act of discrimination; instead, the definition of the term is left to those in power.[22]

Any writing or reporting against the current government's stance could be viewed as revisionism, negationism (genocide denial) or both. Charges of revisionism have primarily been laid on academics and critics whose views of Rwandan history and the genocide differ from those of the current government. For example, government officials I met often used the term revisionist to describe individuals who claim that the civil war provided the context for the genocide. The term is also used to silence anyone who opposes the government-mandated history of Rwanda.[23]

I recognize that my writing may be perceived as critical of the RPF because it raises questions concerning the ethics of Rwandanicity in relation to the ideology of unity. My analysis, however, does not negate either the

genocide or the devastation that it has caused to individuals, families and the nation at large. Current government policies for creating unity and reconciliation are motivated primarily by a complex web of perceived exigencies—both a general desire to avoid war and a desire to maintain a stable power structure. Chantal Mouffe uses the term 'conflictual consensus' (i.e. consensus on the principles but disagreement about their interpretation) as an agonistic model of democracy that allows for pluralism and participation that is not preconditioned (in Miessen 2010: 108–9). Perhaps there is a need for conflictual consensus not only to highlight the shared principles of a democratic society to avoid war but also to potentially maintain a stable power structure by addressing the varied disparities of power and access as evidenced in post-genocide Rwanda.

Further, the ideology of ethnic inclusion or Rwandanicity has not successfully prohibited identification through ethnic categorization; rather, the terminology has been replaced with experiential categories: 'Terms synonymous with Tutsi include victims (*inzirakarengane*), survivors (*abarokotse*), widows of the genocide (*abapfakazi ba genoside yakorewe abatutsi*), and old returnees (*abarutashye*, literally, "the people who returned"). Terms synonymous with Hutu include perpetrators (*abicanyi*), prisoners (*abafunze*), infiltrators (*abacengezi*), and new returnees (*abatahutse* or *abatingitingi*)' (Burnet 2009: 89). Jennie E. Burnet comments on distinct subject positions in Rwanda outside policies of national unity:

> The shared experience among individuals within each of these categories [refugees] shape distinct subject positions from which people view the world and negotiate their way in it. The heterogeneity of individual citizens' experiences of marginalization (political, economic, or social), exile, identity-based violence, and state-sponsored violence before, during, and after the genocide, as well as language communities makes a unified national identity difficult (if not impossible to imagine (ibid.: 83).

The stripping away of ethnicity in favour of a centralized and unified conception of Rwandanicity controlled by the government might well end up impeding the process of peace if political power and economic advantages are not distributed evenly between Hutu, Tutsi and Twa.

Different power discourses have been constructed in Rwanda at different points in history, shaped by the dynasty, colonial powers and shifting power nodes among Hutu, Tutsi and Twa. Examples of current systems

that maintain a particular discourse in relation to the newly constructed Rwandan subject include the ingando solidarity camps, which instil in the participants the new Rwandan ideology that no conflicts occurred between Hutu and Tutsi before colonization; the Ministry of Culture that formally creates new dance styles to fuse former ethnic dances affiliated with Hutu, Tutsi and Twa into a unified and homogeneous version of the previous forms; and gacaca trials, which enforced a prescribed form of justice and reconciliation while also serving as a public confessional forum. Power discourses permeate networks at the local, national and international levels.

THEATRE-MAKER AS SCRIBE

This book originates from my earlier PhD research and the In Place of War project based at the University of Manchester between 2004 and 2007 which sought 'to reveal the complex "imbrication" between "elements of war" and performance practices, and to illustrate how culture is an integrated part of the matrix rather than a simple reflection of or response to war' (Thompson, Hughes and Balfour 2009: 12). The initial Arts and Humanities Research Council funding bid for the project included two primary case studies focusing on performance in Sri Lanka and refugee communities in the UK. As a project member of In Place of War, I worked on an additional case study of performance in post-genocide Rwanda that connected juridical performances (gacaca) to the wider subject areas under examination, including commemoration, memorialization, reconciliation and trauma.

The In Place of War project has significantly contributed to the global understanding and networking of performance practices and practitioners in relation to varied contexts of violence and reconstruction between war and peace round the world. *Performance in Place of War*, published in 2009 by Seagull Books as part of their Enactments series (of which this book too is a part), also originated from the same project. The authors—James Thompson, Jenny Hughes and Michael Balfour—note the significance of 'new wars' citing Edward Newman's focus on wars that are 'intrastate', 'characterized by state failure and a social transformation driven by globalization' and civilians 'deliberately targeted as an object of new wars' (in addition to other characteristics and contexts) (ibid.: 10–11). Identity formation in Rwanda is considered an outcome of these 'new wars'. According

to Thompson, Hughes and Balfour, 'the literature on war and culture is still underdeveloped. In particular, there is little documentation of the links between making art of any kind and the different cultural processes involved in these "new" wars' (ibid.: 11). While the scope of *Performance in Place of War* may not have allowed for an in-depth analysis of the cultural processes involved in the fraught intersection of justice and reconciliation in post-genocide Rwanda, with *Performing the Nation: Genocide, Justice, Reconciliation,* I hope to extend the literature to include the missing links between 'making art of any kind and the different cultural processes', including former traces of how performance was historically used to instil ethnic/clan identity into groups and presently how performance is used towards weaving national and transnational identities.

I assert that the overarching performance of justice and reconciliation staged through gacaca courts, between the national launch of gacaca in 2005 until the culmination of trials in 2012, provides the framework to analyse gacaca as a cultural practice, adopted from an indigenous mediation system, used to try the perpetrators of the genocide and to stage the new Rwandan identity or Rwandanicity.

This book project has been conditioned by the numerous stories, practices and contexts of performance in diverse political and geographic locations. I conducted empirical research in Rwanda at different points in time between 2004, 2005, 2006 and 2010 which I present here as a timely account of how cultural processes were used to negotiate political and social reforms in the aftermath of the genocide. Although I argue that most performances at a micro level were ultimately drawn into the nation-building processes at a macro level, some instances of micro-level performances can be found when individuals resisted dominant discourses for individual narratives or 'hidden transcripts' to emerge.

In terms of methodological problems encountered as a theatre-maker and researcher, I was confronted with decision-making about how, when and where to use theatre (or in many cases, when not to use theatre). As national identity is being shaped through theatre and other cultural forms, the use of theatre can become implicated in larger political and social acts. In his seminal book *Re-Imagining Rwanda: Conflict, Survival and Disinformation in the Late Twentieth Century,* Johan Pottier (2002) has noted that the researcher has at times been used as a scribe for the RPF. He warns researchers and scholars about the government's manipulation of

information, citing as examples government-produced, easy-to-understand sound bites of a single RPF narrative that do not represent some of the multiple narratives in the region:

> The re-writing project, a high priority in Kigali, has benefited from the empathy and services not only of journalists unfamiliar with the region, but also of newcomer academics, diplomats and aid workers. All have helped, although to varying degrees, to popularise and spread an RPF-friendly but empirically question-able narrative [. . .]. Anyone working in zones of conflict is affected by multiple pressures and prone to be manipulated (ibid.: 53).

Pottier advises the researcher not to place one history over another but rather to emphasize the complexity of constructed identities and his-tories at a time when the government is actively rewriting history and working to craft a new Rwandan identity.

I have addressed this dilemma by seeking out a geographically and demographically varied range of perspectives and by working both inside and outside Rwanda. Owing to the porous nature of conflict between bor-ders in the Great Lakes region, I observed and practised theatre in Burundi and the DRC in addition to locales across Rwanda.

In Burundi, I observed the practices of the Burundian theatre troupe Tubiyage by attending a regional theatre tour about domestic violence. Later, I was commissioned by the Ministry of Justice in Rwanda to create a participatory theatre project in collaboration with the Mashirika Creative and Performing Arts Group. The production *Ukuri Mubinyoma* (Truth in Lies) used theatre as a vehicle not only to discuss and disseminate infor-mation but also to address violence beyond the genocide (potentially con-nected with rape during the genocide). The Ministry of Justice funded the national tour to sensitize the public about the new law against gender-based violence (see Chapter 5).[24] Further, in 2005, in Burundian prisons, I observed Belgian theatre director Frédérique Lecomte conduct theatre workshops with prisoners on death row. Lecomte realized that participants of Hutu and Tutsi origin often tried to 'outsuffer' one another. Thus, she began staging theatrical competitions of suffering between historical nar-ratives in conflict. From the observations in Burundi, I was able to note how ethnicity was openly discussed in the reconciliation process and to explore varied theatrical techniques for audience and participant engage-ment in promoting dialogue.

In the DRC, I conducted theatre workshops with the conflict prevention and conflict resolution NGO Search for Common Ground (SFCG) in Bukavu and Kinshasa. Theatre practitioners—often ex–child soldiers or those affected by war personally—rehearsed techniques including Image Theatre, Forum Theatre and Playback Theatre.[25] In a public performance staged for a widows' association in Bukavu, Don Tshibanda, the SFCG theatre coordinator, transitioned from personal stories using Playback Theatre to public interventions using Forum Theatre. Unlike Rwanda, where a semi-dictatorial government enforces tight control of civic life, the vast country of the DRC often suffers from lawlessness or, worse, government acquiescence or participation in violence (such as plunder and rape by the army). The difference in political and domestic spheres requires different theatrical responses.

The techniques used by Lecomte and SFCG demonstrate the role of the 'outsider' and international investment in the peace-making process.[26] Lecomte had been funded to work in Burundi by RCN Justice et Démocratie, and SFCG works in partnership with the United Nations High Commissioner for Refugees (UNHCR), but there are local applications to both projects integrating local companies and directors, including Tshibanda. Although funded by international agencies, Lecomte does not necessarily agree with tropes attached to practices and policies of justice and reconciliation, in particular, concerning forgiveness. In my interview with Lecomte in October 2005 in Burundi, she stated: 'I don't believe in forgiveness. In order to forgive, you have to become numb. It is disempowering and is a kind of desensitization. We need to hold on to our politics—what created the pain and suffering—to redirect our ideas and to develop some kind of understanding.' In a follow-up email interview with me on 10 January 2012, Lecomte further complicated the term forgiveness with her own practice:

> Forgiveness is a special word. I don't like the word very much. I think forgiveness, in the case of trauma, can mask the problem because when you say 'I forgive you,' it is like it didn't happen or that you have forgotten. It is important to forgive oneself but you can't forget. Forgiveness hides memory. That is why I think peace and reconciliation isn't about forgiveness, it's about memory. All we can do (as communities that have experienced conflict) is to put the memories of suffering together and then do something with that . . . theatre or art. But forgiveness for me is propaganda.

Forgiveness hides the problem. The memory *is* the problem—
the trauma and the acting out of war. When you put the memory
together with theatre and victims of conflict, it is a step towards
forgiveness. But by taking this step you don't need forgiveness to
put together memory. Memory is contradictory and it is the role
of theatre to work with those contradictions.

In her workshops with prisoners condemned to death, Lecomte used
a technique that encouraged individuals to tell the truth but not through
the usual demonstration of remorse and confession. In darkness, individ-
uals repeated phrases such as 'I was afraid when . . .'; then they improvised
their own responses. Lecomte instructed individuals to change vocal inflec-
tion and volume as they repeated their responses until the room was filled
with a cacophony of testimonies. Then, one by one, individuals came for-
ward and repeated a phrase, encouraged by Lecomte to laugh. There
were moments in which the contrast between the phrase and the demon-
stration of laughter was particularly absurd; for example, 'I was afraid
when I picked up the baby and bashed him against the wall,' 'I was afraid
when I went to sleep,' 'I was afraid when I looked into the eyes of the
woman I raped.' Often, these moments went from high-pitched laughter
to tears. Lecomte would shout out: 'Laugh harder! Harder!' A part of her
technique was to use laughter as catharsis, to loosen the inner control of
emotions, so that truth could emerge, and to dramatically enact the testi-
mony, thus creating a physical distance between the self (suffering) and
the reality of the event. As Lecomte states:

[The technique helps to] create a distance between the suffering
and the performance of the suffering. In this way it is therapeutic.
I'm not sure catharsis is from testimony, but it does increase
the distance between what one feels and what one wants to say to
the audience. The person is able to then tell their testimony or
story—not as oneself but commenting on oneself.

Lecomte describes the 'chorus form' technique in greater depth:

First, the prisoners are asked to speak softly about what they are
afraid of and what they have done, even if it is dark and horrific.
Not to think about it but to speak about it. Then, they are asked
to speak louder. In the first step, they open up about what they
have done. The second step is for them to [merely] speak louder,
not to tell others what they've done. But everyone can hear what

they've done. [. . .] The third step is for them to ask people to speak one by one (and louder) and then to hear everyone and what they've done. It is a progression, so that people can hear each other and perhaps have compassion for themselves and for others. At the end of the third step we are at the point of theatre. In the fourth step, I can play with the testimonies as theatre. I can have them laugh about what they say. It is a direction I give the actors—to laugh, to sing or to dance, but to jump into theatre. Then, we are sure we are doing theatre because we are laughing about things that we can't laugh about. All the steps have different functions. The first step is to confirm memory. The second step is to share a little bit of that memory. The third step is to act and the fourth step is to play with that memory. During this process, people change because they think in different ways about what they have done and about themselves. They can hear other people's testimonies and place what they have done in relation to others. [It is a way of] opening their hearts and minds.[27]

In various cases, Lecomte takes artistic liberty to adapt these narratives into public performances (See Images 2 and 3). She states:

[T]he common ground I find is the common ground of suffering because everybody is suffering—both sides lost their land, their children—and I have to work with the suffering . . . the people talk to me and say what they are feeling, their truth, not *the* truth, but *their* truth about their *own* suffering. And when I mix the two in the same group, they can hear the suffering of the other part. So the common ground of suffering [is] the base of the play (in Thompson, Hughes and Balfour 2009: 181; emphasis added).

In this quote, Lecomte emphasizes the individual particularity of truth versus the universalized application of truth—to express shared suffering. The grassroots artists whom I interviewed in Rwanda similarly spoke of the significance of shared suffering. It was often at the moment when survivors and perpetrators identified the depth of shared suffering between one another that they decided to create grassroots associations with a combination of perpetrators, survivors and community members (see Chapter 5).

I worked with accused génocidaires in Kigali Central Prison, survivors and perpetrators in grassroots associations and government officials serving on the NURC and in the Ministry of Justice. I used a triangulation approach

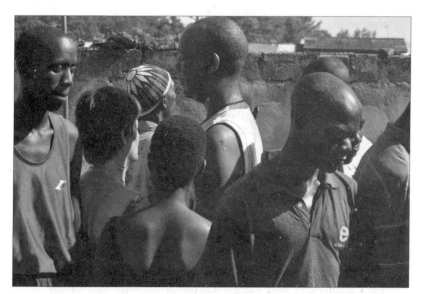

**IMAGE 2** Theatrical exercise with perpetrators and survivors, Burundi, 2008. Photograph by Véronique Vercheval. Courtesy: Frédérique Lecomte

**IMAGE 3** Chorus exercise with perpetrators and survivors, Burundi, 2008. Photograph by Véronique Vercheval. Courtesy: Frédérique Lecomte.

towards observing the performativity of Rwandanicity by investigating both theatrical and non-theatrical events, including gacaca, ingando solidarity camps, legendary theatre and grassroots associations. I had the opportunity to observe the manipulation of culture for nation building through multiple levels of governance and a range of demographics. I was given government permission to attend gacaca and to conduct workshops at ingando solidarity camps and the Kigali Central Prison, thus becoming inherently entwined in the rewriting project.

## *KUGANGAHURA*: CLEANSING GENOCIDE THROUGH CULTURE

Straton Nsanzabaganwa, the former director of Culture in the Ministry of Sports, Youth and Culture in Rwanda, likened the use of theatre in post-genocide Rwanda to a traditional purity ritual called *kugangahura* in which people cleanse themselves of a bad event. As Nsanzabaganwa pointed out to me in an interview on 28 November 2005 in Kigali:

> It is not special to Rwanda; always in human history, when there is a great event—negative or positive—it is a source of creation. This is why I consider the genocide a source of creation and cultural production. It is an inspirer of creation, for cultural creations must have deep emotions and feelings. I think genocide has given us very deep emotions and feelings. It could also give many serious ideas, which could inspire many important actions.

While the Rwandan government expresses support for the use of theatre as a cleansing ritual—a post-genocide solution to wash away the bad event and to construct a desired future—one must nevertheless question Nsanzabaganwa's implicit assertion that genocide in itself invokes culture; the enormity of how the genocide has devastated individuals and communities must be considered when addressing how and why theatre is used as a healing or reconstructive device. According to Nsanzabaganwa, culture in Rwanda is defined by three things: (1) how the universe was created, (2) the expression that emerges from theatre, cinema, poetry, literature, painting, singing and sculpture—all expressions that come from ideas and (3) deeds or acts in relationship to living. He believes that human beings are at the centre of culture in Rwanda and the genocide, which was widespread, aimed to destroy humanity. Nsanzabaganwa stated: 'Now, I wonder what our traditional philosophy is . . . has it disappeared? Can we revive it? The

role of culture is to try to rebuild these things.' He used both gacaca and theatre as examples to illustrate how culture can rebuild society:

> Theatre and the arts can be used to heal society because many people are traumatized—the victims, the actors and society [itself]. Culture can be used to heal those groups or individuals. When traumatized, you need to express yourself, to be listened to. If you play and speak about your problem, it is a way of healing. A reason we have used gacaca is to give actors and victims the ability to talk together, to say, 'You have killed my child.' 'Yes, I have.' Or, 'No, I haven't.' Theatre and the arts are good for that.[28]

This statement affirms the targeted use of culture as a tool for healing and reconstruction. Nsanzabaganwa links theatre to cultural productions, that is, how societies use culture to negotiate identities. He primarily refers to the use of theatre and gacaca to help perpetrators and survivors mend relationships and to facilitate reconciliation within and among communities.

Although performances often contain a beginning, middle and end, acts of reconciliation in Rwanda can be durational. I met with the association Umuhanzi w'u Rwanda (Rwandan Performer) at various points between 2005 and 2006, followed by an interview in 2010. It is worth quoting at length from an interview held on 15 April 2010, the day of the village commemoration, with a survivor of the genocide and a perpetrator who admitted to killing her children:

> SURVIVOR. In the last five years, a lot of things have happened between the two of us. He killed my children during the war, it was hard for me to forgive him, but later on I did forgive him. We came into the same art form, the same association, which later became a cooperative. We tried to be together and forgive one another, to an extent that, after the genocide, I gave birth to a child. He [the child] climbed a tree and broke one of his joints [after a fall]. When I was in the hospital, he is the man who brought food for me, the man who took care of me—paid hospital expenses too. After I came home, he kept visiting my home, digging my garden and helping me out. I will not forgive someone who has not asked for forgiveness. This man came to my house and asked for forgiveness. But there are a lot of people who did wrong to me. If nobody came to ask for forgiveness, I wouldn't give forgiveness.

PERPETRATOR. [From what] she has just told us, it is evident that it is I who killed the children. We went as a group of militia to her house, got the children and I killed them. That is known, and I was put in prison for that. When the president gave pardon to the people who accepted what they did—the crimes they committed—I was one of those who was given pardon and was released. When I came back to the village, one of the reasons that we were able to reconcile is that she didn't know where the children were, so I showed her where I threw the children. She went and buried them. I got into this association and then the association helped me to cleanse myself. I feel my heart is clear. If she has any problem, I go to the house and take care of the problem because I know . . . all the children she had were the ones who were supposed to take care of her, and now they aren't there, so it means that the hands she had, those are the hands that I cut short. So anything that she needs me to do, I quickly go and help her out and that is what is helping me. I don't have any problem in my heart. I don't have any problem with her because we sit and talk. We walk around town comfortably. I walk to different functions comfortably because I know that I am clean.

This interview illustrates the durational process of reconciliation, in which the association and artistic practices provide a continued space for relationships to be negotiated. The perpetrator refers to being 'clean', thus going through a kind of kugangahura due to his participation in the association. In my discussions with numerous associations and performing arts groups in Rwanda, the role of the arts to foster humanity was a predominant theme. The then deputy director of the University Centre for Arts and Drama, Odile Gakire Katese corroborated this in my interview with her on 13 April 2010 in Butare, Rwanda: 'The arts are to rebuild our culture by rebuilding the human being. If the human being isn't strong, then the nation is weak. The power of culture is to bring people together.'

While the overarching analysis of Rwandanicity may help deconstruct how Rwanda is being performed as a national project, micro-performances demonstrate varied approaches to rebuilding human connections—that move between nation building and conciliation from an individual to a national level. As the genocide was carried out differently from region to region, gacaca and associations similarly illustrate varied levels of

participation and adherence to the government project, teetering between reconciliation for its own sake and reconciliation that may be enunciated for other objectives such as international donor aid and political agency.

## FOREIGN INTERVENTION AND AUDIENCES

Inherent ethical dilemmas concern the representation of the genocide to international audiences, which may be portrayed through theatre along with other art forms.[29] After the feature film *Hotel Rwanda* was released in 2004, Jason Cowley (2005) from the *Guardian* asked: 'What is one to make of all this western interest in the unhappy central African state? Is there not an element of atrocity tourism at work here—as well as a stylized poetics of misery?' The general appeal for sympathy towards genocide victims may mask different agendas. As an example, former US president George W. Bush visited Gisozi Genocide Memorial Centre in Kigali on 20 February 2008 and commented that the '800,000 people who were massacred had shaken his emotions to the very foundation.' However, sceptics criticized Bush for using Gisozi Genocide Memorial Centre and the familiar narrative of genocide in Rwanda as a backdrop to funnel $100 million of aid for military training in Africa, potentially to protect mining and oil resources (McGreal 2008). Owing to the Rwandan government's appeal for international donor aid and intended alliances with countries such as the UK and the US, it is important to consider how the genocide has been narrated to large general audiences as the historical events related to conflict in Rwanda have been shaped into politicized collective narratives.

Culture has been shaped as a political and economic commodity that can be used in times of war or peace. Carolyn Nordstrom (2004) addresses issues of globalization and consumerism between profiteering through a visible exchange of resources in an international market but also through what is invisible or exchanged through the black market as 'shadows of war'. She argues that 'extra-state' exchanges or 'shadow networks' are central to processes of war and development (ibid.: 11). In addition to Nordstrom's concepts of legal/illegal and visible/invisible marketing I add culture and embodied practices of politicized identities as a 'shadow network' of war. According to Rebecca Schneider, '[h]istorical events, like wars, are never discretely completed, but carry forth in embodied cycles of memory that do not delimit the remembered to the past' (2011: 32). Schneider considers

the past as never fully complete but as 'remains' that engage with that incomplete past: 'If the past is never over, or never completed, "remains" might be understood not solely as object or document material, but also as the immaterial labor of bodies engaged in and with that incomplete past: bodies striking poses, making gestures, voicing calls, reading words, singing songs, or standing witness' (ibid.: 33).

The use of culture in Rwanda can be considered as engaging with that incomplete past as embodied cycles of memory, but varied embodied practices of former ethnic identities can be entrenched as a kind of haunting that cannot be easily dismissed or forgotten—whether through legal structures enforcing a legalized Rwandan identity or not. These 'shadow networks' remain alive and active but may not be visible.

### AFTERMATH

In an interview with me on 12 January 2005 in Kigali, Fatuma Ndangiza, who was then the executive secretary of the NURC, stated: 'It took 30 years to create genocide ideology for the genocide to happen, it will take that long to correct it.' Although culture is used to inculcate Rwandanicity as a corrective, I provide examples of how culture can alternatively create spaces for identities and relationships to be negotiated.

Chapter 1 provides a historical background to events leading up to the 1994 genocide and the rewriting of history after it. The rewriting project aims to create a unified Rwandan identity that is rehearsed through lessons taught at the ingando solidarity camps and performed through what I call 'legendary theatre' (see Appendix). The ingando solidarity camps indoctrinate Rwandanicity through history lessons that incorporate state-driven ideology and rhetoric that is disseminated orally through a series of daily lectures.[30] 'Ingando' comes from the Kinyarwanda (one of the official national languages of Rwanda alongside English and French) verb kuganda, which refers to 'halting normal activities to reflect on, and find[ing] solutions to national challenges'.[31] According to the NURC, the ingando was used in precolonial times to prepare for war under the guidance of the mwami (king). Similar to the precolonial emphasis on unification through a militarized notion of the nation, following the 1994 genocide, the ingando was initially revived as a vehicle to re-integrate ex-FAR (Rwandan Armed Forces) soldiers from the DRC. Over time, it was redefined as

a broader vehicle for civic education to encompass returned refugees, university students and various community groups.[32] Legendary theatre performs nationhood through cultural forms that are inherently politicized (Breed 2008: 33). It performs Rwandanicity through theatrical productions primarily directed by returned Tutsi refugees who used theatre in neighbouring countries for a militarized return to Rwanda through the RPF (ibid.: 32–50). State-sponsored theatre employs the diasporic Rwandan community—artists in exile after 1959. Theatre in Rwanda is currently steeped in the poetic imagery of the exile. But cultural memory connected to former ethnic identities may be sustained through performative social memory that is embodied and not easily erased.

Chapter 2 interrogates what is being performed as Rwandanicity, why it is being performed, for whom and for what purposes. The slogan 'never again' links the genocide in Rwanda with past and current genocides. *The Investigation* specifically correlates representations of the Holocaust and the Rwandan genocide. Comparisons have been drawn linking negotiated cultural and political discrepancies in post-apartheid South Africa, performing the 'rainbow nation' through the TRC and theatre that explores national identity formation and testimonials, including the productions *Truth in Translation* and *Ubu and the Truth Commission*.

Chapter 3 examines gacaca in relation to culture, globalization and conflict. The Rwandan government deliberately sought out a time-honoured local form of justice in reaction to the larger global forces impacting Rwanda before and after the genocide. Gacaca courts sanctioned Rwandanicity through weekly iterations of the genocide mandated and controlled through national scripts, inculcating the post-genocide juridical subject. National scripts are iterated through gacaca laws (Organic Law) and the Constitution.[33] Zorbas (2009) refers to national scripts as 'public transcripts' that emphasize the RPF government's national unity and reconciliation policy. Hidden transcripts, revealed through personal interviews, provide alternative discourses to the public transcripts—including ideas of punitive justice, the possibility of not forgiving and a return to a pre-genocide utopia (implying the time of the Hutu Republic). The chapter looks at stages of gacaca from rehearsal (sensitization campaigns and information-gathering courts) to the performance of its implementation in which over 1,210,368 files were tried at local-level courts, emphasizing discrepancies between public and hidden transcripts (see Bikesha 2010).

Chapter 4 questions concepts of reconciliation and poses the limits of empathy when grassroots associations developed from community-driven initiatives are co-opted by the government. The analysis gives evidence of the relationship between reconciliation that emerges as a community response to perpetrators and survivors living side by side and the construction of new national subjects by underlying powers of governance through discourses of justice and reconciliation. Grassroots associations inculcate Rwandanicity through embodied cultural practices—music, dance and theatre—that illustrate the state-driven rhetoric of unification through theatrical collaborations between survivors and perpetrators. However, cultural forms are linked to ethnic identities. Thus, while associations iterate Rwandanicity, simultaneous performances of ethnic identities can be seen through dance styles that association members self-differentiate as Hutu, Tutsi or Twa. However, the emphasis on shared suffering between survivors and perpetrators and the use of arts-based practices to create an alternative space for coexistence illustrate how some individuals have reconstructed relationships and communities in the aftermath of the genocide.

Chapter 5 integrates a gendered analysis of the use of rape as a weapon of war in the genocide with current issues of gender-based violence, concluding with empirical research from the theatre project Ukuri Mubinyoma about gender-based violence that toured Rwanda between March and June 2006.[34] Although the use of rape for genocide and the potential after-effects of gender-based violence cannot be linked directly, there is a correlation between gender-based violence during conflict and post conflict which should be noted as a continuum of violence, embodied and enacted through larger narratives of power discourses concerning gender, identity and nation building.

Chapter 6 relates theatrical performances and commemoration to the genocide and representation as a form of secondary witnessing. In the case of trauma, in which events are shattered into broken narratives, the voicing of traumatic events may provide the physical distancing outside of the body necessary for healing to occur. However, recent empirical research cautions transitional justice systems against condoning the provision of testimony as a talking cure (Brounéus 2008). The concept of performing social trauma on the international stage raises questions concerning the ethics of representation and correlations with international donor aid. Memorials and commemorations historicize Rwandanicity by establishing

the genocide as the foundation from which a new identity is built. The traumatic event of genocide as the point of departure from which history is rewritten must be regarded critically when the vast majority of civic acts (ranging from gacaca to commemoration) are used to inculcate the new Rwandan identity. If this identity remains fractured or adversely dominated by RPF (and predominantly Tutsi) recollections, Rwanda will inevitably be caught in a continual cycle of violence.

In a visit to Rwanda in 2010, I revisited several government officials, artists and grassroots associations and asked them what they wanted from this book project. Members of Abiyunze Association, in an interview with me on 15 April 2010 in Eastern Province, said: 'We want others to know that we aren't just barbarians. We want others to know the possibility of forgiveness and reconciliation.' Another contributor, a prominent theatre artist in Rwanda, in an interview with me on 8 April 2010 in Kigali, stated that as artists there is little time to analyse events concerning the magnitude of the genocide and subsequent campaigns for unification: 'Studies such as yours can enable us to learn from the research and adjust practices accordingly.' In this way, my research continues to be negotiated between borders but hopefully provides an account of profound acts of humanity in contrast to the well-known tale of genocide, while simultaneously exploring how Rwandanicity is being performed on a national level. There are two dynamics at play: reconciliation for its own sake and a nationalist reconciliation promoting the government's concept of unity.

Although the reimagining project in Rwanda may spectacularize a unified future by performing a simplified version of the dynastic past as a macro-performance, varied micro-performances often disseminate the government narrative or, alternatively, may provide a space for resistance or improvisation to seek out new relationships and encounters.[35] As an example, Katese, in her interview with me, stated that the objective for the University Centre for Arts and Drama in 2010 was 'to create memory, but memory in which one can reconcile with death, happiness and life'. The project is called 'The Book of Life'—to write one's own history. Katese further said: 'There may be some programmes for survivors such as building houses, but the houses can be empty. The arts can be used for people to rebuild their world—to recompose families through culture—building the environment for people to live happily.' The Book of Life project resists

dominant discourses that repeat tropes such as reconciliation, forgiveness and justice. Katese described how perpetrators, widows and orphans write to the dead:

> Perpetrators present their apologies and testimonies within a certain format for gacaca [pre-scripted] and ask for forgiveness. But words like reconciliation and forgiveness have lost their power because they have been misused, used in mass. These words are overused and people don't trust them because they've been dealt with on a mass scale [rather than] at a personal level . . . There is a list of words that we put on the board, such as unity, forgiveness and reconciliation, which we talk about to find their meaning and how we feel. The perpetrator is guided to find other ways to express what he or she feels. Might be to ask not to be forgiven, or to ask for the ability to sleep again, but to find new ways of expressing outside the gacaca framework, thus a personal conversation. It is important for people to write their own histories . . . I understand the government's will to unite people as Rwandans, but people are particular concerning their identities as Hutu, Tutsi and Twa. For us as artists, we know that diversity is important. . . . We learn not to fear what is different from ourselves. We need to fight *for* things [rather than] *against* things. We are constantly fighting against genocide, against AIDS . . . but what are we fighting for?

Katese highlights the negotiation between the government drive for unification at the exclusion of ethnic identities and the need for artists to incorporate alternative discourses other than genocide theatre or theatre for development. Although I explore government constructions of Rwandanicity through various performances and performatives that enlist artists in Rwanda, this is not to discredit their ethics or practices but rather to highlight the tenuous negotiation between government campaigns and artistic endeavours.

After visiting several youth associations that consisted of young people who were orphans of both perpetrators and survivors, I asked a youth director of an association (in private) how many children belonged to perpetrator families and how many to survivor families. The director said that he would not disclose who had what history as children do not want to be labelled for crimes their parents committed or suffered. They claimed they were all Rwandan, united to create a peaceful future.[36] While the young people may

have internalized government ideology, the myth of a unified Rwanda is ideologically hopeful, potentially fuelling peaceful coexistence.

## AN ACT OF CONCILIATION OR RESISTANCE

The example of the dance performed by Abiyunze Association at the beginning of this Introduction is notable for several reasons: it demonstrates reconciliation between the perpetrator and the survivor, and the use of dance to create a transformative space to weave new relationships. Dance can be used as a vehicle for community cohesion and cultural expression or, as Thompson signifies, as a source of nourishment for resistance: 'as a protective force with an "in spite of" quality that enables people to tolerate suffering not so that they become immune to it, but so that they have the energy to continue to resist' (Thompson 2009: 2) In response to Thompson's theorization for a kind of politics based on affect and 'beautiful resistance', I believe that the use of dance for redress implies a personal politics of resistance but that the dance forms inherently carry narratives of ethnicity, identity and power that can be easily subsumed into political campaigns.[37] One does not stand easily outside the other. Judith Hamera (2002) comments on archival traces through dance as 'subjectivities and socialities to history' that I extend as a vehicle for conciliation outside prescribed public transcripts as another form of resistance: 'Dance technique offers more than protocols for reading the body; it is also a technique of subjectivity, a template organizing sociality and an archive that links subjectivities and socialities to history. As archive, technique contains and organizes the traces and residues dance leaves behind, and out of which forms again: injuries, vocabulary, relationships' (ibid.: 65).

It is worth noting varied phases of the Rwandan Umudiho dance in detail to understand the relational negotiation between the self and the other as a medium of embodied communal redress. Dancers face each other over the course of the dance and change places through a movement that consists of each person going forward and doing a half-turn, which leaves each dancer in the exact position their companion has just been in. Umudiho, performed by couples facing each other and entering into dialogue with each other's bodies, implies a kind of identification with the other, making reference to the shared vertigo of the body experienced through the dance form.

Umudiho is derived from the verb *kudiha*, to dance by beating one's feet to the rhythm of a popular song. This category of dance involves a series of movements in which the feet hit the ground with a certain force and to a particular rhythm. Jean-Baptiste Nkulikiyinka (2002) illustrates the three phases of Umudiho: *ugutoza* (preparation), *ugushinga icumu* (the launch or the flight) and *ugutuza* (relaxation).

## PHASE 1: UGUTOZA

The noun ugutoza is derived from the verb *gutoza*: to exercise or train for, to prepare for, to gradually learn or to become used to. The phrase 'to prepare for' conveys the gentle movement of the swell and the spiritual state that animates the dancer at the moment that he or she enters into a dance. In the first phase, the dancer gets familiar with the rhythm and the melody. The dancer is still at the point of performing the basic steps and finding a synthesis with the choir group whose clapping is as important as the singing. The dancer's movements gradually increase in intensity and heat up to the point where he or she feels carried into the second phase.

## PHASE 2: UGUSHINGA ICUMU

The verb *gushinga* can be translated as: to drive in, to fix (in the ground), to build, to construct, to raise. The first two meanings of the term relate to the *icumu*, the spear, to fix the spear into the ground, to hold it straight. They are among the many terms that dance has borrowed from warrior vocabulary and here they refer to the movement of the second phase in which the dancer swings his or her arms upwards and holds them there for a moment as if holding a spear. This swinging of the arms assumes a certain elevation of the whole body.

This phase is the main focus of the dance. It represents a state in which the dancer gives over to the rhythm and emotion and, as heated as he or she can be, dashes forward, leaving behind the rhythm and the melody and the basic steps. In this state, the dancer pays no attention to the choir, to the audience or to anything else round him or her. The dancer's entire body is rhythm and harmony moving in unison with the earth. Gertrude Kurath (1977: 53) believes that the primary function of dance is the metamorphosis that allows the dancer to enter the spiritual world through ecstasy and euphoria with curative side results—the communion between the dancer and the forces of the cosmos.

PHASE 3: UGUTUZA

Ugutuza means to be calm, soft, wise, peaceful, but also, to lessen in intensity, to momentarily stop. This third phase is where the dancer 'drops out', what Alphonse Tierou (1992) calls 'coming home'. The dancer finds the way back to his or her real-world surroundings and falls back into the basic steps and movements, coming back into contact with physical reality, with the melody and the claps, and therefore renews the dialogue with the choir. At this moment, the dancer can still feed off the rhythm and prepare for another flight or can drop out altogether and leave the dance space.

Umudiho can be used for prayer, conciliation, identification and appeasement. Although I have noted varied public performances that inscribe Rwandanicity, cultural forms such as dance and practices of Umudiho are used at a grassroots level to cultivate coexistence and perform reconciliation. There is an uncertain balance between state-inscribed notions of justice and reconciliation and local-level practices of social cohesion— they can be mutually beneficial but may also work against one another, as dance notably contains traces of histories, memories and practices linked to ethnic identities and stands outside the state's notion of unification at the exclusion of ethnicity; thus the repertoire contains historic power relations that are not easily erased or disavowed.

In terms of how these conceptual and physical spaces have been negotiated in Africa, Dele Layiwola refers to the use of dance in Rwanda (and other regions of Northwestern Tanzania and Burundi) as an instance of ritual disjunction, noting that 'the arena of dance is a "battlefront" where the performer does not only confront the antagonist but also other related forces of margins and spaces. The ace dancer or performer is therefore a protagonist and warrior' (2003: 2). Dance and performance is related to the liminal stage, a 'borderline between art and religion' (ibid.). African theatre includes performance that can evoke religious and spiritual divination and provide a space for debate (Ukala 2000). Dance and performance in Rwanda was used in the royal court by the *intore*, or court warriors and dancers, and has a historic connection with the narration and dissemination of court recordings and Rwandan mythologies. In this way, based on what is to be embodied (and archived) at a national level, the Rwandan government performs its curative function.

Similar to the construction of the past in Rwanda, Leslie Witz (2003) extrapolates on the curation of the past and the future to entrench

Afrikaner nationalism and the apartheid state. Festivals and performances in South Africa were used to create an ideological and political hierarchy of whiteness, embedding racism—and establishing a European lineage based on the advent of apartheid in South Africa—in the founding of a white settlement in the Cape of Good Hope by Dutchman Jan van Riebeeck in 1652 (ibid.: 1).

> The state assigns a set of associations between selected moments to fix a national narrative, which moves in a specific direction toward an already determined future. This function of the state has been referred to as 'curating the nation', where the nation, with its monuments, statues, memorials, museums, and so on, is equated with an open-air museum where the state, as curator, decides what to display and how (ibid.: 11).

In terms of setting the stage for how performance is used in Rwanda, I draw on theories related to the construction and deconstruction of the self and the nation through violence but also through the arts. As noted, there are multiple objectives of the use of the arts in Rwanda: I focus primarily on the use of theatre and dance for identity construction and nation building. National narratives are curated; in the context of post-genocide Rwanda, the state carefully selects what is or is not allowed on the national stage, both literally and metaphorically, conceptualizing the geographic and political boundaries of Rwanda.

*Notes*

1  *Gacaca* (pronounced ga-cha-cha), derived from *umucaca* (a type of grass eaten by livestock), is Kinyarwanda for 'grass' or 'lawn'. The gacaca court is based on an indigenous, precolonial form of mediation in which opposed parties 'sit on the grass and resolve community conflicts'.

2  *Abiyunze* is Kinyarwanda for 'united'. The association consists of 30 survivors, 40 perpetrators and 60 community members. Though contentious, these terms are often used to define one's role within the justice and reconciliation process. The example provided illustrates the use of performance for justice and reconciliation at the beginning of one such gacaca court. However, I would note that although performances were often correlated with gacaca, in my experience, they rarely occurred in quick succession. The example

illustrates significant efforts by the government for popular participation in gacaca through sensitization and mobilization campaigns using the arts.

3   The current government of Rwanda claims that there is only one culture, with the same dances and language. However, several government officials have differentiated between dances as being regional and loosely connected to the ethnic identities of Tutsi, Hutu and Twa. In this way, dances of reconciliation may actually have stronger political affiliations.

4   For in-depth studies of how genocide was carried out, see Gérard Prunier (1995), Lee Ann Fujii (2009) and Alison Des Forges (1999). Des Forges estimates at least 500,000 people were killed in the genocide, while the government of Rwanda claims 1 million.

5   For the full text of Organic Law No. 16/2004 of 19 June 2004, Article 34, see Government of Rwanda (2004).

6   The gacaca trial of Emmanuel was held on 4 August 2005, which I attended.

7   *Interahamwe* is Kinyarwanda for 'we who stand/work/fight/attack together.' Mahmood Mamdani (2001) states that it was formed as a youth organization in 1990 and was eventually trained to carry out the genocide as death squads. They were largely responsible for the mass killings of 1994.

8   This description is adapted from Ananda Breed (2007: 306–12).

9   The UN controversially claimed that Rwanda might even have committed genocide against Hutu in the DRC in 1996 and 1997 (see UNCHR 2010).

10  'Gacaca was first launched in June 2002. Following a two-and-a-half year pilot phase, it was rolled out nationwide in January 2005, and trials of lower-level perpetrators finally got underway throughout the country in July 2006. Most of those trials were completed by the end of 2007, partly as a result of an increase in gacaca benches hearing cases concurrently. In late 2008, gacaca courts began hearing cases involving higher-level suspects (including those accused of rape). In 2009, the government opened a new information-gathering phase. After trials had largely ended in August 2010, gacaca courts continued hearing some appeals. Gacaca officially closed in June 2012, having tried more than 1.9 million cases involving just over a million suspects. Most remarkably, the vast majority of those trials occurred in a four-year period—from mid-2006 to mid-2010' (Lars Waldorf, in email correspondence, August 2013).

11  Linguist John Langshaw Austin (1962) used 'performative utterances' to describe speech acts that create a subject (i.e. the matrimonial speech act 'I do' creates the subjects 'husband' and 'wife') that was reinterpreted as

performativity by Judith Butler (2000) as discourse having reiterative power to produce what it names.

12  Rwanda's population before the 1994 genocide was estimated at 84 per cent Hutu, 15 per cent Tutsi and 1 per cent indigenous Twa (see www.hrw.org/-reports/1999/Rwanda/Geno1-3-09.htm; last accessed on 25 March 2013).

13  Johan Pottier states: 'When the Amin era ended with the return of Obote, the armed faction of the Rwandan Tutsi refugees chose to join opposition leader Yoweri Museveni, who was of Hima origin and thus "related" to the Rwandan Tutsi' (2002: 23). The Hima is a subgroup of the Tutsi.

14  Scott Straus (2006) argues that genocide was possible under the conditions of war. Youth militia were trained in 1992 and 1993 as part of the civilian defence programme.

15  See www.nurc.gov.rw (last accessed on 10 October 2011).

16  For information about RPF strategies to silence criticism and international manipulation, see Filip Reyntjens (2010).

17  *Ingando* is Kinyarwanda for 'military encampment'—an assembly area where troops traditionally received their final instructions while preparing for a military mission abroad.

18  Research conducted by Eugenia Zorbas (2004: 44–5), citing a survey by A.-E. Gakusi and F. Mouzer in April/May 2002, makes explicit the unequal sharing of power in Rwanda, in particular, the dominance of Tutsi power and the domination of the government by RPF members and returnees whose parents fled in 1959 and returned in 1994. Claiming that all are Banyarwanda and prohibiting ethnic labels from being used renders invisible some of these social and political imbalances. At the time of Zorbas' research, and according to Gakusi and Mouzer's survey, 7 of Rwanda's 12 préfêts were Tutsi, 5 were 'returnees' and 11 were members of the RPF; of the 12 commissioners on the NURC, 9 were Tutsi and 4 were returnees (no political affiliation cited); of the 22 Supreme Court judges, 14 were Tutsi and 15 were returnees (no political affiliation is cited); of the 28 heads of State-Owned Enterprises (SOEs), 23 were Tutsi, 24 were members of the RPF (no figure available for proportion of returnees); of Rwanda's 15 ambassadors, 13 were RPF members, 12 were Tutsi (no figure cited on returnees).

19  The idea of a precolonial utopia is false. For works on the dynastic oppression of the Hutu, see Catherine Newbury (1988), Gérard Prunier (1995) and Nigel Eltringham (2004).

20  Owing to the erasure of ethnic identities, the public is not able to openly denounce distribution of power among Hutu, Tutsi and Twa. Although there are supposedly no ethnic divisions, Tutsi are in positions of power (see Zorbas 2004). In Rwanda, the primary reason for conflict has been the uneven distribution of power and wealth among the ethnic groups.

21  Structural violence was a factor of the 1994 genocide and economic disparity continues to threaten peace in the region (Uvin 1995).

22  Examples of unjustified prison detainment include: 'Pierre Gakwandi and Leonard Kavutse, both arrested on charges of divisionism prior to the presidential elections and named in the 2003 parliamentary commission report, remained in pre-trial detention. Others accused of "divisionism" lost employment or were deprived of their passports' (Human Rights Watch 2005).

23  Rwandan reporter Gilbert Rwamtwara fled to Zambia in October 2005 after reporting negatively about gacaca courts, fearing government threats (see Human Rights Watch 2007).

24  The inclusion of partners, such as the Ministry of Justice and local health organizations, ensured experiential and factual information within the messages promoted through *Ukuri Mubinyoma*.

25  Image Theatre and Forum Theatre originated from Brazilian theatre practitioner Augusto Boal. As the director of the Arena Theatre in Sao Paulo from 1956 to 1971, Boal created the genre Theatre of the Oppressed (see Boal 1979). After a military coup in 1968, he developed exercises to engage the populace in creating their desired future by staging and rehearsing problems they faced and their potential solutions. Image Theatre and Forum Theatre were both theatrical devices Boal used to establish dialogue and community problem solving. Playback Theatre originated from American theatre practitioner Jonathan Fox in the 1970s, integrating elements of storytelling, ritual and psychodrama into a participatory form of theatre. During a playback workshop or performance, the emphasis is on discovering the 'essence' of the story and 'playing it back' through different techniques.

26  For information about insider–outsider relationships and the work of Frédérique Lecomte and SFCG, see Thompson, Hughes and Balfour (2009: 136–92).

27  All quotes from Frédérique Lecomte are from the email interview by the author, 10 January 2012, unless mentioned otherwise.

28  All quotes from Straton Nsanzabaganwa are from the interview by the author, Kigali, 28 November 2005, unless mentioned otherwise.

29 For a robust account of how art and performance has been used by IOs/NGOs in Uganda to circulate trauma narratives for international funding, see Laura Edmondson (2005).

30 I attended an ingando for over a month in Kigali, in 2005, where I led a theatre workshop and attended daily lectures. The lectures repeated the government's version of history found in several brochures and documents referring to the historical background of Rwanda. Ingando participants are expected to repeat to others the history and ideas they have heard at the ingando, thereby disseminating those ideas throughout Rwanda.

31 See www.nurc.gov.rw (last accessed on 10 October 2011).

32 Ingando camps have been created for specific community groups including moneychangers and prostitutes to enable the groups to define their problems and address them in relation to government programmes and policies.

33 Hirondelle News Agency (2011) notes how, due to appeal court trials and cases of people who were convicted in absentia, the trials had been trickling to a close after the official announcement in 2010.

34 I had drafted the Ukuri Mubinyoma project, in partnership with Hope Azeda and the Mashirika Creative and Performing Arts Group. *Ukuri Mubinyoma* was co-directed by Hope Azeda and written by Sam Kyagambiddwa through a series of devising workshops with members of Mashirika. Data was collected during the course of my research trips to Rwanda from 2005 to 2006. The project included two preliminary focus groups, one in a rural and one in an urban area. I conducted interviews after each performance, in each of the (formerly) 12 provinces. Discussions followed each performance, which elicited about 10 to 30 attendees. I attended the tour of performances and met regularly with the Ministry of Justice regarding the script and performances, modifying them according to feedback and responses from the population.

35 Michael Jackson has argued that storytelling works at a 'protolinguistic' level by symbolically restructuring experiences: 'Stories, like the music and dance that in many societies accompanies the telling of stories, are a kind of theatre where we collaborate in reinventing ourselves and authorizing notions, both individual and collective, of who we are' (2002: 16).

36 For further information on the impact of promoting national unity and reconciliation for youth, see Kirrily Pells (2011).

37 Thompson, Hughes and Balfour use the term 'beautiful resistance' (2009: 28), borrowed from Al Rowwad, as a survival of creativity and the imagination by making theatre which itself is a resistant act.

## RWANDA: HISTORY AND LEGEND

When the first German colonizer Count Gustav Adolf von Götzen shook hands with the Rwandan mwami, there was fear that the whole of Rwanda would suffer from an earthquake (Prunier 1995: 9). The body of the mwami was considered to be the physical embodiment of the land of Rwanda, which in Kinyarwanda means universe, and the geographic landscape of Rwanda was considered to be broken into spiritual dimensions of the universe (Stockman 2000: 20–41). The mythical and spiritual division of space in Rwanda is important in relation to current and past conflicts because power has been constructed through geographic and mythical spaces related to ethnic groups. Gérard Prunier writes about the symbolic geography of the land:

> Ryangonbe lived in the cold Virunga chain to the north, hell was in the Nyiragongo volcano near Gisenyi, and the river Nyabarongo divided the country into two ritual areas which could not be crossed by certain people, such as a king bearing a certain reign name. Rwanda was at the geographical centre of the world and each of its hills fitted within the King's game plan (1995: 18).

Northern Rwanda, historically, has been populated primarily by Hutu, the Tutsi dynasty failing to penetrate politically until aided by the Belgian colonizers in the 1930s. Geographically and spiritually, the north was demonized as hell in the Tutsi conception—the antithesis of Central Rwanda, the stronghold of the Tutsi monarchy and the country's political centre.

Before colonization, borders were fluid within Africa. To some extent, this changed when colonizers fixed definite national borders throughout the Great Lakes region. At one time, the name Ruanda-Urundi was given to the topography now known as Burundi and Rwanda.[1]

Thinking about the current cultural and political practices in Rwanda from a Euro-American point of view, it is easy to assume that Rwanda is a sovereign nation state, without placing current events in the context of Rwanda's historically fluid borders. However, when Tutsi refugees migrated to neighbouring areas, there were political issues inherent in the ethnic identities of Hutu and Tutsi that were, and remain, embedded in groups throughout the Great Lakes region. These regional considerations of ethnicity characterize the context of diaspora theatre creation and performance both in the country of refuge and in Rwanda upon their return after 1994.

Here, I explore some of the quasi-mythic developments of Rwandanicity related to precolonial, imperial, national and postcolonial periods and the use of theatre to envision a utopian past for the government-sanctioned version of history, which I refer to as the 'rewriting-history project'.[2] Although this project aims to create a unified Rwandan identity rehearsed through lessons taught at the ingando solidarity camps and performed through legendary theatre, cultural memory connected to former ethnic identities may be sustained through performative social memory embodied through habit-memories and may not be easily erased. Bodily social memory transmits practices and knowledge from the past, conveyed through what Paul Connerton (1989) refers to as ritual performances that may include dance or theatre practices, by incorporating postures or mnemonics of the body. I expand on Connerton's arguments in terms of what I maintain will ultimately be the failed project of the RPF to completely inculcate Rwandanicity into a newly recast, unified national identity. While the 'new beginning', ostensibly based on ideals of Rwandanicity, is actually based primarily on Tutsi recollection, counter-narratives remain embedded in cultural forms, collective subjects and individual bodies that contain and communicate the recollection of ethnic identities.[3]

Cultural forms in Rwanda are imbued with power imbalances because of how culture has been historically used to maintain social hierarchies related to the ethnic identities of Tutsi, Hutu and Twa. In Rwanda, body arts, including sports and dance, promoted a Tutsi ideology that subjugated Hutu and Twa through the dominance of the Tutsi dynasty (Bale 2002: 22). Thus, any reimagining or evocation of a precolonial unified past inherently evokes a favoured Tutsi narrative of unity, not a historical narrative that includes the injustices that may have been experienced by Hutu and Twa during the reign of the precolonial Tutsi monarchy.

In the aftermath of the 1994 genocide and RPF victory, a discarded, idealized representation of Rwanda's precolonial past resurfaced. 'This model originated in a functionalist anthropology nurtured by the colonial desire to justify indirect rule and conjured up an idyllic integrative society devoid of ethnic divisions and tension. This pre-colonial Rwanda enjoyed harmony, so the story went, because its chief social institution—*ubuhake* or cattle clientship—had facilitated social mobility across ethnic categories' (Pottier 2002: 110).[4] Before the polarization of ethnic identities by strategies of indirect rule used by the Belgian colonizers, it was possible (though rare) for a Hutu to acquire the status of a Tutsi by possessing more than 10 cows. During the nineteenth century, however, ethnic divisions became more rigid and a clientship form of labour was enforced. By focusing on the easy terms of cattle ubuhake at the expense of promoting an understanding of the conditions created by different forms of land clientship, the pro-RPF discourse resuscitated an idealized representation of Rwandan society and history. This representation glossed over significant social complexities to intellectually justify a system of leadership by Tutsi minority rule.

Similar to the use of theatre to evoke a precolonial utopia and to disseminate Rwandanicity, the 'enactment' of history through bards emphasized the heightened role of 'telling' and performance within the precolonial structure. In precolonial times, the *abiru* (court historians) played the role of the interpreters of the *ubwiru* or code of the monarchy. The abiru is described as playing a significant role in interpreting judiciary rules in accordance with the charter of the country and propagating myths that delineate a social order. Lemarchand notes the mythical distribution of power among Hutu, Tutsi and Twa:

> According to a dynastic poem entitled 'The Story of the Origins', the history of Rwanda begins with the reign of Kigwa, who descended from heaven and sired three sons—Gatwa, Gahutu and Gatutsi. To choose his successor Kigwa decided to entrust each of his sons with a pot of milk to watch over during the night. When dawn came it turned out that Gatwa had drunk the milk [. . .] To Kigwa this was conclusive evidence that Gatutsi should be his successor and be forever free of menial tasks. Gahutu was to be his serf. As for Gatwa, who showed himself so utterly unreliable, his station in society was to be that of a pariah (1970: 33).

Following the sixteenth century, Mwami Mukobanya established the intore, a group of Tutsi elite who trained in the cultural arts of Rwanda. According to John Bale, '[t]he court became the diffusion center for the model elite Tutsi and the site that forged Rwandan culture and mentality' (2002: 35). In this way, theatre and performance played an epic role in constructing and maintaining the kingdom. The intore were trained as the court military in skills including 'poetry, panegyrics, dancing, self-defense, self control, fighting, spear throwing, running, and *gusimbuka* (ibid.).[5] After 1994, the intore perform on the national stages of Rwanda and are a symbol of the dynastic past.

In an interview with me on 28 November 2005 in Kigali, Joseph Habineza, who was then the Rwandan minister of Youth, Sports and Culture, asserted that theatre was used by Tutsi artists in exile to promote the RPF and to keep the Tutsi identity alive between the 1959 revolution—when many Tutsi fled into exile in neighbouring countries—and their return to Rwanda after the 1994 genocide. Some of these artists, including Kalisa Rugano and Jean-Marie Rurangwa, who produced theatre in neighbouring Burundi, as a way of preserving Tutsi culture, have returned to present the same productions on the Rwandan national stage.

In an interview with me on 25 April 2006 in Kigali, playwright and essayist Rurangwa stated: 'I wrote poems and plays to sensitize the diaspora to go back to their homeland. I have played a big role in Rwandans coming home.' Few legendary theatre productions, then, are free from entanglement with the complex struggles marking Rwanda's past. Rwandan scholar Alice Mukaka claims: 'For every exiled poet, every gesture was quite like a sensual and permanent quest for the country of their ancestors, which became mythic and imaginary. To get back to this connection, there was no other choice apart from working on the social memory, on the language memory and on the memory of the culture' (2005: 37).

The use of culture for nation building in precolonial times resonates with how the RPF currently utilizes culture for political and social purposes. The difficulty in the case of Rwanda is that because of the specific political history wherein one ethnic subgroup long held power at the exclusion of another, the construction of national identity may embed ethnic identities rather than create a unified identity. Because Tutsi exiles are largely responsible for creating the new Rwandan identity performed on national stages, this identity, rather than being universalized across the different ethnic

identifications, is effectively a *Tutsi* ideal of the new Rwandan subject. This unified national identity, in some cases, may exacerbate tensions along ethnic lines owing to continuing unresolved power imbalances.

I provide a basic overview of events leading up to the 1994 genocide, noting how identity has been constructed through myths and legends, the enforcement of identity cards, the politicization of ethnic identities and the citizenship crisis in post-revolutionary Rwanda. Although I begin this chapter with a well-known timeline for readers to synthesize critical events, my research adds to existing literature the relationship between history and the construction and performance of identities. I close the chapter with a moment from fieldwork conducted at the Kicukiru ingando camp in Kigali in which I question the effectiveness of calls for a single nationalistic identity when remnants of ethnic identities have been given visibility through the fictional frame of theatre.

## HISTORICAL BACKGROUND: IDENTITIES REBORN

The relationship of culture and identity with historical shifts in power between Hutu and Tutsi has been dramatic. Mahmood Mamdani identifies three major historical shifts: 'the global *imperial* moment defined by Belgian colonialism and its racialization of the state; the *national* moment that was the 1959 revolution and that reinforced racialized identities in the name of justice; and the *post-colonial* regional moment born of a link between the citizenship crisis in post-revolutionary Rwanda and its neighbors' (2004: 20–1; emphasis in the original). Mamdani argues that the development of identity in Rwanda is based on political identities that reinforced ethnic identities, constructed and maintained by law at each of the major moments. I expand his framework to include the *precolonial* moment for the construction of mythic identities, maintained through hierarchical divisions of power among Tutsi, Hutu and Twa.

## PRECOLONIAL MOMENT: MYTHIC ETHNIC IDENTITIES

The Tutsi monarchy was established in Rwanda around the fifteenth century. In early precolonial Rwanda, there was a tripartite system of governance in which three chiefs were in charge of the local community, usually including two Tutsi and one Hutu. The quasi-mythical division of power is evident in an origin myth, describing how two brothers called Gahutu and Gatutsi

were asked by their father Imana (God) to beat the earth with their walking stick. Gahutu refused but Gatutsi obeyed and a herd of cows appeared. Imana then proclaimed that Hutu would be dominated by Tutsi (see National Curriculum Development Centre 2005). Several other origin myths build a similar social hierarchy, all placing Tutsi at the top, Hutu as subordinate and Twa at the bottom of the social and political ladder.

The politico-religious superiority of Tutsi evidenced through mythology 'provided a moral justification for the maintenance of a system in which a tiny minority assumed the status of a leisure class through the exploitation of the masses' (Lemarchand 1970: 33). Prunier notes: 'First, the sacred nature of the *mwami*ship meant that, even apart from the obvious problems of material control, the kingdom had to impose a politico-religious vision of quasi-mystical proportions on its conquered subjects' (1995: 18). As Prunier argues, the clear underlying geographical and mythical dimensions must be taken into account when considering historical events in Rwanda's past. Tutsi established control in Rwanda through military force, centralizing power and extending political control to the peripheral areas under the reign of Mwami Kigeri Rwabugiri (1860–95). This conception disappeared briefly between 1973 and 1994 during the regime of President Habyarimana, a Hutu from the north who made the north (which had previously been mythologized as hell) the dominant region for political and social control.

IMPERIAL MOMENT: SOVEREIGN IDENTITIES

Rwanda was colonized by the Germans from 1897 until 1919, when the League of Nations mandate ceded control of the territory to Belgium (ibid.: 25). Under Belgian colonization, effective on ground from 1916, though made official by the mandate in 1919, the inherent ethnic divisions that had been strengthened under the rule of Rwabugiri were enforced through indirect rule. Tutsi were proclaimed superior to Hutu and were given preference for government positions, administrative roles and education. Colonization made the extant ethnic divisions based on social hierarchies rigid.

The distribution of power became even more skewed in 1929 when the three-chief system, which generally reserved one seat for a Hutu as 'Chief of the Land', was converted to a system with only one chief who was usually a Tutsi (ibid.: 27). According to Prunier, the period between the 1920s and 1940s was marked by massive mobilization of the workforce, aimed at creating an efficient and centralized state:

The Belgian reforms of 1926–31 had created 'modern' Rwanda: centralised, efficient, neo-traditionalist and Catholic—but also brutal. Between 1920 and 1940, the burden of taxation and forced labour borne by the native population increased considerably. Men were almost constantly under mobilisation to build permanent structures, to dig anti-erosion terraces, to grow compulsory crops (coffee for export, manioc and sweet potatoes for food security), to plant trees or to build and maintain roads. These various activities could swallow up to 50–60% of a man's time. Those who did not comply were abused and brutally beaten (ibid.: 35).

The treatment of Hutu and Twa under Tutsi and colonial rule must be noted in relation to current tensions in Rwanda. Mandatory labour is, even now, enforced once a month and prisoners must provide community service.

Ethnic identities narrated through myths and legends in the precolonial era were rigidified as sovereign identities by colonization in the imperial era through the enforcement of identity cards. In 1935, the Belgian colonial administration issued identity cards to each citizen denoting their ethnic identity and origin, thereby locking identities into a legally binding identification system. But when other African countries experienced a wave of independence during the following decades, Rwanda was not far behind. For centuries, the minority Tutsi population had dominated the majority Hutu. However, that was to change with the 1959 revolution led by the Parmehutu (Party of the Hutu Emancipation Movement).

NATIONAL MOMENT: POLITICAL IDENTITIES

The 1959 revolution overturned Tutsi rule to the Hutu majority and reinforced racial identities as political identities during the national era. The revolution was in some ways influenced by missionary Catholicism, as a growing number of Hutu had been educated through missionary schools. Catholicism played a large role, alongside colonialism, in establishing the race distinctions among Tutsi, Hutu and Twa. Though initially propagating the Hamitic hypothesis at the advent of Rwanda's colonization, Catholic missionaries mythologized the racial purity of Tutsi as related to Ham from the Bible. Mamdani states:

> As a process both ideological and institutional, the racialization of the Tutsi was the creation of a joint enterprise between the

colonial state and the Catholic Church. Missionaries were 'the first ethnologists' of colonial Rwanda. As such, they were the primary ideologues of colonization. For Father Léon Classe, the future bishop of Rwanda and the key architect of missionary policy, the Tutsi were already in 1902 'superb humans' combining traits both Aryan and Semitic, just as for Father Francois Menard, writing in 1917, a Tutsi was 'a European under a black skin'. If the Church heralded the Tutsi as 'supreme humans' in 1902, the same Church would turn into a prime site for the slaughter of Tutsi in 1994 (2001: 87–8).

The Catholic Church affected the religious, social and political fabric of Rwanda and was an integral agent of colonization. A Catholic order called the White Fathers developed the first schools which favoured Tutsi, '[a]nd since the Tutsi were the *natural-born chiefs*" they had to be given priority in education so that the church could enhance its control over the future élite of the country' (Prunier 1995: 33; emphasis in the original). Under the authority of the church, Tutsi were given priority in education and governance. However, some Hutu were also educated by the church and eventually formed a Hutu intellectual elite that influenced the 1959 revolution. The switch from church endorsement of Tutsi to Hutu was largely influenced by post–Second World War politics, with an increased global sensitivity to racism, and clergy sympathetic to the Hutu plight. Prunier states:

> The combination of changes in white clerical sympathies, struggle for the control of the Rwandese church and increasing challenge of the colonial order by the Tutsi élite, all these combined to bring about a slow but momentous switch in the Church's attitudes, from supporting the Tutsi élite to helping the Hutu rise from their subservient position towards a new aspiring middle-class situation (ibid.: 44).

Mamdani cites the rise of the Hutu counter-elite as being dependent on three major factors: 'the subjugation of Hutu elite in Northern Rwanda by the German colonizers and the Rwandan state, the education of Hutu intellectuals by missionaries, and the socio-economic freedom of Hutu who ventured into Congo and Uganda for a prosperous labour market driven by sugar, coffee and copper, escaping forced labour in Rwanda'

(2001: 106). The rise of the Hutu intellectual elite was illustrated in the play *L'Optimiste* (The Optimist), written by Saverio Naigiziki in 1954:

> After commiserating aloud on the injustices of *buhake* [sic], one of the Hutu characters in Naigiziki's play, *L'optimiste*, asks his companion, 'How long shall we have to wait until our injustices are redressed?' The interlocutor replies, 'Until the Hutu no longer has the soul of a serf. For that he must be reborn.' The midwife of that rebirth was a political movement of the Hutu counterelite (ibid.: 113).

In 1957, several Hutu intellectuals banded together to promote their views regarding violations of human rights and to seek independence. Their document, the *Bahutu Manifesto*—otherwise named 'Notes on the Social Aspect of the Racial Native Problem in Rwanda'—was created to influence the UN trusteeship mission (Prunier 1995: 45). Simultaneously, political parties began to form in opposition to the Belgian colonizers.

The Belgian colonizers, under Colonel Guy Logiest, decided to grant independence to Rwanda but feeling betrayed by the Tutsi who had fought for independence turned over control of the country to Hutu. The optimistic independence movement quickly disintegrated into bloodshed, with victims targeted according to their ethnicity. The Parmehutu won elections supervised by the UN in 1961 and proclaimed the Republic of Rwanda in 1962. The following year, civil war broke out again. Approximately 20,000 people died and 160,000 Tutsi were expelled from the country (The Third World Institute 2003: 472). Some refer to this period of history as the beginning of the genocide.[6]

REGIONAL MOMENT: POSTCOLONIAL IDENTITIES

The citizenship crisis in post-revolutionary Rwanda and its neighbouring countries marks the postcolonial era. While Tutsi refugees were negotiating with the Ugandan government for recognition of land rights during this period of exile, the RPF enjoyed success in recruiting Tutsi exiles to prepare for a militarized return to Rwanda.[7] However, citizenship issues related to property rights presented a constant legal struggle for Tutsi exiles in both Uganda and the DRC: the governments of both countries vacillated between supporting the Tutsi refugees and depriving them of their citizenship rights, with the degree of welcome dependent upon the variable security situation within each country. Mamdani (2004) claims that there would

have never been a genocide had Uganda not revoked Tutsi citizenship rights, overturning a 1986 law granting political rights to anyone who had lived in Uganda for 10 years with a 1990 decree that granted citizenship only to those who could prove Ugandan ancestry on the basis of whether a grandparent had been born in Uganda.

During the same period, the coffee-market crash in 1989 and scarcity of land created a general fear of impoverishment in Rwanda. The causes of violence in Rwanda can be linked to what Johan Galtung refers to as structural violence, 'that violence exists whenever the potential development of an individual or group is held back by the conditions of a relationship, and in particular by the uneven distribution of power and resources' (quoted in Cockburn 2001: 17). Throughout the colonial period—from 1897 until the first days of independence—the distribution of resources among Hutu, Tutsi and Twa was consistently skewed because of the divide-and-rule tactics of the colonizers (Prunier 1995: 25).

The threat of invasion posed by the infiltrating RPF led to increased Hutu hate propaganda that labelled the Tutsi cockroaches (*inyenzi*), creeping into Rwanda by night to take over the resources of Hutu and restore Tutsi domination. In December 1990, the Hutu Ten Commandments were published in the Kinyarwanda newspaper *Kangura* (Wake Up!), advocating the separation of Hutu and Tutsi by demonizing Tutsi and identifying any Hutu who was married to or who supported a Tutsi as a traitor (Power 2002: 338).

The period between 1990 and 1994 was one of increasing conflict between the RPF sheltered in neighbouring Uganda and the Hutu-led Republic of Rwanda. In the context of the civil war, the RPF sought greater inclusion of Tutsi within the Rwandan government. The leaders of the Hutu Republic were frightened that any ceding of power to Tutsi would lead inexorably to a total Tutsi takeover of the government. To mediate the conflict, the Arusha Peace Talks began on 10 August 1992 and the Arusha Agreement was signed on 3 August 1993. One of the prerequisites of the Arusha Peace Accords was the implementation of a multi-party political system in Rwanda.[8] While such a multi-party system may have seemed democratic, it would arguably have worked to reinforce old clan and kinship ties along ethnic lines. The genocide began on 6 April 1994, hours after the plane carrying President Habyarimana of Rwanda and President Ntaryamira of Burundi was shot down, causing their death.[9]

After the initiation of the genocide in April, the Hutu-led government quickly blamed the plane crash on the RPF and called on the people of Rwanda to participate in the slaughter of Tutsi as a matter of national defence. The international community did little to stop the genocide. In fact, the French government was instrumental in fuelling the killing by providing weapons and military support to the Hutu Republic through Opération Turquoise, which was intended to serve as a peacekeeping mission (Pottier 2002: 39). From the beginning of the genocide, Radio Télévision Libre des Mille Collines (RTLM) broadcast lists of 'names, addresses, and license plate numbers of Tutsi and moderate Hutu', to be targeted (Power 2002: 333). The attacks were swift, brutal and usually carried out by large groups of interahamwe. RTLM provided the names of those on the 'death list' and motivated the interahamwe to kill, through popular music by artists such as Simon Bikindi.[10] Instead of sending in more troops as the genocide gained momentum, the UN peacekeeping force was reduced from 2,000 to 270 (although Lieutenant-General Roméo Antonius Dallaire retained 503 peacekeepers)—the result of a policy choice by the international community to avoid monetary or political commitment to intervention that could have prevented the escalation of violence (ibid.: 350–69).

The UN resisted describing the killings as genocide until 21 May 1994, because the use of the word obligates the international community to intervene in accordance with the Genocide Convention. The world turned its back on Rwanda. Thus began the third of Mamdani's great shifts, the *post-colonial* regional moment, which I link to the use of theatre by the Tutsi diaspora to cultivate performative social memory.

## LEGENDARY THEATRE: A RETURN TO THE LAND OF MILK AND HONEY

The Tutsi diaspora used theatre in exile to inculcate pride in Tutsi identity and as motivational propaganda up to the civil war. It is therefore important to understand the historical regional context in which the diaspora lived between 1959 and 1994 and the relationship between issues of identity and power and land rights and citizenship during this time, as these factors served both to reinforce ethnic identity and to impel the diaspora back to their homeland of Rwanda.

The revolution of 1959 dismantled the centuries-old rule of Tutsi over Hutu, which had been maintained as a social order through legends enacted by the abiru. Following the revolution and the establishment of the Hutu

Republic in 1962, over 400,000 Tutsi fled to neighbouring Burundi, the DRC, Kenya, Tanzania and Uganda (Prunier 1998: 119, 121n11). This exodus marked the migration of a culture which otherwise may have been annihilated but that continued to be performed and enacted elsewhere. While Rwandan domestic politics may have shifted internally, the narratives of the Tutsi diaspora continued externally and have since been promoted to the national stages of Rwanda in the post-genocide period.

In light of this use of myth and legend in the plays written by the Tutsi diaspora, I have coined the term legendary theatre to describe theatre produced by the returned Tutsi exiles, performed on the national stages of contemporary Rwanda as an emblem of national identity and unity.[11] Playwrights and poets such as Kalisa Rugano, Jean-Marie Kayishema and Jean-Marie Rurangwa used theatre to build a sense of Rwandan nationalism and identity for Tutsi refugees. It was used to create a vision of Rwanda for the Tutsi diaspora, the ancestral land that many Tutsi refugees had never lived in or experienced.

The use of culture to instil ethnic nationalism and identity by exiled Tutsi playwrights finds parallels in similar manipulations of culture by Hutu refugees in Tanzania, according to research by Liisa H. Malkki (1995). Echoing common tropes of 'rootlessness' among diasporic peoples, Malkki discovered that one's Hutu identity became further ingrained with the use of culture within a rural Hutu refugee community in Tanzania (ibid.). The community experienced a heightened sense of culture and nationalism following exposure to Hutu diaspora artists' plays and songs extolling Hutu identity.[12] The plays and songs spun a web of history and culture fixing Hutu ethnic pride, according to Malkki, in the 'natural order of things', to concretize the identity. Malkki states:

> The spider's web—the analogy used [. . .] to describe how everyday events become transformed and standardized into mythico-historical events—could also serve here to describe historical consciousness itself, insofar as it entails a process of dynamic transformation, an active seizing of events, processes, and relations in order to ingest and subvert them and, finally, to build something new (ibid.: 242).

Likewise, culture was used in Tutsi refugee camps to build nationalism and a 'mythico-history'.[13] The exiled Tutsi playwrights and poets used theatre to 'revive cultural traditions while advocating social change by

employing the traditional motifs of oral history, belief, myth, magic, incantation, ritual, sacrifice, proverb, metaphor, song, etc.' (Mukaka 2005: iii) (see Image 4).

To explore the intra-cultural links between performances conducted on the national stages of Rwanda today and those by the exiles in neighbouring countries, I refer to the work of Mukaka, a graduate of the University of Rwanda and a company member of the cultural troupe Mutabaruka. She argues that drama in Rwanda is a ritual stemming from theatrical enactments of history and legend that date back centuries. Rwandan drama, she claims, contains a complex system of symbols, metaphors and proverbs that ultimately create and maintain a social order and hierarchy. Her analysis of the Tutsi exile plays *Rugari Rwa Gasabo* (1991; The Wide extent of Gasabo) by Rugano and *Ruganzu* (1988) by Kayishema suggests that the imagery and ideology in the plays are an invocation of the traditional past. Mukaka states:

> In both plays, the authors use elements of oral history, myth and legend [. . .] in a subversive manner by exploiting the considerable power which tradition exerts in an effort to positively influence

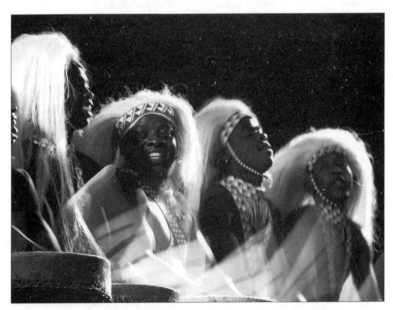

**IMAGE 4** Rwandan Music and Dance Performance, Rwanda, 2005. Courtesy: Alice Mukaka from Ministry of Youth, Sports and Culture.

contemporary Rwandan life. In these plays, they radically revise and reshape familiar history, myth and legend in the light of contemporary realities in order to stress their dialectical dynamism, and to seek out fresher meanings from them. Furthermore, they expose the ills of the society and provide the audience with their vision of a new social order. History is for this widely used to establish the will for change and the return to customs of traditional Rwanda as long as it does not stop from progressing and emancipating (ibid.: 59).

Telling parallels exist between the use of culture for nation building in precolonial times and the ways in which the RPF currently uses culture for political and social purposes. The productions of various Tutsi exiled artists, while distinct in their own right, demonstrate a particular canon of work.

### UMUKINO W'UMUGANURA (THE FIRST HARVEST)

*Umukino w'Umuganura*, directed by Rugano and performed by Mutabaruka, exemplifies how Rwandanicity is performed through theatre on the national stages of Rwanda. I attended the performance on 5 August 2005 at the Intercontinental Hotel. The lights dimmed and the audience entered the performance space, a large conference room with rows of chairs facing an elevated proscenium arch stage. The stage was lined with traditional Rwandan woven crafts, including *ibisabo* (churns) and *ikibindi* (pots). The musicians sat left of centre stage, seated with the *ingoma* (drum) and *inanga* (traditional guitar). The *mise en scène* and elements of production resembled in many respects those of Rugano's plays performed in Burundi: 'The implied message was especially to remind his targeted audience about the origin of the country Rwanda and her heroic and beautiful past. The symbolic objects revealed in the plays were various. There were some related to cult, to daily life and to the army' (ibid.: 47). In the case of *Umukino w' Umuganura*, Tutsi identity was represented through intore dancers' costumes and enactments of warrior monologues, as well as instruments and crafts.

At the beginning of the production, Rugano dedicated the evening's performance to President Paul Kagame and the RPF for halting the genocide. Government speeches opened the performance, with officials including the minister of Sports, Youth and Culture and the director of Culture greeting the audience and stating the importance of the arts in Rwanda in terms

of unification: 'Rwandans are from one culture with the same dances and language.' The pre-production performatives—including the sharing of traditional brew in a gourd and the speeches by government ministers—framed the inculcation of Rwandanicity.

The performance staged dances related to the worship of the cow and the pride and glory of Rwanda's war heroes. Several performers stood in various strategic positions in the audience until cued to approach the stage, singing and dancing. The female dancers represented the walk of the cow, their chests pushed forward, their arms above their head and footwork patterns resembling a cow's lumbering gait in a herd. Tutsi identity has long centred upon ownership of cattle and it was this possession of cattle that distinguished Tutsi pastoralists from Hutu agriculturalists. Umusha-giriro—the reverential dance to honour the cow—was therefore powerfully and inextricably linked to ethnic symbols and memories.[14] Although *Umukino w'Umuganura* centred on dances revered as intore dances from the royal court, there are other notable dances in Rwanda (Misago and Mesas 2000: 71–2).

Other dances that followed included the warrior dance Umuhamirizo, in which the male dancers' heads were covered by wigs of long white grass, with bells round their ankles and spears and shields in their hands. The men occasionally broke out into monologues of self-praise called *icyivugo*, which are used to narrate tales of heroism to the mwami. These monologues often praised acts of war, where the battle was fought and the number of people killed. In the background, a chorus sang the praises of Rwanda, the land of a thousand hills. The dance glorified Rwanda, emphasizing how Hutu, Tutsi and Twa would fight together united in the service of the mwami and the country. The messages pertaining to development included issues such as tourism, economy and international donor aid: 'In October, the thunder of the Rwandan Patriotic Front (RPF) broke from Kagitumba. They stopped the genocide while other countries were watching;' 'Economically, base the country on one's own natural resources, do not become dependent on the international community and foreign exchange;' 'When we call for foreign help, it is like clinging to a serpent;' and 'Who told you God lives in Heaven? What if you find that God lives in the hearts of people?' The monologue aside can also be related to warrior dances, which include spontaneous monologues related to the feats undertaken in battle (ibid.: 71).[15]

The slogans identified cultural resources that could be used for development in tourism. At one point, the volcanoes of Ruhengeri were compared to the pyramids of Egypt, and it was insinuated that the Egyptians were inspired by the volcanoes to build their pyramids. The development-oriented messages were explicitly spoken in English rather than in Kinyarwanda, thus pointedly directed to the international (Anglophone) audience members.[16] The performance portrayed an apparently unified cultural heritage, rich in tradition and pageantry. However, closer study revealed contradictions within the dances used in the production.

Intore dancers, such as those who performed in *Umukino w'Umuganura*, are the pride of Rwanda. Traditionally based in the royal court at Nyanza, the dancers are today housed at the National Museum of Rwanda in Butare. Dance is frequently cited in Rwanda as an example of the sharing of a single, homogeneous culture among Hutu, Tutsi and Twa—the source of a common heritage from which all Rwandans can draw equally. In the face of this argument, the language describing these dancers in the Rwandan tourism magazine *Eye* is remarkable for its explicitly ethnic tenor and the distinctions drawn between ethnic cultural forms: 'In Butare, Intore Dancers of Tutsi descent perform to the beat of large drums. The Intore Dance Troupe was formed centuries ago as entertainment for the Mwamis (Kings) of Rwanda: they are dramatic dancers whose movements are greatly different from other traditional African dance' (2005–06: 6). *The Eye* continues: 'As with music, there are variations of style and subject among the three groups (Hutu, Tutsi, and Twa)' (ibid.).

Through the dance honouring the beauty of cattle and the inclusion of the descendants of the (Tutsi) monarch's dance troupe, the cultural forms used in *Umukino w'Umuganura* clearly evoked ethnic identities, government rhetoric professing a single, common cultural heritage notwithstanding. What is more, symbols historically associated with Tutsi—and kept alive during the Tutsi exile in Burundi, of which Rugano was a part—were presented as being Rwandan cultural forms of a national order, standing in for the 'new', unified Rwandan identity while eliding differences of historical experience among ethnic groups. *Umukino w'Umuganura* propagated the ideology of the victor in times of conflict, paying homage to the RPF and glorifying a mythic utopian past while overlooking the political differentiation of ethnic identities embedded in cultural forms.

## BODILY MEMORIES

Memory is used to construct new traditions and to mould collective memories, but embodied habit-memories may undermine the indoctrination process. Connerton distinguishes memory that is performance-based as habit-memory and states: 'Social habits are essentially legitimating performances. And if habit-memory is inherently performative, then social habit-memory must be distinctively social-performative' (1989: 35). Social codes and rules are embedded in the body through repetition and social structures, maintaining among other things hierarchies of power experienced individually and collectively by subjects within that culture. Connerton claims that habit-memory does not necessarily require the ability to remember but is usually inscribed or encoded socially, and is thus very difficult to destroy:

> Bodily practices of a culturally specific kind entail a combination
> of cognitive and habit-memory. The appropriate performance of
> the movements contained in the repertoire of the group not only
> reminds the performers of systems of classification which the
> group holds to be important; it requires also the exercise of habit-
> memory. In the performances explicit classifications and maxims
> tend to be taken for granted to the extent that they have been
> remembered as habits. Indeed, it is precisely because what is per-
> formed is something to which the performers are habituated that
> the cognitive content of what the group remembers in common
> exercises such persuasive and persistent force (ibid.: 88).

The imposition of power by the government to craft new histories and identities is not uncommon in authoritarian states but the desired use of culture to rewrite history will 'entrust to bodily automatisms the values and categories which they are most anxious to conserve' (ibid.: 102). Connerton argues that memory is constructed by repeated bodily practices (habit-memory), usually maintained through ritual performances.

David Middleton and Derek Edwards contextualize how social memory is contained within cultural forms: 'Variability of re-presentation within particular genres, be they dance, song, theatre or story, carries with it a social memory marking continuities in the community of participation out of which any particular performance has developed' (1990: 4). As previously noted, theatre was used during precolonial times to perform the historical records of the court and to construct the mythology of the origin of Hutu, Tutsi and Twa, with Tutsi as dominant and of direct lineage to Imana

(Lemarchand 1970). In this way, in precolonial and contemporary times, history and identity are performed and enacted, embodied and rehearsed. The use of culture for indoctrination inherently maintains power discourses.

The power of theatre and dance as a vehicle for dissemination may be attributed to the predisposition of the Rwandan population to centuries of dynastic historical tales (*ibiteekerezo*) passed down orally as mythico-history.[17] History is propagated orally at the ingando solidarity camps.

> Thus this history will spread among the entire population, not just the ex-prisoners. The tradition of oral transmission in Rwandan culture, in the shape of dynastic poetry, is seemingly believable, but selects and eliminates certain historical facts, and appears to be perpetuated with the contemporary historical narratives of some Rwandans who would like to see history arranged to their taste (Penal Reform International 2004: 38).

The inclusion of university students, ex-combatants, released prisoners and community groups at the ingando solidarity camps ensures mass indoctrination of government-sanctioned history through the memorization and repetition of information transmitted through cultural forms. Selective memory has been an operative function of nation building, as evidenced through the rewriting-history project.

### REWRITING HISTORY: INGANDO SOLIDARITY CAMPS

After conflict, the victor is usually given sovereign power to rewrite history —this has certainly been the case in Rwanda. History has not been taught in Rwandan schools since the 1994 genocide. Currently, the government is rewriting the textbooks, primarily to remove anti-Tutsi propaganda found in history books published prior to the genocide. History is now taught orally at the ingando solidarity camps and there are government brochures and documents with a condensed version of government-sanctioned national history.[18] Fatuma Ndangiza, who was then the executive secretary of the NURC, asserted in an interview with me on 12 January 2005 in Kigali that the genocide was created by over 30 years of indoctrination using false information. Thus, the rewriting-history project is a corrective. The process of rewriting history after a war or genocide is problematic since the multiple narratives competing with each other during wartime are repressed by the victor's rewriting of history as a single dominant narrative.

The ingando is being used for nation building on the basis of traditional practices of devising history, the historicizing and memorizing of oral text through lectures, song and theatre. The goal of the ingando, which is mandatory for returned prisoners among other constituents, is to promote reconciliation and inculcate a sense of Rwandanicity: 'The government encourages or requires Rwandan citizens from diverse walks of life— students, politicians, church leaders, prostitutes, ex-soldiers, ex-combatants, génocidaires, gacaca judges and others—to attend ingando for periods ranging from days to several months, to study government programs, Rwandan history, and unity and reconciliation' (Mgbako 2005: 202). Participants are then expected to repeat what they have heard and learnt at the ingando to their families, co-workers, friends and neighbours, thereby further disseminating the government's message.

The RPF government has invested considerable effort in presenting the ingando not simply as a means of mass public re-education devised by current leaders but, rather, as a precolonial form of community building using traditional forms. In another interview I conducted with Ndangiza, on 11 August 2005 in Kigali, she said that 'ingando, like the other Kinyarwandan words for precolonial forms of community building, is an important venue for reconciliation, using traditional forms. In addressing problems related to the genocide, we revisit the traditional modes prior to colonization when the ethnic divide and genocidal ideology was formulated.' In an interview conducted by Therese Jönsson, on 10 June 2005 in Kigali, Ndangiza characterized the origins of the ingando: 'Ingando comes from Rwandan tradition; it means to make a temporary halt to a retreat. This was seen in precolonial Rwanda. If a disaster was threatening, Rwandans would come together to analyse the root of the problem. They would analyse the problem and come up with strategies to solve it.'

The prominence of ingando in pre-1994 Rwandan culture is nevertheless disputed. Chi Mgbako challenges the notion that the ingando existed in precolonial times, highlighting instead the role the RPF has played in bringing to prominence the idea and use of ingando:

> While the practice of elders gathering together to address challenges facing the community is present in Rwandan culture, there is little indication that this practice was ever called 'ingando.' Ingando is more likely a pre-war RPF creation aimed at grassroots mobilization for RPF campaigns. From 1990 to 1993, the RPF

installed participants in *ingando*s or 'RPF schools' for three weeks, after which participants would be expected to return to their villages and disseminate pro-RPF ideology. This RPF practice may have occurred in Uganda and RPF-controlled territories in Rwanda. In addition, the RPF, whose ideological mentor is Yoweri Museveni of Uganda, may have modeled *ingando* on solidarity camps in Uganda (2005: 208).

Whether or not the ingando was widely known or used in precolonial times, its value to the current Rwandan government clearly lies in its homegrown—rather than imported and Western—character. With the government's reiteration of Rwanda's precolonial history as being unified and harmonious, cultural mechanisms such as ingando that can be imbued with precolonial origins play into the government's overarching goal of creating a stable nation with a common, unified sense of Rwandanicity and a shared vision of Rwanda's future.

PERFORMING HABIT-MEMORIES

I was granted permission to conduct a month-long theatre workshop at the Kicukiru ingando camp in Kigali.[19] The objective of the workshop was to use participatory theatre as a tool to help participants discuss problems of reconciliation and their potential solutions. Several participants had either become actors or theatre directors during their time in prison or had worked in theatre before being incarcerated. The participants elected one group member to be a co-facilitator because of his fluency in English and knowledge of theatre. After the introductory session, 13 men and 5 women expressed their interest in continuing with the project—a series of workshops culminating in the staging of a production during the closing ceremony of the ingando camp.

After several rehearsals, the co-director stated that the group preferred to use the workshops to write a play based on the causes of the genocide and what they learnt at the ingando camp, a play through which they could thank the government. I was sceptical of the value of theatre used as a device for the participants to play the ideal citizen 'to thank the government'. According to their approach, theatre was to be the vehicle to perform Rwandanicity, regardless of whether they actually believed in what they learnt at the ingando camp and in the new Rwandan identity.

It wasn't until two weeks into the rehearsals that I understood the precariousness of freedom for the released prisoners. While we were rehearsing on top of a hill that overlooked a football field, all one thousand residents were called onto the field below. The actors stopped to watch. When I tried to find out what was happening, several theatre participants hushed me. After several names had been called out, the individuals were carted into a caged truck to be returned to prison. The theatre participants were relieved that none of their names had been called out but abruptly cancelled the rehearsals for the day, stating that they were upset by the incident and feared being put back into prison. Their fear was palpable.

There was one moment during the rehearsals when lessons taught at the ingando camp were challenged. There was a scene based on the Hutu revolution that exposed potential counter-narratives. The group began singing songs from the Hutu-led republic, as called for by the scene—hesitantly at first, looking around to see if anyone was listening or if the authorities would reprimand. After the actors realized that they were free to perform the songs under the guise of 'performance' because they were engaged in a theatre rehearsal, their behaviour changed. I observed a lightening in mood and spirit and saw them exchange glances that demonstrated a kind of in-group 'knowing'. There was a shift from what was 'rehearsed' to what they 'embodied' during rehearsals.

I began to question the effectiveness of official strategies to instil the unified Rwandan national identity when cultural forms still contain latent habit-memories. While the objective of the play was to perform what had been learnt at the ingando camp, identification of 'Hutuness' was allowed expression through theatre, which provided an alternative space to perform repressed identities. In this way, there were two contrasting narratives: one consisted of depicting the events leading up to the genocide within a theatrical structure that represented the crimes of the released prisoners; the other was represented by the rehearsal itself, which allowed an outlet for expression of their former ethnic identities. While the whole of Rwanda is expected to adopt Rwandanicity, awareness of individuals' Hutu, Tutsi and Twa identities may remain dormant but may not be erased.

The government of Rwanda is in the process of carefully deciding which traditions and cultural forms will be reimagined as part of the national social consciousness and memory. In one notable example, the National Museum of History in Rwanda is establishing a codified cultural

dance—a homogenized fusion of cultural dances that had formerly been individually identified as Hutu, Tutsi or Twa. The problem with inventing a new dance form to enforce national unity is that the body is the site of habit-memories, which may be different from the social memories being fabricated. Histories and identities are connected to the cultural forms used, which leads to inherent political tensions.

## INCULCATING THE NOTION OF THE LAND OF MILK AND HONEY

The construction of identities during precolonial, imperial, colonial and postcolonial moments serves as a precursor to the inculcation of Rwandanicity in contemporary Rwanda. The vision of the 'land of milk and honey' was performed through myths and legends as legendary theatre to instil Tutsi nationalism for a return to the motherland.

But in present-day Rwanda, government efforts to develop and disseminate the idea of Rwandanicity are caught between the identities that have been forged and the vision for identities coming into being. In this way, construction of identity is in a liminal phase of 'betwixt and between'.[20] Signifiers of ethnic identity linked to kinship ties and ontological awareness of self remain under the surface.

Theatre in Rwanda can be analysed in terms of Victor Witter Turner's four phases of social drama defined as 'units of aharmonic or disharmonic social process, arising in conflict situations' (Schechner 1985: 167). The four main phases of social action are breach, crisis, redress and re-integration or schism. Breach is a disruption in a community, crisis the zenith of violent conflict, redressive action a restoration of community that may include judicial or cultural solutions, and reintegration or schism a completion of the cycle back to the original community or alternatively to begin with another break or breach which would begin the cycle again. Turner emphasizes the role of culture in consolidating power but also states that culture can be used as the genesis of community identity and values during the stage of redress:

> The winners of social dramas positively require cultural performances to continue to legitimate their success [. . .] it is the third phase of the social drama, redress, that has most to do with the genesis and sustentation of cultural genres, both 'high' and 'folk', oral and literate [. . .] Ultimately, rituals of reconciliation may be

performed, which, in their verbal and nonverbal symbolism, reassert and reanimate the overarching values shared by all Ndembu, despite conflicts of norms and interests on ground level (1982: 74–5).

In this redressive phase, the RPF in Rwanda has used culture as a legitimizing construct. The illustration of Rwandanicity is linked to a historical legacy of how theatre has been used by the RPF to provide impetus for a return to the homeland and how the gacaca courts have been resurrected to try crimes of the genocide.

The use of culture and legends as part of the rewriting-history project exposes various strategies for re-imaging and implementing former systems of governance including the ingando and gacaca. Theatre has been used to evoke a precolonial utopia but these apparent precolonial cultural forms used for educating the population are susceptible to manipulation and distortion through the integration of international norms that alter original practices. The sheer magnitude of the genocide and the quest to adjudicate crimes on a local level promotes the spectacularization of suffering on a national and international scale.[21]

*Notes*

1   Tutsi and Hutu conflicts in Burundi have historically mirrored those in Rwanda; thus, it is not surprising that the Tutsi poets and playwrights in exile in Burundi were censored for fear of inciting political tensions not only between Rwanda and Burundi but also between Tutsi and Hutu within Burundi's borders.

2   For more information on the government-sanctioned version of history of Rwanda, see the Government of Rwanda website: www.gov.rw (last accessed on 1 September 2007).

3   Allen Feldman (1991) looks at the staging and commodification of the body through violence in Northern Ireland.

4   '[U]buhake was a form of unequal clientship contract entered into by two men, the *shebuja* (patron) and the *mugargu* (client). In the "classical" form of ubuhake [. . .], a Tutsi patron gave a cow to his Hutu client. Since the Hutu were in theory not allowed to have cattle, which were a sign of wealth, power and good breeding, it was not only an "economic" gift but also a form of upward social mobility' (Prunier 1995: 13).

5   *Gusimbuka* refers to high jumping body culture.

6   Charles Gahima, who was then the director general of the National Curriculum Development Centre (NCDC), stated in an interview with me on 25 November 2005 in Kigali, that the character of the historically significant 1959–62 period is widely debated in Rwanda between civil strife and the beginning of the genocide, or a revolution.

7   One explanation for why Rwandan Tutsi were given refuge in Uganda is the ancestral links between Tutsi in Rwanda and Hima rulers of Uganda. The armed faction of the Rwandan Tutsi refugees, with military support of Yoweri Museveni, helped overthrow Milton Obote (see Pottier 2002: 23).

8   The Arusha Peace Accords, an internationally-brokered peace agreement in 1993 between the RPF in Uganda and the Republic of Rwanda, called for multi-party systems of voting and democratic revisions of the single-party system that had prevailed in Rwanda since independence in 1962. Donor support has consistently been used to fuel political competition, including the Belgian support of the Rwandese Democratic Union (RADER) in opposition to the Rwandese National Union (UNAR) funded by the Soviet Union.

9   The shooting down of President Habyarimana's plane was like a war cry for many Rwandans. RTLM stated that the war had begun and called on Hutu to take up arms because Tutsi had attacked. Although the plane crash was initially blamed on Tutsi, there have been theories that suggest that within the Hutu government of Rwanda, there were fractured political views and that the plane may have been shot down by a member of the Hutu militia. Recently, there has been a court case brought against President Kagame's Chief of Protocol Rose Kabuye and eight other Rwandans, who stand accused of bearing responsibility for the plane crash (see Tran 2008).

10  In considering the potential of the arts to heal after genocide, it also bears noting how the arts were used during the genocide. I travelled to several ingando camps in which theatre artists and musicians used music to promote reconciliation but many of them stated that during the time of the genocide the arts were equally used to motivate communities to participate in the genocide. I conducted interviews with released prisoners in the ingando camps of Cyangugu, Kigali, Ruhengeri and Gisenyi.

11  This term is coined to best describe theatre that performs the Webster dictionary definition of legend: 1. A non-historical or unverifiable story handed down by tradition from earlier times and popularly accepted as historical.

2. The body of stories of this kind, especially as they relate to a particular people, group or clan.

12 For more information about the role of performance in refugee communities, see Alison Jeffers (2011). Laura Edmondson (2009) explores representations of Rwandan refugees on the international stage.

13 The term mythico-history was coined by Liisa H. Malkki (1995).

14 Habineza noted in his interview with me that Umushagiriro was repressed during the time of the Hutu Republic.

15 I attended rehearsals for *Umukino w'Umuganura*, during which a company performer made the distinction between the warlike monologues practised by the intore and various monologues and dances within the production. As previously discussed, there are regional differences in terms of ethnicity. Thus, even if there is a regional distinction in terms of what is performed on the national stages of Rwanda as being from Central Rwanda, it is primarily Tutsi, whereas dances from Northern Rwanda are predominantly Hutu.

16 Kalisa Rugano is Francophone. The use of English was based on an *overt* choice to communicate messages to an Anglophone audience.

17 Ibiteekerezo are extensively documented by Jan Vansina (2000).

18 As discussed in my interview with Gahima, the project is part of a methodological design called 'Facing History and Ourselves', and is based on the participation of over 25 research consultants from Rwanda. The consultants are faculty at the National University of Rwanda, religious leaders, government officials, officers from NGOs and playwrights. The events shaping Rwanda's history have been debated and analysed within several focus groups searching for common timelines that can be used to forge a new Rwandan identity.

19 Susan Thomson (2011) has written about her observations on the ingando camps as an under-studied aspect of the government's post-genocide reconstruction policy of national unity and reconciliation.

20 The liminal phase was originally theorized as part of ritual (preliminal, liminal and postliminal) by anthropologist Arnold van Gennep (1960), although adopted into the theories of Victor Witter Turner (1982) and Richard Schechner (1985).

21 Useful references for spectacularization include works by Vivian M. Patraka (1999), who uses the term 'spectacular suffering' in relation to the idea of a 'Holocaust performative', and Richard Schechner (2009), who applies Guy Debord's (1994) *Society of the Spectacle*, originally published in 1967, to the mediatization and globalization of 9/11 as avant-garde art.

The auditorium was filled to capacity; viewers sat on the floor or propped themselves up against the back wall of the theatre at the National University of Rwanda. For weeks, there had been rumours about the controversial subject of the play. Posters for *L'Instruction* (title changed to *The Investigation* for the international tour) drew in diverse crowds of students, artists and residents to the village of Butare where the university is based. At various points during the production, audience members responded with audible sighs of approval or tongue clicks of disapproval. In 2005, individuals were caught between telling the truth (as ordained through gacaca law) and protecting themselves from what could be perceived as victor's justice. Few felt safe enough to speak openly about their version of the genocide (if different from that of the RPF) or to question gacaca as a national recourse for justice and reconciliation. *The Investigation* staged testimonies from the Frankfurt Auschwitz trials in Germany but attendees recognized the testimonies that overlapped between the Holocaust and the Rwandan genocide. In my interview with Dorcy Rugamba, the co-director of *The Investigation*, and performer Aimable Twahirwa, in November 2007 in London, Rugamba stated:

> Similar to Rwanda, Germans judged Germans during the Frankfurt Auschwitz trials. In Rwanda, Rwandans judge Rwandans—to examine the national consciousness. Both the Holocaust and the Rwandan genocide are based on legal crimes. The accused ask, 'How can I be judged if I followed the law?' This is the case in Germany as [well as] in Rwanda. It is important for us to bring this play to Rwanda, so that Rwandans can see how it has been in

other countries. Also, to understand genocide ideology, to understand the killers' stories.

During the twentieth century, transitional justice became the operative modality between human rights and international law. According to Catherine Cole, 'transitional justice not only formulates a relationship between political transition and the law, it also addresses the unique challenges that a history of state-sponsored atrocity presents *to* the law' (2010: 2). This chapter addresses the interplay between theatre and justice through performatives including systems of transitional justice—gacaca in Rwanda and the TRC in South Africa—and theatrical counterparts that, at times, work through either codes of compliance or codes of resistance. The difference in delivery is primarily based on the sociopolitical context surrounding the performances and performatives, whether or not discourse and debate about the transitional justice systems are permitted. Whereas the previous chapter, based on history and legend, illustrates how Rwandanicity is indoctrinated through ingando camps and performed through legendary theatre, this chapter politicizes how theatre is used both inside and outside Rwanda's borders to negotiate narratives of violence and to transmit transcultural memories, juxtaposing frames of national performatives (juridical identities constructed through transitional justice systems) and theatrical productions.

Although the Rwandan genocide occurred as a result of specific legacies of violence in the Great Lakes region, comparisons between other theatrical representations of violence provide alternative frameworks to address the interaction between transitional justice and theatre. Jean Baudrillard's adaptation of Peter Weiss' 1965 play *The Investigation* explores discourses of war and justice between the gacaca courts in post-genocide Rwanda and the Frankfurt Auschwitz trials from the Holocaust.[1] Similarly, *Truth in Translation*, written in collaboration between interpreters who worked at the TRC, writer Paavo Tom Tammi and the company of Colonnades Theatre Lab, conceived and directed by Michael Lessac with music by Hugh Masekela,[2] and *Ubu and the Truth Commission*, written by Jane Taylor (1998) and directed by William Kentridge and the Handspring Puppet Company,[3] use the fictional frame of theatre to negotiate between state-driven performatives of justice and reconciliation evidenced in the TRC and the paradoxes of representation and witnessing in post-apartheid South Africa. Applying Erving Goffman's (1974) notion of framing, it is crucial to examine both *what* is being framed within the construction of

post-violence identity formation (national and individual) and *how* it is being performed or enacted.[4] The aforementioned productions respond theatrically to juridical performatives of nation building—gacaca, Frankfurt Auschwitz trials and the TRC.

Although I relate past atrocities and theatrical productions to national performatives and the use of theatre as a fictional frame to examine counter-discourses, I question the intended representation of atrocity for international audiences. *The Investigation, Truth in Translation* and *Ubu and the Truth Commission* present a frame (theatre) within a frame (trials). Working within the context of post-apartheid South Africa, Yvette Hutchison (2005) applies the concept of framing to her analysis of theatre in South Africa but specifies a 'fictional frame' to designate theatrical enactment that she posits can be used to counter government-driven narratives constructed through TRC testimonies for post-apartheid amnesty and national unification. Hutchison describes how theatre was used in South Africa to negotiate 'different perspectives and memories and the exploration of these for our ongoing redefinition of identity in and through memory and narration of self and other' (ibid.: 361). She makes a distinction between the construction of history and narrative through the TRC and the ability of theatre to hold complex counter-narratives and multiple histories.[5]

In contrast to South Africa, where the fictional frame makes possible multiple counter-narratives, the authoritarian political climate of Rwanda poses a dilemma concerning what can be represented theatrically and whether the dominant government narrative can be subverted (see Hutchison 2005). While South Africa strives for reconciliation through the granting of amnesty in exchange for truth telling, Rwanda seeks justice and reconciliation through gacaca. In Rwanda, citizens thus arrive at the point of performing reconciliation and Rwandanicity through mandatory obligation—including their participation in gacaca. Critically, Rwandans face the possibility of retribution and incrimination if they do not perform in adherence to the dominant narrative, risking legal consequences for saying something the government may consider 'wrong' or for otherwise stepping outside the frame.[6] Thus, *The Investigation* may have enabled a fictional frame by using the Frankfurt Auschwitz trials as a reception-adaptor, what Patrice Pavis defines as 'conducting elements that facilitate the passage from one world to the other. These adapters allow for the source culture and for their adaptation to the target culture' (1992: 17).

National identities are reconstructed and re-imagined after periods of extreme violence and shifts in state governance, particularly true of Rwanda and South Africa. Collective memory, or what Michael Rothberg (2009) calls 'competitive memory', situates the state in a struggle for recognition and remembrance of the past and the formation of a plural unified identity in the present. As an alternative to competitive memory, multidirectional memory is 'subject to ongoing negotiation, cross-referencing, and borrowing' (ibid.: 3). The concept of multidirectional memory could be applied to Carol Martin's use of constructivist postmodernism for 'theatre of the real' defined as '[t]heatre and performance that engages the real participants in the larger cultural obsession with capturing the "real" for consumption even as what we understand as real is continually revised and reinvented' (2010: 1). Martin notes the significance of touring productions as a kind of global cosmopolitanism:

> Location remains defining, although not in the sense of a nationalist politics or fixed cultural representation. Works from distinct destinations travel to different destinations to present *versions* of global cosmopolitanism. [. . .] In this constellation of the local in the global, the places that are enacted are no longer timeless, fixed, discrete, or stable entities. Rather, these places are in process and as such are incomplete and indefinite. [. . .] What this indicates is that our assumptions about the ways in which performance practices and productions move between destinations cannot be solely based on notions of unique bound cultures with closed systems of meaning. Touring productions as well as performance and dramatic texts in translation result from the recontextualization and marketing of the local. Taken a step further, the global itself can be a kind of cultural destination that reaffirms cosmopolitanism and its movement of people mapped onto specific places (ibid.: 4).

Similar to Martin's use of constructivist postmodernism, Rothberg positions multidirectional memory as a productive and dynamic force that shifts between time and place, inclusive of cultural, political and geographic contexts. While I use theatrical examples like *The Investigation* to illustrate multidirectional memory between the Rwandan genocide and the Holocaust to generate discourse about gacaca courts in Rwanda, comparison between genocides may also serve as competitive memory, if the Holocaust is used as a screen memory to enlist international support for the RPF.[7]

In this case, I would argue for 'the recognition that although postmodern techniques are shared by many cosmopolitan places in the world, these techniques can be and are used for very different ends' (ibid.: 3) and the 'recontextualizing and marketing of the local' (ibid.: 4) might displace local political agency. Rustom Bharucha indicates the limits of global networking and performance by stating that 'global manifestations of cultural practice are inseparable from the political, social, and economic conditions in which culture is produced at local, regional, and national levels. The global cannot be adequately understood outside the intricate network of these mediations' (2007: 52–3). Although the following performances may have been presented to international audiences exploring universal themes of justice, trauma, truth and reconciliation, the local political and cultural context of each production provides a different imperative.

The correlation between transitional justice systems (gacaca and the TRC) and theatrical productions (*The Investigation*, *Truth in Translation* and *Ubu and the Truth Commission*) postulates alternative dimensions of witnessing. In response to the sociopolitical contexts of each production, *The Investigation* promotes dialogue about gacaca; *Truth in Translation* touches upon the universality of experiencing other people's pain through the traumatic embodiment of testimony by the translators of the TRC; and *Ubu and the Truth Commission* disembodies the personalization of suffering through the use of puppetry.

The productions illustrate varied theatrical responses to overriding performatives of 'post-conflict' states. *The Investigation* exemplifies the use of multidirectional memory between the Rwandan genocide and the Holocaust through the correlation between the gacaca courts and the Frankfurt Auschwitz trials. As a comparison between transitional justice systems and their theatrical counterparts, I switch to the TRC and productions in South Africa.[8] My analysis of *Truth in Translation* emphasizes the delicate balance between secondary witnessing and emotive voyeurism. *Ubu and the Truth Commission* demonstrates how puppets were used for what I coin 'aesthetic dismemberment', by physically removing entrenched perpetrator and survivor narratives from bodily sites of violence.

These examples magnify performed effects of atrocity, either by extending events to another time and place, rendering the 'voices' of the TRC to our own or by relocating the repertoire of pain and suffering to inanimate objects. I discuss how the Human Rights Violation Committee (HRVC) may

have provided alternative narratives beyond the theatricality and perfor-
mativity of the TRC and present an overriding analysis of how national
narratives are curated through court trials versus truth commissions.

### THE INVESTIGATION: RECEPTION-ADAPTOR

The correlation between the Holocaust and the Rwandan genocide is made
explicit in the adaptation of Weiss' play, co-directed by Rugamba, Rwandan
artist and genocide survivor, in collaboration with his theatre troupe Urwin-
tore. *The Investigation* is based on the testimonies Weiss recorded while
attending the Frankfurt Auschwitz trials between 1963 and 1965. He the-
atricalized the trial testimonies, an early form of verbatim theatre. Similar
to the gacaca proceedings in Rwanda, the Frankfurt Auschwitz trials were
implemented on a local level in Germany.

Rugamba staged the production with almost no theatrical signifiers,
except several platforms used to represent a courtroom setting. Actors were
clad in crisp white suits and some smoked cigars (see Image 5). Overhead
screens translated text from Kinyarwanda and French into English. The
main theatricality of the production was that Rwandan actors (who were
survivors of the genocide) portrayed characters from the Holocaust.

The production explored the roles of perpetrator, witness and survivor
when framed through post-atrocity justice courts, thus bringing to the fore
epistemological questions based on the use of memory for justice, the neb-
ulousness of truth and the tenuous balance between state-driven justice as
war and individual guilt for state crimes.

The script was divided into separate scenes according to themes,
including the process of selection (The Loading Ramp), methods of torture
(The Swing) and extermination (Cyclone B, Phenol, The Fire-Ovens). The
prosecutor drove the narrative, questioning various witnesses, many of
whom were prisoners in concentration camps (see Image 6).

The counsel, who played as a chorus, intermittently interjected during
court proceedings—at one point, defending their clients as soldiers of war:
'Our clients acted in the best of faith basing their actions on their uncondi-
tional duty of obedience. With their oath of allegiance even unto death
they all bowed down before the goals determined by the then existing
national government just as the administration, the laws and the army had
done' (Weiss 2010: 149).

**IMAGE 5** A scene from *The Investigation*, Young Vic Theatre, London, 2007. Photograph by Keith Pattison. Courtesy: Dorcy Rugamba.

**IMAGE 6** Actors in *The Investigation*, Boufffes du Nord, Paris, 2007. Photograph by Enguérand Bernand. Courtesy: Dorcy Rugamba.

*The Investigation* illustrated different levels of participation during the genocide: including civil servants who operated the railways, doctors who administered medicine in concentration camps and officials who orchestrated methods of torture and execution. There were saviours as well as perpetrators. As one witness remarked: 'I saw the physician Dr Flage standing by the fence with tears in his eyes as a file of children was being led to

the crematorium. He let me take the medical records of individual prisoners who had been picked out so I could save them from death' (ibid.: 84). The Holocaust was enacted as a system: 'These proceedings were known to every one of the 6,000 members of the camp personnel and everyone carried out his own job—what had to be carried out for the functioning of the whole' (ibid.: 198).

Several similarities exist between the portrayal of the Frankfurt Auschwitz trials in *The Investigation* and the gacaca courts. In Rwanda, gacaca sorted perpetrators into three categories: Category One criminals were the planners/leaders of the genocide and rapists; Category Two criminals were those who killed during the genocide; and Category Three criminals were those who committed property crimes. Sentences for Category One and Category Two crimes ranged from 25 years to life imprisonment, whereas Category Three crimes obliged fiscal reparation. Yet, these categories were not static. Defendants charged under Category Two for killing during the genocide might have also saved numerous lives. Further, *The Investigation* mirrors perceptions in the general population about the varied roles that civil society played during the genocide and the potential threat of gacaca as victor's justice.

*The Investigation* was performed globally, but here I distinguish between the reception of the productions that I saw in the UK in 2007 and in Rwanda in 2005. In the UK, it historicized and remembered the atrocities of the Holocaust alongside the Rwandan genocide whereas in Rwanda the production actively engaged with current politics and debates. In a post-show discussion, an Auschwitz survivor who attended the Young Vic Theatre production in London remarked that it was important to 'never forget', whereas audience members at the National University of Rwanda in Butare and the French Cultural Centre in Kigali identified with common narratives between *The Investigation* and gacaca, providing a forum for people to debate larger ideological and political discrepancies between government and citizen narratives. The play allowed further reflection based on the complexity of roles during the genocide beyond perpetrator and survivor. In my 2007 interview with Rugamba and Twahirwa, Rugamba underlined the importance of *The Investigation* to understand the human capacity to commit genocide:

> What we are trying to do is to understand how it [negationism] happens. One of the ways that it happens is to take into account that it was war. Because war is morally defendable, isn't it? During

war, you need to show your brave side, you defend yourself . . . that means you are a warrior, an officer, a big person . . . you are not a killer but a warrior. And it is also the way people explain it, making people think that it was in that way they committed those acts. Obviously, those people will try everything to interpret the situation in a war context. In this play, it is exactly the same thing happening: 'It was war . . . don't forget that it was war . . . and we were attacked.'

Similarly in gacaca, there are some situations where a perpetrator would say: 'We were at war,' while his neighbour would reply: 'You know well that I didn't possess any weapon at home. I haven't been in the military nor my wife and children. I don't even know how to use a gun. How could you say we were at war?' Through that exchange of words, you notice a kind of confusion that re-emerges. The genocide against Jews happened during the Second World War. Because war creates a special climate, a government can create a state of emergency by suspending certain rights; laws are suspended and it is possible to create some new exception laws. With that climate of war, there is tension in people's minds. People become vulnerable to be used as instruments and it becomes very easy to spread slogans. People's heads are too fragile. You know, it is obviously in the context of war that genocide happens but that is not how you can distinguish between the two situations. We need a clearer distinction.

Thus, Rugamba emphasizes the link between genocide and war. Similarly, Scott Straus notes the significance of the Rwandan genocide to war: 'War was critical in legitimizing violence and causing the fear and uncertainty that led some to kill. Without war, I believe genocide would not have happened' (2006: 226). Although the context of war does not legitimate genocide, it perhaps brings us closer to understanding how genocide was made possible through a strong state authoritarian structure led by Hutu hardliners who bred fear into the population under orders to attack Tutsi as a defensive. The Frankfurt Auschwitz trials were conducted under ordinary statutory (as opposed to international) law. The Federal Republic of Germany tried to grapple with genocide through ordinary criminal law, using domestic law to prosecute their own genocidal history.

West German criminal law was designed to deal primarily with very different kinds of crimes: ordinary crimes, committed for the most part by individuals or small groups driven by personal motives. Yet the legal categories developed to differentiate defendants according to their subjective relationship to the crime became at best misleading when applied to a crime whose implementation did not depend wholly on the specific individual motivation of any one of its numerous perpetrators. The Holocaust was not merely massive in scale but also bureaucratically organized and state-directed. Consequently, the personal motives of any one of the thousands of perpetrators became subsidiary factors in a process of mass murder that extended well beyond any one of them (Pendas 2010: 2).

Although I have emphasized the significance of *The Investigation* as a reception-adaptor between the Frankfurt Auschwitz trials and gacaca for audiences in Rwanda, the sociopolitical significance of the production changes when performed for an international audience. The implication of constructing narratives of the Rwandan genocide as synonymous with the Holocaust, transporting the events of the Second World War to the Rwandan genocide, must not be overlooked, since the events of the Rwandan genocide are being linked to representations and collective memories of the Holocaust that have *already* been constructed. According to Michael Billington (2007), '[w]hat strikes one most forcibly is the company's moral right to the material: they understand, better than most of us, the way genocide is made up of myriad, remembered fragments.'

However, the stated 'moral right' to narratives that cross over between the Holocaust and the Rwandan genocide may be dangerous and ethically problematic. Certain judicial and political responses to the Rwandan genocide by international forces may be a reaction to the Holocaust as a collective memory, rather than to specific social, political and cultural factors particular to the genocide itself. Nigel Eltringham criticizes the use of Holocaust discourse by the Rwandan government to support varied political decisions: 'When clear distinctions are drawn with the Holocaust, it is not to suggest a difference *per se*, but to imply that the Rwandan genocide was "worse" than the Holocaust, both in the speed of killing and the participation of the population' (2004: 52–3).

The RPF has equated the Tutsi as the 'Jews' of Africa; in this way, secondary witnessing correlates with other genocides, becoming its own master narrative. While *The Investigation* may correlate multidirectional memories between the Rwandan genocide and the Holocaust, it is not free from master narratives constructed through competitive memory. The use of testimony in *The Investigation* (often performed by survivors) builds upon the notion of affect for international audiences.

## TRUTH IN TRANSLATION: SECONDARY WITNESSING

*Truth in Translation*, based on the role of the witness (as translator) during the TRC, makes explicit and performs the role of the secondary witness. This South African production calls into question the role of the witness and considers the impact of testimony in relation to atrocity, providing a counter-narrative to the predominant TRC discourse that promotes testimony as healing. The translation of traumatic events may embed traumatic narratives by the witnessing of the event, albeit secondary, through the physical and verbal embodiment of testimony.

*Truth in Translation*, performed in 2006 both in South Africa and Rwanda, posits the role of the translator as 'betwixt and between', providing an analysis of the testimonies through their theatrical curation for production and heightening the role of the witness as agent and voyeur. Michael Lessac's production integrated further narratives from the various countries and contexts in which it was being performed, emphasizing the dialogic capability of theatre. One of the main goals of *Truth in Translation* was to create a 'non-threatening platform for provoking dialogue', conducting post-show discussions and incorporating workshops during the tour, which influenced the development of the script. The production was staged at Amahoro Stadium in August 2006 in Rwanda and at The Market Theatre in Johannesburg in September 2006. It opened in Rwanda, celebrating the tenth anniversary of the TRC, thus deliberately creating correlations between the two countries. The musical composition by Hugh Masekela used testimony from the actual court proceedings:

The hair of your husband was pulled out.
I-i-yoh! Hey!
His tongue was pulled and stretched. His fingers were cut off.
Achoo-wee-iyoh!

Forty-three wounds in his body. They poured acid on his face.
Mayi-ba-bo-ho-ho-ho
Chopped off his right hand. Then he was blown up.
His pieces were . . . scattered . . . all over the floor.
His pieces were . . . scattered . . . all over the wall.
His pieces were . . . scattered . . . all over the ceiling.[9]

The lyrics refer to a court proceeding in which witness Nombuyiselo
Mhlawuli states: 'They poured acid on his face and chopped off his right
hand. Why? Why did they want my husband's hand?' The hand of Sicelo
Mhlawuli was put in a jam jar and used by the police station as a scare
tactic (see Ross 2006). Although the production used various testimonies
from the TRC and presented the narratives of both victims and perpetra-
tors, the focus of the production was on the translators. The TRC required
translation in first person, in the 11 (12 including sign language) official
languages of South Africa. Thirty-five translators were provided by the
Unit for Facilitation and Language Empowerment. They were commis-
sioned for two and a half years, but counselling was not provided as part
of their work agreement, thus increasing the potential for traumatization
through secondary witnessing. The script was initially devised through
interviews with several translators from the TRC in 2003 and workshops
with South African actors that began in 2005. Translators commented on
their experiences with the TRC:

> The interpreter was the sponge that absorbed all the pain
> throughout the process.—Siphithi Mona
>
> We were actors. You see that kind of story. We were living someone
> else's life.—Advocate Wisani Sibuyi
>
> Interpreting in the first person, in order to do that as effectively
> as possible, you visualize and that is where the trick sets in because
> now you are visualizing how somebody is dying so there is a little
> movie playing in your head. You are visualizing exactly what is
> going on and it's almost as if you are there.—Charlene Dobson[10]

The quotes emphasize the role of the translators in the embodiment
of text and emotion, speaking in first person and often using the body lan-
guage of those providing testimony. Wendy S. Hesford (2004) notes the
connection between the performed pain of the subject and the relationship
of pain to the observer; narratives of pain and suffering allow the spectator

to feel, connecting to pain and suffering which is potentially more psychological than physical in the Western world. Similarly, Amelia Jones (1998) explores the relationship of pain in body art practices, how meaning is constituted in relation to a back-and-forth movement between the performer and the audience, connecting the desire of the audience and the subjectivity experienced by the artist. Although there is a vast difference between the performance of pain and audience viewership of performance art, and the empathic responses to testimonies of pain by the translators of the TRC, there may be similarities in terms of the voyeurism of the audience and the dynamic through which audience members connect to their own psychic traumas as a means of making sense of what they are watching. Hesford notes the significance of human rights testimony (which she refers to as *testimonio*) for intersubjectivity, allowing one to bear witness. However, the relationship between the traumatic event and the witnessing agent goes through a process of rhetorical negotiation.

> This negotiation speaks to the rhetorical dynamics of witnessing and the intersubjectivity of testimonial acts. For trauma [. . .] 'cannot be simply remembered, it cannot simply be "confessed": it must be testified to, in a struggle [and rhetorical negotiation] shared between a speaker and listener to recover something the speaking subject is not—and cannot be—in possession of'. I emphasize 'rhetorical negotiation' to highlight the material rhetoric of trauma; that is, to see the process of working through trauma as an act that involves the negotiation of available cultural and national scripts and truth-telling conventions (2004: 108).

The act of 'working through trauma', in the case of *Truth in Translation*, was a negotiation between the lived experiences of the translators as secondary witnesses to the national scripts and truth-telling conventions of the TRC that was mediated through visual representations and oral narratives. Video montages of TRC coverage during the performance were projected onto white shirts strung on clotheslines and actual testimonies were sung as lyrics or portrayed through text. Although the intention of the play was to foster dialogue, promoting forgiveness, I emphasize the issue of secondary witnessing—the potential voyeurism of suffering that may expand into a universalization of suffering by the viewers of *Truth in Translation*. Similar to *The Investigation*, this production serves as a fictional frame to respond to larger sociopolitical discourses on juridical performatives. As I highlighted

potential ethical concerns of overlapping representations of the Rwandan genocide to the Holocaust in my analysis of *The Investigation*, *Truth in Translation* implicates the effect of trauma on witnesses—translators, in this case— but can be extended to symbolize the international community as well.

### *UBU AND THE TRUTH COMMISSION*: AESTHETIC DISMEMBERMENT

Regarding ethical and political constraints of representing atrocity, *Ubu and the Truth Commission* sought alternative aesthetic choices to animate counter-narratives to the TRC. Standing outside predominant narratives of the 'rainbow nation', the performance highlights some of the potential weaknesses of the TRC as illustrated by the shredding of documentation into the mouth of Niles the Crocodile, the distortion of accountability through the character of Three-Headed Dog (who stands for the head of political affairs, the head of the military and the agent of ghastly deeds) and the limited disclosure by Pa Ubu before the commission. The play culminates with Ma Ubu and Pa Ubu on a boat with Niles the Crocodile as they sail towards an animated giant eye that turns into a setting sun. In the end, the production does not reconcile perpetrators and victims, nor does it provide catharsis through the punishment of horrendous deeds, but rather, illustrates some of the inconsistencies of justice and perhaps the inability of the TRC to heal the wounds of victims.

The use of puppetry, testimony and animation exemplifies *Ubu and the Truth Commission*. The artistic team of the Handspring Puppet Company devised the production through a series of workshops and experiments, seeking to facilitate debates about the TRC, questioning notions of violence, memory and mourning through the character of Pa Ubu as perpetrator (borrowing from Alfred Jarry's 1896 play *Ubu Roi* [Ubu the King]) and the witnesses as puppets. The use of animation and puppetry made it possible to create metaphorical associations with the testimonies of witnesses, while the human enactment of Pa Ubu and Ma Ubu set the perpetrator as the protagonist and main agent of dramatic action and tragedy.

The production highlights the linguistic and burlesque style of Ubu for the performances of Pa Ubu and Ma Ubu, illustrating the deceit and secrecy of Pa Ubu who hides covert apartheid operations from Ma Ubu who suspects him of infidelity, while he sneaks out at night with his Three-Headed Dog of war to torture and interrogate, after which he shreds

incriminating evidence into the mouth of Niles the Crocodile. Pa Ubu uses a shower booth to wash off the blood of his victims, which then turns into a testimonial chamber, the shower head serving as a microphone. Metaphorically, the TRC may be used to absolve or wash away the sins of perpetrators, as Pa Ubu eventually provides testimony and is granted amnesty. The performance vacillates between scenes that portray the nightmares of Pa Ubu and the jealous rages of Ma Ubu, with intermittent testimonies from the witnesses portrayed by puppets. The testimonies provide bloody accounts of torture and violence: 'The way that they killed my son, hitting him against a wall and we found him with a swollen head, they killed him in a tragic manner and I don't think I'll ever forgive, in this case, especially the police who were involved and who were there,' Ma Ubu recalled. 'It wasn't personal. It was war!' Pa Ubu responded (Taylor 1998: 55). Hutchison expands on the use of imagery to critique notions of truth: 'The play thus appropriately juxtaposes verbal narrative with images to layer and critique the state supported truth [. . .] that truth is beyond a compilation of lived experiences' (2010: 66).

The witnesses' testimonies were primarily derived from actual court proceedings, but the theatrical enactment of staging the testimonies through puppetry and animation allowed for varied representations outside the media-centred and documentary style of the TRC. 'There is thus, I suppose a sense of ambiguity produced by the play. This is not an ambiguity about the experiences of loss and pain suffered; rather, it is an ambiguity about how we respond to such suffering,' states Taylor (1998: v). As previously quoted, Hesford (2004) argues that suffering is often witnessed as an agent of one's own grief and mourning. However, by representing testimonies of witnesses through puppets rather than actors, the production curtails some of the ethical considerations of performing someone else's story but does not exonerate the audience member from the events.

As mentioned earlier, I use the term 'aesthetic dismemberment' to analyse the artistic separation of testimony from the bodily sites of violence. In this case, puppets were used as a staging device to represent witnesses who testified during the TRC. By physically removing the testimonies from the body, violence was not forcibly portrayed on an affective body, and the utterances through an inanimate object limited the power of speech acts to inflict further bodily injury. Kentridge expands on the artistic choice to use puppets rather than actors:

What is our responsibility to the people whose stories we are using as raw fodder for the play? There seemed to be an awkwardness in getting an actor to play the witnesses—the audience being caught halfway between having to believe in the actor for the sake of the story, and also not believe in the actor for the sake of the actual witness who existed out there but was not the actor. Using a puppet made this contradiction palpable. There is no attempt to make the audience think the wooden puppet or its manipulator is the actual witness. The puppet becomes a medium through which the testimony can be heard (in Taylor 1998: xi).

Although puppets are used elsewhere in the play, for Niles the Crocodile and Three-Headed Dog, these puppets expose other characteristics of Pa Ubu through representative animalistic features and symbolic imagery, extending the three-headed dog as an agent of death and the crocodile as a live shredding machine to erase incriminating evidence from the past.

The puppet draws attention to its own artifice, and we as audience willingly submit ourselves to the ambiguous processes that at once deny and assert the reality of what we watch. Puppets also declare that they are being "spoken through". They thus very poignantly and compellingly capture complex relations of testimony, translation and documentation apparent in the processes of the Commission itself (ibid.: vii).

Here, the artistic team of *Ubu and the Truth Commission* grapple with ethical issues of representation but also draw attention to the use of puppetry as a mediating force to be 'spoken through' and for the testimonies to be heard. In this way, the aesthetic artistry used for both the visual representation of the witnesses and their physical manipulation by puppeteers provides a vehicle to literally remove or dismember traumatic testimony.

Vivian M. Patraka (1999: 98) poses the dilemma of performing the body of the victim as standing in for the dead, exemplifying mass death. The use of puppets or dummies may serve to mediate between the voices of survivors, both living and the dead, but I believe portraying the role of Pa Ubu through a human actor who serves as the perpetrator and is the protagonist may exacerbate power relations between notions of the dominant perpetrator and powerless victim.

Although I have presented theatrical examples of how the fictional frame has been used through alternative framing or aesthetic choices, it is worth considering the performativity of the TRC proceedings themselves and where hidden transcripts might emerge. Cole (2010) considers HRVC hearings as a space to offer counter-narratives to the predominant Amnesty Committee hearings.

## ALTERNATIVE JURIDICAL FRAMES

Although *Truth in Translation* and *Ubu and the Truth Commission* juxtaposed the testimonies of witnesses and perpetrators (in a general sense), the actual TRC proceedings incorporated two primary hearings: the HRVC hearings and the Amnesty Committee hearings. Cole states the difference between the two hearings: 'Within the structure of the TRC these two committees were kept institutionally separate, and their rules of decorum and procedure as well as their performance conventions were entirely distinct' (ibid.: 4). She notes that the HRVC hearings were conducted nationally, like a site-specific travelling performance event that would set up in a community for eight weeks and stage the testimonies of victims, often in areas where blacks had previously been excluded. Cole frames the hearings as a theatrical enactment, allotting various roles including the audience as chorus and the commission as casting director, determining which testimonies would be selected for the public audience. While the HRVC testimonies were emotive and contained an improvisational quality, as witnesses were able to speak for half an hour each without cross-examination, the Amnesty hearings were conducted under legal auspices, as perpetrators were required to provide full disclosure of events and where the bodies were buried in order for them to be considered for amnesty. Cole regards the Amnesty hearings as performative, since the function of utterances is to 'do something'—in this case to provide amnesty.

The town hall and previous sites of apartheid power were often used for the HRVC hearings. 'The audience as chorus was thus newly empowered at the TRC, enjoying a status and prestige unknown during the old regime' (ibid.: 14), as black spectators entered the government establishment knowing that they were victorious. The comparison between theatrical enactments, including *Truth in Translation* and *Ubu and the Truth Commission*, and the actual commission hearings signifies the relationship between

performance and performative events as integral to negotiating the historicity of violence and post-conflict reconstruction.

Michael Humphrey distinguishes between truth commissions and trials:

> While truth commissions focus on the ritual 'purification' of the individual, trials focus on the ritual purification of society. Truth commissions, focusing on the suffering of individual victims, employ the language of psychology. The legacy of violence is supposed to be expelled from the individual through the cathartic experience of revealing and sharing it. This ritual process is in turn meant to be socially healing through the public witnessing of the truth about the origins of that suffering. [. . .] Reconciliation in this case means the individual abandonment of the desire for vengeance and public forgiveness. Trials, on the other hand, seek to achieve social healing by identifying the source of the violence and expelling (imprisoning, executing) those responsible from society as a punishment. Society is 'healed' through the prosecution and punishment of the perpetrator, who in turn provides the social benefit of the moral renewal of the national community (2002: 127).

As Humphrey has contextualized truth commissions and trials, one of the fundamental differences between the two systems is that truth commissions reintegrate the individual confessor into a new moral community. Whereas truth commissions focus on a spiritual and moral order, trials focus on a national and legal order. The performance of confession in gacaca differed markedly from that in South Africa's TRC, to which gacaca is frequently compared. Both stem from a religious ideology of contrition but gacaca provided a lighter prison sentence and an earlier court hearing in exchange for a guilty plea, whereas confession in the TRC secured amnesty. The foundation of testimony as healing in the case of the TRC, as a public cleansing of the evils of apartheid, may not be promoted for the same objectives nor reach the same outcomes in the gacaca.

The TRC in South Africa developed from a religious and moral imperative moulded by iconic leaders such as Nelson Mandela and Desmond Tutu. The goal of the TRC was to use amnesty as an exercise for truth and testimony and a narrative act for collective healing rather than as a potential

defence against allegations. Emphasis was placed on the therapeutic effects: 'for healing to occur, the testimony should include attention to how the individual has tried to understand what happened, and how those understandings can be reintegrated with the individual's values and hopes' (Minow 1998: 70). Yet the act of telling does not guarantee a cathartic effect. Often, the telling can lead to retraumatization. For example, Lyn S. Graybill (2002: 83) claims that 50–60 per cent of the victims who testified in the TRC were affected adversely.

There is therefore a delicate balance between using testimony for justice and for reconciliation. The cross-examination approach, often used in trial cases, does not lend itself to creating a testimony that is ordered and framed through the experiences of the teller. Instead, the narrative can often remain fractured, according to the specific events or information requested by the judge or jury. Martha Minow elaborates on this point: 'Unless the commissioners and staff of a truth commission attend to these dimensions of an integrated personal narrative of meaning, emotion, and memory, the therapeutic effects for testifying victims will be limited' (1998: 70).

In the case of gacaca, where the goal is to use the trials for both justice and reconciliation, there may be hindrances to meeting these dual objectives by issuing sentences as opposed to amnesties. Yet, while the individual process of testifying may be different for the survivor and perpetrator—one seeking justice and truth, the other redemption—the constitution of the courtroom drama itself is a formative process that aligns these narratives to the state, held accountable by law. Memories may be constructed by the state, as opposed to being narrated by the individual shaping his or her own memories, limiting the potential of gacaca for healing. Concerning the delicate use of trials to construct public memory, Mark Osiel suggests that 'collective memory probably can only be enshrined through trials if the intention to achieve this end is concealed from the public audience; revealing an orchestrated plan to shape the content and message would corrode public confidence in the fairness and open-endedness of the trial' (cited in ibid.: 46).

In the case of Rwanda, the government was faced with various options regarding how to establish justice and reconciliation, including the potential establishment of a truth and reconciliation commission. According to Jeremy Sarkin, '[a] truth commission was at work in Rwanda in 1993, confirming the severity of human rights abuses committed from 1990 to

1993' (1999: 777). However, the truth commission was subverted by the attacks and killings, making it impossible to be implemented during the period of continued violence:

> Not only was its legitimacy and potential to contribute to reconciliation subverted by the ongoing violence, but the killing of potential witnesses robbed the process of the element of safety necessary [. . .] if the goals of a truth and reconciliation commission are to be realized and participants in the process, both victims and accused are to be protected (ibid.: 778).

One possible reason the RPF government did not establish a truth commission in Rwanda following the genocide is that a truth commission would necessarily have to acknowledge the grave human rights abuses committed by the RPF. Although Sarkin argues for the potential of a truth commission in Rwanda, he invariably indicates that it would require the full participation of the RPF government to include crimes beyond the current mandate of gacaca (crimes against humanity between 1 October 1990 and 1 December 1994). He suggests the need for truth commissions to investigate human rights abuses after the 1994 genocide, allowing both Hutu and Tutsi victims and perpetrators to have their testimonies acknowledged along the lengthy violence in Rwanda's history.

> Therefore, if the Rwandan Government were willing to participate actively in a truth and reconciliation commission process and to accept responsibility for abuses committed by it, reconciliation could become a realistic goal. Government willingness to 'open up' would assist in legitimizing the process and could have a very positive effect on the willingness of other groups and individual citizens to participate honestly and fully in truth and reconciliation commission investigations. [. . .] About 6000 people, many of whom were civilians, are believed to have died in Rwanda between January and August 1997 alone. [. . .] Thus, the violence on both sides is continuing with no end in sight (ibid.: 785).

It can be argued that the choice of implementing trials in Rwanda rather than a truth commission coupled with amnesty as in South Africa was a further result of victor's justice, given that the RPF overthrew the Hutu government to end the genocide and has retained political control of Rwanda ever since. Sarkin distinguishes three categories of post-conflict

transitions: overthrow, reform and compromise. Rwanda represents over-
throw in which the opposition toppled the government, whereas post-
apartheid South Africa represents compromise in which the old order and
the new order worked together towards democracy (ibid.: 769). According
to Kimberly Lanegran, '[i]n Rwanda, where the Hutu forces were defeated,
the government stresses retributive justice via prosecutions. In contrast,
with South Africa simmering in violence, ANC leaders explicitly determined
that they needed to use amnesty in order to convince authorities to negotiate
the country's transition to democracy' (2005: 116). While retributive justice
calls for punishment, restorative justice seeks individual and community
acknowledgement of the harms committed and endeavours to promote
dialogue and responsibility between all parties on a large social scale.

CONCLUSION

Violent acts are performed and embodied for various political, socioeco-
nomic and juridical objectives: not only the performativity of the violent
acts themselves but also the representation of violence through theatrical
performances and public trials.

The representation of violence through theatre links to multidirectional
memory and wider international politics concerning the Holocaust, poten-
tially providing the RPF with a moral high ground for continued conflict
in the DRC. Patrick Anderson and Jisha Menon convey the imperative of
linking theatrical enactments with political agency stating that '[t]his sug-
gests, of course, that representations of violence are both descriptive and
performative: not merely involved in staging and framing specific acts of
violence, but also of *producing* the context in which violence is rationalized
and excused as a symptom of inter-cultural encounter' (2009: 6). The over-
lap between violence performed and the performativity of structuring
nations after genocide through performative measures such as gacaca and
the TRC, as seen in the examples provided, illustrates that narratives are
*still in formation*, and that theatre can be used to either subvert or enforce
narratives being scripted as national discourses of power.

In comparing the case of Rwanda with that of South Africa, it should
be noted that the gacaca courts have enforced justice rather than amnesty.
However, the use of fictional frames can serve as an aesthetic and imaginary
border to negotiate counter-narratives outside national ideological and

political borders, or alternatively can reinforce the performativity of national identity construction after conflict. The context within which the productions have been staged for various political and social purposes has been provided to contextualize how performative iterations of nation building become ingrained into performances or otherwise resisted.

## Notes

1   Peter Weiss' original *Die Ermittlung* premiered on 19 October 1965 on stages across 14 East and West German cities and at the Royal Shakespeare Company in London. Jean Baudrillard's adaptation was conceived and directed by Dorcy Rugamba and Isabelle Gyselinx. The UK production, in 2007, was performed in French and Kinyarwanda, with projected English subtitles, at the Young Vic Theatre in London.

2   See http://www.truthintranslation.org/index.php/v2 (last accessed on 3 January 2014).

3   The play was first showcased at The Laboratory, The Market Theatre, Johannesburg, on 26 May 1997. Its world premiere was at the Kunstfest in Weimar, Germany, on 17 June 1997, and it was staged shortly afterwards at the National Arts Festival in Grahamstown, South Africa. It toured to Italy, France and the US in 1998 and featured at the London International Festival of Theatre (LIFT) in 1999.

4   Erving Goffman used the term 'framing' to describe a process of creating meaning via analysis of the self and society by setting parameters for observation. Goffman maintains that the social organization of events determines what is being constructed or framed. He claims, 'I assume that definitions of a situation are built up in accordance with principles of organization which govern events—at least social ones—and our subjective involvement in them; frame is the word I use to refer to such of these basic elements as I am able to identify' (in Lemert and Branaman 1997: 155).

5   Examples of theatre in South Africa which provide a 'fictional frame' as noted by Yvette Hutchison (2005) include Jane Taylor's (1998) *Ubu and the Truth Commission*, Paul Herzberg's (2002) stage play *The Dead Wait* (based on a true story of the journey of an athlete-turned-soldier in the background of the 1982 Angolan War and the creation of a new South Africa; the play, directed by Jacob Murray, was first performed in October 2002 at the Royal Exchange Theatre) and the Khulumani Support Group's (1997)

workshop play *The Story I'm about to Tell* (*Indaba Engizoxoxa*, in which torture victims tell their stories of atrocities; the play accompanied *Ubu and the Truth Commission* to the LIFT in 1999 and subsequently appeared at the National Arts Festival in Grahamstown the same year).

6  The legal implications of going astray in speech and performance in Rwanda are real: with gacaca trials ongoing, performers ran the risk of being accused of perpetuating genocide ideology if they expressed messages that did not conform to the government's narrative. Performance was closely monitored and tightly controlled.

7  The concept of a screen memory was presented by Sigmund Freud on the basis of the repression and distortion of memories, screening out potentially unpleasant or traumatic memories with an earlier memory. In relation to the use of the Holocaust as a screen memory—it has already been documented, adjudicated and memorialized—nuanced accounts of genocide can serve as an immediate screen memory to represent the Rwandan genocide.

8  Hutchison (2010) provides an account of theatre in South Africa as crossing between the 'fictional' and 'real worlds'. One reason for the blurring between the fictional and the real is political (especially concerning plays produced during apartheid that challenged the state). The other, 'concerns an African philosophical approach to truth that is not predicated on a binary approach and thus does not place a high value on empirical proof to validate an inquiry or conceptual position' (ibid.: 62).

9  Truth in Translation Project Education Packet, 'Truth in Translation: The "Truth" behind the Play', available at: http://www.truthintranslation.org/educational_materials.pdf (last accessed on 18 October 2010).

10  Truth in Translation Project, 'Interviews with Translators'. Available at: http://www.truthintranslation.org/index.php/v2/video/ (last accessed on 19 October 2010).

# GACACA COURTS AS *KUBABARIRA*:
# TESTIMONY, JUSTICE AND RECONCILIATION

In an interview with me on 29 October 2005 in Butare, Simon Gasibirege, professor at the National University of Rwanda and practicing psychologist, said:

> In Rwanda, when you say 'forgiveness' it means something different than how it is understood in Europe or the US. We do not think the same thing. When we say the word *Kubabarira* there is an emphasis on suffering. It means to share suffering. In Rwandan culture, the important thing is the quest of suffering. It means sharing his or her suffering.

During gacaca proceedings, I witnessed several examples of performed kubabarira: a survivor who stood in defence of a perpetrator; a first-aid worker who walked through a large crowd of community members to hand the defendant a tissue while he wept and gave testimony about his crimes; and grassroots theatre association members comprising genocide survivors and perpetrators who claimed they used art to create a new space to live with one another—that they all suffered together (see Image 7). Gasibirege said: 'The workshops that I conduct in prisons are based on the healing of wounds using psychological processes round bereavement, because all of those people lost lots of people during the genocide and suffer from bereavement. My process of healing is focused on bereavement.' This chapter illustrates varied negotiations of the gacaca courts on macro and micro levels to address the espoused goals of justice and reconciliation alongside Kubabarira but alternatively provides examples of how gacaca had been used as a national performance to stage the power of the RPF, the collective guilt of the Hutu population and to memorialize

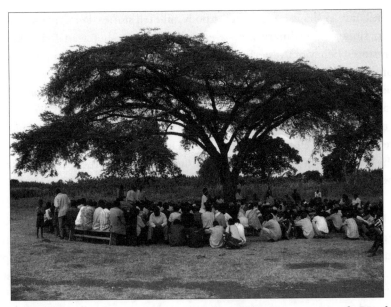

**IMAGE 7** Gacaca in progress, Eastern Province, 2005. Courtesy: Ananda Breed.

and commemorate the genocide through a weekly ritual of testimony, justice and reconciliation, from its national inception in 2005 to its culmination in 2012—excavating memories of the genocide as a traumatic point of departure from which history is rewritten and Rwandanicity is enacted, iterated and performed.

In the aftermath of the genocide, the Government of National Unity was faced with enormous moral, legal and administrative challenges. At their request, the UN created the International Criminal Tribunal for Rwanda (ICTR) on 8 November 1994 to try high-level planners of the genocide but because of the extensive amount of time and money allotted for each case and the distance of the ICTR (in Tanzania) from Rwanda, there has been controversy concerning its effectiveness. To speed up the trials in classic courts in Rwanda, lessen the load on the overburdened prisons and to engage the active participation of Rwandans towards 'truth seeking' and 'fighting against impunity', the government sought a local solution that resulted in the establishment of the gacaca courts.[1]

I frame gacaca as a performative event, from the rehearsal stage (sensitization campaigns and information-gathering sessions) to the performance stage. Richard Schechner has written that '[p]erformances mark identities,

bend time, reshape and adorn the body, and tell stories. Performances—of art, rituals or ordinary life—are made of "twice-behaved behaviors", "restored behaviors", "performed actions that people train to do, that they practice and rehearse"' (2002: 22). Although gacaca is not a discernible performance event like legendary theatre or theatre at the ingando solidarity camps, deeper probing reveals that gacaca is also twice-behaved behaviour and can be theorized as a performance event on several levels, including its reenactment as a precolonial ritual used for mediation and reconciliation, the use of gacaca plays to rehearse for the actual court proceedings and the performative nature of the gacaca courts themselves.[2]

The gacaca courts instilled Rwandanicity on a local and state level, while mediating between justice and reconciliation. Brigadier General Frank K. Rusagara wrote in the *New Times* that gacaca is not only an instrument of justice but also a tool for disseminating the ideology of Rwandanicity, a 'lubricant' that potentially smooths out friction or resistance against the RPF government or the concept of the new Rwandan identity:

> The concept and institution of the gacaca justice system comes
> through as one of the most enduring in Rwanda, not only in con-
> flict management through restorative justice, but in serving as a
> lubricant to the ideology of rwandanicity that ensured unity and
> cohesion in the society since the pre-colonial times. By definition,
> rwandanicity was an idea and a philosophy that guided the people's
> conduct and perceptions. As an ideology, therefore, it is what the
> people of Rwanda understood themselves to be, what they knew
> about themselves, and how they defined and related to each other
> and their country as a united people (*Ubumwe*). Thus, other than
> giving identity, rwandanicity is also the medium in which Rwandans
> got their worldview (2005: 1).

As mentioned earlier, gacaca, meaning 'judgement on the grass' in Kinyarwanda, was a 'traditional' justice mechanism used to mediate local-level disputes (Tiemessen 2004). Abolished by the Belgian colonists in 1924, through Ordinance Law No. 45 dated 30 August 1924, contemporary gacaca was reinvented to try criminals of the genocide. Its proponents assert that gacaca courts not only achieved justice for crimes of the genocide but also had the potential to cultivate reconciliation within communities through reiterated weekly performances of contrition and

forgiveness while inculcating the population with a national sense of Rwandanicity and working to sculpt collective memory (Clark and Kaufman 2009; Clark 2010). According to detractors, the gacaca courts did not serve to foster reconciliation on a national scale on the basis of community-level actions but represented instead a top-down imposition of mandated confessions, reenacted along a traditional, ethnically defined hierarchy of power.[3] While traditional gacaca dealt with crimes on a community level, contemporary gacaca was implemented nationally and required mandatory citizen participation.

In an interview with me on 11 January 2005 in Kigali, Domitilla Mukantaganzwa, who was then the executive secretary of the National Service of Gacaca Jurisdictions (SNJG), stated that gacaca originated as a traditional mechanism to resolve disputes. Aggrieved families used to meet to discuss their problems. If they could not resolve the problems on their own, then the heads of each family met and solved the problem. They were to help the community debate the issues as facilitators rather than judge the situations on their own. Mukantaganzwa stressed the importance of resolving the problem rather than punishing the individual. If the individual couldn't repair, then the whole of the community had to repair the wrong—it was not just material reparation but 'moral reparation'; the community had to give something from the heart. Following an agreement or solution, local banana brew was shared. Charles Villa-Vicencio provides a similar account of brew sharing as the Mato Oput ritual of the Acholi in rural Uganda:

> The ceremony begins after a council of elders has mediated between both the individuals or groups party to a conflict, as well as their families and clans. The mediation involves truth telling, a cooling-down period, and agreement on compensation and restoration. To mark the settlement, the conflicting parties partake of a drink made from the bitter roots of the Oput tree to wash away the evil, after which a goat is slaughtered and a ceremony of restoration is held (2009: 138).

One of the main areas of tension relates to the traditional system of gacaca as a cultural form for *mediation* and the reinvented version as a contemporary system for *justice*. Villa-Vicencio stresses the importance of pre-verbal and non-verbal healing and relationship building as elements of traditional African reconciliation practices, 'as a pretext for rational debate and conversation to take place as a way of dealing with the violence and

trauma of the past. Through ceremony and ritual, perpetrators and victims are encouraged to make an attitudinal and behavioral shift from a prelinguistic state to the point where they can begin to articulate their experiences in words and ritual' (ibid.: 134). Several grassroots associations that I observed used performance (particularly dance and music) in correlation with the gacaca courts. These case studies demonstrated strong links between arts-based grassroots associations and participation in the gacaca courts. However, the reinvention of gacaca for crimes solely related to the genocide against Tutsi may have altered its traditional characteristics, further embedding ethnic strife.[4] Eltringham (2004) attributes the government's use of the terms perpetrator and survivor as synonymous with Hutu and Tutsi. Citing Eltringham, Waldorf emphasizes the impact of accusations on the unification of Rwanda: 'Overall, gacaca imposed collective guilt by generating accusations of genocide against perhaps one million Hutu—a quarter of the adult Hutu population [. . .] Thus gacaca has reinscribed the ethnic labeling of the past (Hutu–Tutsi), using new labels (génocidaire–victim)' (2010: 200).

At the end of Rwanda's experiment, over a million Rwandans were accused of genocide, in over 12,000 community courts. What are the ramifications of gacaca? Though gacaca was staged as a transitional justice model with the aim of administering justice and facilitating reconciliation through local-level courts, these objectives may not have been achieved at the local level. In this way, gacaca has not been administered in correlation with the benefits of the traditional gacaca courts that aimed for social restitution and reconciliation between the aggrieved parties.

JURIDICAL SCRIPTS

Following the genocide, Rwanda and its infrastructure were in a state of ruin and the already overtaxed formal justice system was overwhelmed. With more than 120,000 accused perpetrators incarcerated in teeming, overflowing prisons round the country, only 5 judges and 50 lawyers remained nationwide; the others fled or were killed (Daly 2002: 368).[5] Mass arrests by the RPF, coupled with a crippled judicial system, left tens of thousands of perpetrators and possibly innocent prisoners awaiting trial for more than a decade (Sarkin 1999).[6] With the formal justice system's limited resources and at ordinary court-trial pace, it was estimated that it

would take over 150 years to try all the genocide suspects in custody (Stockman 2000: 2). Implemented as Rwanda's solution to Rwanda's problems, gacaca was resurrected to hasten the trials for the accused.[7] Gacaca court hearings were led by newly trained inyangamugayo, or persons of integrity, elected from within the community, with the community itself acting as accusers, defendants, witnesses and judges.[8]

According to the SNJG, the gacaca aimed to: (1) disclose the truth about the genocide events; (2) speed up genocide trials; (3) eradicate a culture of impunity; (4) reconcile Rwandans and strengthen unity among them; and (5) prove the Rwandan society's capacity to solve its own problems.[9]

Adjudication on genocide crimes was mandated down to cell-level gacaca courts also—the cell being the most local of Rwanda's government structures, consisting of just 100 households—but gacaca was implemented at this level only for property crimes. Prunier (1995), among others, has noted the speed and efficiency that typifies the dissemination of state-mandated policies from state to cell level in Rwanda, an authority-driven legacy that influenced the startling rate at which mass atrocity was carried out during the genocide. It was hoped that the same efficiency could be harnessed in the national implementation of gacaca to achieve some measure of justice and reconciliation.[10] Gacaca hearings began with a pilot phase in 12 sectors on 19 June 2002. The second phase of hearings was conducted in 751 courts at a sector level, one in each district, on 25 November 2002. The third phase included the national implementation of gacaca courts at a cell and sector level on 10 March 2005 (see Longman 2006).

As set forth in Organic Law No. 08/1996 of 30 August 1996, the gacaca courts' jurisdiction extended to acts perpetrated against Tutsi between 1 October 1990 and 31 December 1994. The law further established categories of crimes, clarified the respective jurisdictions of the military and civil courts vis-à-vis gacaca courts and set forth the procedure for confessions.[11]

A perpetrator could be sentenced for three categories of crimes. Category One criminals—planners/leaders of the genocide, their accomplices, and rapists—were heard in the ordinary or military courts; Category Two criminals—those whose aim was to kill, whether or not they succeeded, and their accomplices—were heard at the sector level; and Category Three criminals were tried at the cell-level gacaca courts. Under Organic Law No. 10/2007 of 1 March 2007, there was a doubling of sector-level courts,

allowing a large number of cases from Category One to be moved to gacaca courts (Penal Reform International 2010: 63). The drive to expedite trials created an additional burden upon Rwanda's penal and judicial infrastructure, as the gacaca proceedings incriminated over a million Rwandans.[12] The gacaca demanded mandatory participation once a week for seven years, which may have economically and psychologically strained the nation.[13] Further, gacaca procedures demanded the performance of contrition.

According to Organic Law No. 16/2004 of 19 June 2004, the accused had to provide a confession in order to be considered for release:

> Article 54: Apologies shall be made publicly to the victims in case they are still alive and to the Rwandan Society.
>
> To be accepted as confessions, guilty plea, repentance and apologies, the defendant must:
>
> 1  Give a detailed description of the confessed offence, how he or she carried it out and where, when he or she committed it, witness to the facts, persons victimized and where he or she threw their dead bodies and damage caused;
>
> 2  Reveal the co-authors, accomplices and any other information useful to the exercise of the public action;
>
> 3  Apologize for the offences that he or she has committed.[14]

The first court cases to be heard were for those detainees who had pleaded guilty (i.e. those who confessed), whereas the last cases to be heard were of those who claimed innocence. The gacaca law mandated public confession by the individual. But the performance of the guilty plea had roots in the American judicial system of plea-bargaining and had little to do with traditional gacaca procedures. In fact, the performance of guilt might have been counter to the Rwandan culture of silence, based on secrecy, and might have ignited further hostility. According to a report by the gacaca monitoring agency Penal Reform International:

> Confessing in front of the victims is considered an insult and an aggravating circumstance as it is considered as a show of force. In fact only those who have very strong family support may confess in front of their victim: the family is then obliged by religion to avenge the person outside their family who has committed this crime on one of theirs. Revenge is carried out on the male members of the parental family of the delinquent. Normally it is

the head of the family who asks forgiveness in the name of the delinquent (2003: 3–4).[15]

Moreover, since the last court cases to be heard were of those who pleaded innocence, it was possible that innocent individuals could plead guilty to gain early or provisional release from prison.[16]

A gacaca coordinator told me about a case in his jurisdiction where an inmate who originally claimed innocence eventually confessed to crimes of genocide. He was provisionally released after he pleaded guilty and provided a list of names of those he had killed. At his trial at the gacaca, in front of the inyangamugayo and the community at large, one by one, those names were called out. And as the names were called out, individuals in the audience began raising their hands to protest that they were still alive. In this case, the defendant was taken back to prison. But his act of protest, that is, providing names of people still living to be allowed provisional release, points out the absurdity of the trial procedure.

## GACACA AS PERFORMATIVE

Gacaca courts were generally held in the shade of a tree, in community halls or under the cover of temporary shelters. Several wooden benches were lined up in rows for the community or audience to sit on but because the courts were attended by huge numbers, many community members sat on the ground. On a single wooden table with a bench, the inyanga-mugayo sat facing the audience (see Image 8).

At the opening of the gacaca, the crowd was asked to stand for a moment of silence in memory of the lives lost in the genocide and to think about their role in addressing the crimes committed. The inyangamugayo reminded the audience, 'that whoever testifies must swear to tell the truth by raising his or her right hand, saying: "I take God as my witness to tell the truth"' (Republic of Rwanda National Service of Gacaca Courts 2005a: 4).

The sequence of events included the identification of the defendant, the victims and witnesses, the enumeration of charges against the defendant and the minutes of the defendant's guilty plea and confession. Testimonies were heard according to the charges against the defendant. All in attendance at the gacaca were allowed to speak after raising their hand and swearing to tell the truth.[17]

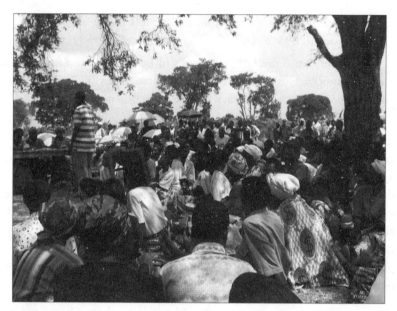

**IMAGE 8** Gacaca in progress, Eastern Province, 2005. Courtesy Ananda Breed.

Following the hearing, the inyangamugayo retired for a short recess to decide on the verdict, which they then presented and the defendant put his or her thumbprint on the case file: 'In Rwanda, just as elsewhere in Africa, the imposition of a thumb-print is the equivalent of a signature; it was therefore as if, in Europe or North America, the voter had signed the ballot paper with his own name' (Reyntjens 2001: 6).

The gacaca was performed as a weekly ritual that established the narrative of the genocide, as codified by law. Perpetrators took on their 'role' of asking for pardon while survivors granted forgiveness. It was mandatory for prisoners to ask for forgiveness as part of the procedure for their provisional release and although victims were strongly encouraged to accept it as part of the national campaign of reconciliation, it wasn't enforced by law. However, released prisoners, in an interview with me on 19 July 2005 in Gaheneri, stated that their guilty pleas were often refused unless they admitted having committed crimes that the officials delegated to them. They felt that although they told the truth, their truth was negated. When questioned about whether reconciliation was possible, the prisoners emphasized the necessity for face-to-face interactions with survivors, to 'tell them the truth, so that the distance between us may end and we can reconcile'.

Yet, the process was often controlled in gacaca as opposed to personal encounters. The gacaca placed the events of the genocide and the bodies of the survivors into an order, either by noting how the genocide was conducted or by determining where bodies had been buried. In this way, there was a weekly reimagining of the events of the genocide and a return to that time and space—scripting a national or collective memory.

Run by government agencies, the gacaca courts were a performative event. Rwandanicity was inculcated on a cell-to-district level and reinforced through the repeated portrayal of state power and the enactment of a 'moral community' in performances of justice, forgiveness and reconciliation.[18] It was a primary means through which the Rwandan government sought to disseminate and instil a new sense of Rwandanicity within the population at large. In describing the mission of the NURC, the Norwegian Helsinki Committee (NHC) claims: 'The Commission's role in the process of creating a Rwanda for everybody is to [. . .] develop a *common identity without differences*' (2002: 11; emphasis added). Rwandanicity was inculcated through both the fictional staged renditions of gacaca courts and the real gacaca court proceedings.

The courtroom itself stages certain roles and scripts and is presented in a theatrical manner. Similarly, gacaca proceedings represent a form of theatre. The perpetrator was required by law to testify his or her contrition for a penalty reduction and the survivor was requested to forgive. Reports from Penal Reform International state that 'in encouraging detainees to confess, emphasis was placed more on the sincerity of the apology than the truth of the confession itself' (2010: 37). During the actual court proceedings, the roles of perpetrators, survivors and witnesses had to be acted out according to the state-driven narrative mandated by law for subject formation. The script for enacting Rwandanicity through gacaca entailed performing pre-ordained social roles of perpetrator, victim and witness along ethnic lines, with the Hutu as perpetrator and the Tutsi as victim.[19]

The public confession helped to perform the role of law-abiding subject in relation to the power of the RPF state. Michel Foucault asserts:

> One does not confess without the presence (or virtual presence) of a partner who is not simply the interlocutor but the authority who requires the confession, prescribes and appreciates it, and intervenes in order to judge, punish, forgive, console and reconcile;

a ritual in which the truth is corroborated by the obstacles and resistances it has had to surmount in order to be formulated; and finally, a ritual in which the expression alone [. . .] produces intrinsic modifications in the person who articulates it (1990: 61–2).

The individual confessions and testimonies of the survivors, perpetrators and community members, through the court sessions, came to be woven into collective narratives as a result of the state-mandated requirements for testimonies presented in the gacaca courts. The perpetrator had to report and perform his or her contrition under the auspices of state power. Thus, the gacaca moulded Rwandanicity through the repetition and inclusion of the state-acknowledged subject.

The long-term effectiveness of the gacaca was predicated on the success of reconciliation performed through forgiveness and contrition, and ran the risk of being undermined if the performance was seen by the population at large to be just an 'act' rather than manifestations of genuine sentiment. In *On Cosmopolitanism and Forgiveness*, Jacques Derrida questions the state construction of forgiveness:

> Each time forgiveness is effectively exercised, it seems to suppose some sovereign power. That could be the sovereign power of a strong and noble soul, but also a power of State exercising an uncontested legitimacy, the power necessary to organise a trial, an applicable judgement or, eventually, acquittal, amnesty, or forgiveness [. . .] You know the 'revisionist' argument: the Nuremburg Tribunal was the invention of the victors; it remained at their disposition to establish the law, judge and condemn, as well as to pronounce innocence, etc. (2003: 59).

He identifies the 'geopolitics' of forgiveness as a construction of sovereignty enacted on an individual as part of juridical procedures for crimes against humanity, stating that:

> [w]hether we see here an immense progress, an historic transformation, or a concept still obscure in its limits, fragile in its foundations (or one and the other at the same time—I would lean that way, for my part), this fact cannot be denied: the concept of the 'crime against humanity' remains on the horizon of the entire geopolitics of forgiveness (ibid.: 30).

The concept of forgiveness can be linked to Judaeo-Christian heritage, thereby conjoining Christian values and political forces.[20] Derrida remarks on the theatre of forgiveness in which religion has theatricalized the act of forgiveness. For the nation state to demand the performance of repentance, the subject must admit to a specific period of the past, in the case of gacaca, the period of 1990–94. Derrida refers to the Nuremburg trials as a performative event, noting that '[t]his sort of transformation structured the theatrical space in which the grand forgiveness, the grand scene of repentance which we are concerned with, is played, sincerely or not' (ibid.: 29).

Like gacaca, the laws require that perpetrators seek pardon and provide confession as a testimony—potentially to promote reconciliation and healing through 'telling'. The confession must be performed to be accepted as part of the juridical requirement. TRC chairperson archbishop Desmond Tutu remarked that, before implementation of the gacaca, he counselled Rwandan president Paul Kagame to implement a system of amnesty instead, supporting restorative versus retributive justice. Tutu describes the delicate balance between forgiveness and revenge in Rwanda:

> I told them that the cycle of reprisal and counter-reprisal that had characterised their national history had to be broken, and that the only way to do this was to go beyond retributive justice to restorative justice, to move on to forgiveness, because without it there was no future. The President of Rwanda responded to my sermon with considerable magnanimity. They were ready to forgive, he said, but even Jesus had declared that the Devil could not be forgiven (1999: 209).

Although Tutu prescribes forgiveness as a necessary ingredient for restorative justice, the term is vague at best. Derrida problematizes 'forgiveness' as a top-down enforcement of contrition for which he has coined the term globalatinization, the spread of Roman Christianity that 'over-determines all language of law, of politics, and even the interpretation of what is called the "return of the religious"' (2003: 32). In accordance with Article 54 of Organic Law No. 16/2004 of 19 June 2004, the accused had to perform their apologies publicly and the quality of their performance determined whether they obtained provisional release or remained in prison.[21] Demonstrations of affective confessions usually entailed standing before the congregated community to ask for forgiveness, providing a detailed

description of the crimes committed, identifying accomplices and sharing or affirming information to determine the whereabouts of bodies that may still be missing. If any of these steps were skipped, the confession was considered incomplete.[22] Rwandans I spoke to acknowledged the risk that less-than-sincere performances of contrition in the gacaca courts could hamper true reconciliation. But some asserted that the performance of reconciliation itself had the potential to heal communities and that the potential for reconciliation could be found within the reiteration of performances of forgiveness and contrition in the weekly gacaca court hearings.

## REHEARSING GACACA

The gacaca courts included theatrical performances or rehearsals as part of a nationwide sensitization and education campaign before the implementation of formal, binding gacaca proceedings. Once gacaca officially became law, there were several implementation phases prior to the actual court proceedings, from sensitization and mobilization to data collection to court hearings. Radio, television and theatre were used to spread the message regarding the upcoming gacaca courts. The data-collection phase included the use of gacaca pilot sessions to create a census-like database of information about the number of households located within that gacaca jurisdiction, information about the members of each household, whether any members were killed in 1994, property looted, persons injured and alleged crimes.

During the sensitization phase from 2001 to 2002, there was little national awareness of the gacaca courts. In an interview with me on 11 January 2005 in Kigali, Johnston Busingye, who was then the secretary general of the Ministry of Justice, asserted:

> Gacaca was something new. Not only new in Rwanda, but new in the world. We did not have a lot of experience from other parts of the world, did not have books to borrow from Europe, from Africa, from Asia to see what to do. So, the government thought, 'Okay, this is a very good thing. Maybe rooted in our own culture. Our culture proves that it kept Rwanda peaceful a long, long time, centuries and centuries when there was no classical justice to talk about. So why don't we try it?' When the government adopted a decision to try it, it also said, 'Let's be very careful, let's put up a control to begin with. Let's start a pilot gacaca, set it up

all over the country, to be geographically spread out.' Gauge: 'Is the system answering the problem? Are people receptive? Do they support it? Will it lead to more and more unity and reconciliation? Will it lead to justice? Will the victims agree or not agree?'[23]

The sensitization phase was designed in part to promote the idea of gacaca as a Rwandan response to a Rwandan problem. Busingye said:

We wanted to allow this genocide—the whole of this genocide issue—to appear like it is a Rwandese problem, created by us, and therefore to be solved by us. Those who were killing were not paid by anybody, they just went from their house and went to kill. Others should also start from their house and start to sort it out, and this is the message that we have been drumming.

The reinvention of gacaca was promoted as a legacy of a precolonial utopian past. But Peter Uvin questions the role of gacaca as a traditional process: 'Why not assume that the "gacaca" appellation is there just to lend a sense of history and legitimacy, an invention of tradition' (2000: 7). Indeed, mass media—newspapers, radio—and theatre, in particular, had been widely used to sensitize, mobilize and educate the nation concerning gacaca procedures and goals. A report on gacaca issued by the NHC states: 'The authorities use large public gatherings to inform and discuss various issues with the people, for example, the gacaca or the new constitution. In addition, information videos and even drama, theatre, art and comics have been used' (2002: 22).

A gacaca play directed by Rwandan playwright Kalisa Rugano, funded by the Rwandan ministry of Justice and Johns Hopkins University, was created for this purpose. It evoked the past, performing the history of the use of gacaca in precolonial times, inscribed with legendary status. It was a communal mechanism that few remembered; it was therefore the retelling, similar to the use of legends, that sensitized the public to the role of gacaca in precolonial Rwanda and its role in the vision of Rwandanicity in the present. In an interview with me on 11 July 2005 in Kigali, Rugano mentioned that the play went on national tour in 1999–2001 to educate the population and help them to rehearse for the upcoming implementation of the courts.[24] It illustrated the gacaca laws through the performance of what a gacaca would look like, the roles of the inyangamugayo, the community as witnesses and the apology of the accused. An evaluation report of the play states:

Persons interviewed are strongly convinced that the theatre requests them to be ready to tell the truth when the proceedings begin (73%). Nearly the total persons questioned think that the theatre is not only for sensitisation, but also educative (88%). The presentation of the theatre will be necessary for transmitting a variety of messages susceptible to bring the population to massively and voluntarily support *gacaca* courts (Ministry of Justice 2004).

The gacaca play toured 10 out of (formerly) 12 provinces in Rwanda. The evaluative sample was conducted with 220 people comprising 54 per cent men and 46 per cent women. The audiences primarily responded to the play by agreeing that the gacaca was created to address the rights of the victims and accused perpetrators by establishing the truth about the events of the 1994 genocide, cell by cell. However, the production did not alleviate fears that those with incriminating information might be murdered or harassed, witnesses might refuse to testify or some people might not tell the truth. These anticipated problems were actually reinforced by the production.[25] While the gacaca play was used for mass publicity, local associations also adopted theatre as a tool for mobilization and sensitization.

I visited seven communities that used theatre as part of the gacaca campaign between July and December 2005. Of those communities, the Rulindo district of the Rusagara sector staged the performance of a gacaca court proceeding in their production *Urubanza Rwa Gasaruhanda Alias Kigomeke* (The Trial of Gasaruhanda Alias Kigomeke).[26] Illiteracy is high in the region, a factor that enhances the utility of theatre to illustrate the procedure of the gacaca. In an interview with me on 13 July 2005, the gacaca district coordinator of Rulindo stated that Rusagara is one of the 1,500 pilot gacaca sectors and observed that 'theatre has had a good effect on sensitization and participation in this area. Many people come to watch. We have had a very big number of guilty pleas here as a response to the play, a large percentage of confessions.'

## GACACA DRAMA: *URUBANZA RWA GASARUHANDA ALIAS KIGOMEKE*

The performance of *Urubanza Rwa Gasaruhanda Alias Kigomeke* on 13 July 2005 began with the community sitting on a hill. A large wooden desk was placed in the middle of a clearing; the audience was seated on a slope facing the performance area. Several benches were placed facing the

inyangamugayo's table, with one bench directly in front and two on either side, creating an open square formation.

The actor playing the role of the district coordinator addressed the audience directly, stating the objectives of gacaca and the community's responsibility to tell the truth about what they had witnessed during the genocide. Then eight inyangamugayo entered in single file (initially nine inyangamugayo were required for court proceedings; later it was reduced to seven). They wore sashes of the same colour and design as the national flag and with the word inyangamugayo across their chests. The inyanga-mugayo actors consisted of two women and six men.

When the actors reached the inyangamugayo's table, the audience was asked to stand for a moment of silence for those who had died during the genocide. After a moment of silence, the secretary of the court stood up to read the case file for Alias Kigomeke. The actor playing the accused was called to the table.

One witness from the audience (an actor who was planted in the crowd) stated that she saw Kigomeke killing the victim Bugingo, but Kigomeke denied all charges. Several other actors in the audience testified as witnesses that they saw Kigomeke kill Bugingo, but Kigomeke denied each accusation, stating that the reason the witnesses testified against him was to get his land.

The inyangamugayo took a recess to deliberate. Although in actual time the verdict could be delayed a few hours, until the following week or until additional evidence was gathered, in the staged version, the inyanga-mugayo returned after a few seconds. They referred to several articles in the gacaca handbook of Organic Law No. 16/2004 of 19 June 2004. The verdict was read, sentencing Kigomeke to 26 years in prison because he did not confess to his crimes and because he had looted. Kigomeke was informed that he had 15 days to appeal the decision. The play concluded with the inyangamugayo exiting in the same manner as they had entered.

These grassroots plays were a rehearsal for the actual gacaca courts.

RADIO, TELEVISION AND THEATRE: MOVING THE MASSES

Media was used to spread propaganda, hate slogans and instructions for killing during the genocide. As illiteracy rates were high, radio was the

medium of widest reach and it became the primary source of news and the voice of authority for most people.

Radio Télévision Libre des Mille Collines (RTLM), popularly known as the Hate Radio in Rwanda, broadcast from 8 July 1993 to 31 July 1994, received support from the government-controlled Radio Rwanda. RTLM is regarded to have played a significant role in creating racial hostility by promoting racial propaganda against Tutsi and Hutu moderates. Alison Des Forges notes its role in the initial phases of the genocide:

> A large number of Rwandans could not read or write and, as a result, radio was an important way for the government to deliver messages to the population. [. . .] In March 1992, Radio Rwanda was first used in directly promoting the killing of Tutsi in a place called Bugesera, south of the national capital. On 3 March, the radio repeatedly broadcast a communiqué supposedly sent by a human rights group based in Nairobi warning that Hutu in Buge-sera would be attacked by Tutsi. Local officials built on the radio announcement to convince Hutu that they needed to protect themselves by attacking first. Led by soldiers from a nearby military base, Hutu civilians, members of the *Interahamwe*, a militia attached to the MRND party [Mouvement républicain national pourla démocratie et le dévelopement], and local Hutu civilians attacked and killed hundreds of Tutsi (International Commission 1993: 13–14; cited in Des Forges 2007: 42).[27]

After the genocide, radio and television have been used (in addition to theatre) as a method of sensitization and mobilization of the people for gacaca. The radio station La Benevolencija has been used to broadcast messages about reconciliation and to address issues concerning trauma healing and the roots of evil (how violent acts evolve and can be stopped before they escalate into large-scale violence). La Benevolencija started in 2002, and, on the basis of the work and theories of Ervin Staub and Laurie Ann Pearlman, put educational messages into radio format, broadcasting twice a week. Staub and Pearlman define reconciliation as:

> [a] change in attitude and behaviors toward the other group. We define it as mutual acceptance by members of groups of each other, and the processes and structures that lead to or maintain that acceptance. While structures and institutions that promote and serve reconciliation are important, the essence of reconciliation

is a changed psychological orientation toward the other. Reconciliation implies that victims and perpetrators do not see the past as defining the future. They come to accept and see the humanity of one another and see the possibility of a constructive relationship (2006: 214).

At a conference I attended in Kigali on 1 September 2005, conducted by La Benevolencija, Johan Deflander, who was then the head of mission, stated that, following a workshop with academics regarding trauma and methods to prevent further violence in 2004, a new programme would be used during the gacaca proceedings for both perpetrators and survivors to promote respect for human rights. During the conference, attended by academics, NGO/IO representatives and Rwandan government representatives, several comments and questions illustrated the multiple expectations of the people from gacaca. One speaker emphasized the right to truth, the right to memory and the right to reparation and compensation through gacaca as a site for commemoration: 'Rwandans must come to the gacaca for commemoration and memory. Some think that in 1959, we did not commemorate. Some say that there were those killed by the RPF, but we did not commemorate those deaths. It is a social wound in our society.' Several questions from the audience concerned the right to memory—whose right? How does the right to memory affect the accused?

The right to memory during the gacaca proceedings has been granted solely to individuals who testify to crimes committed against Tutsi. For reconciliation to be achieved, RPF war crimes and injustices enacted through gacaca must eventually be brought into the official discourse and acknowledged. However, at the time of writing, this goal has not been achieved through either sensitization campaigns or official discourse.

Television broadcasting was also used to promote the upcoming gacaca courts. Rwandan artist Hope Azeda developed the screenplay *Ukiri Kurakiza* (*The Liberating Truth*) for television in 2002. During the initial writing period, Azeda worked alongside the Ministry of Justice and Johns Hopkins University to develop the storyline.

'It contains one particular story in which a young girl goes back to school and suffers from flashbacks [about] her teacher, potentially a perpetrator of crimes against her parents. She can't focus or study because of the repetitive violent mental images and nagging doubt. She continues to

have flashbacks until the truth is revealed.' The Ministry of Justice directed Azeda to collect 'real life' stories from the public. She visited prisons, genocide survivors, widows of genocide victims, elders and youth so that everyone had a voice in the process. Another story that evolved from meetings with Association des Veuves du Genocide (AVEGA; Association of genocide widows) was about a girl who was traumatized because her teacher had a birthmark she recognized and every time he called on her in class, she had flashbacks.

Gacaca hoardings across the country advertised the slogan 'Tell what we have seen, admit what has been done, and move forward to healing.' The images on the national hoardings were from *The Liberating Truth*, depicting a wide-eyed (traumatized) woman and collages of a man whose hands are collapsed over his head (perpetrator), a schoolroom and a gacaca assembly, in the backdrop of a fire. In Jenny Hughes' interview with Azeda, conducted for the In Place of War project on 14 April 2005 in Manchester, UK, she described her screenplay as being focused on the legacy of violence and the negotiation of truth:

> The woman with the strong eyes—that is the genocide survivor. It's everywhere in the country [the hoarding], so I think that was the most powerful, emotional bit I did. You know that has some real big percentage of truth because my story began with the traumatized girl at the association. In school, it's not only a child who is a survivor. It's also a child of a criminal. But they're in the same classroom. And both children are totally innocent. You know? Their parents did the crimes, not them. But they're implicated, they're victims. [For example] Angela is being isolated and people are [saying] 'Her father is a killer, her father killed.' There is that society of children. They live it and they're totally torn apart by a situation that they never even [created]. You see? So that's why I built the story round it because I wanted every view to be represented.

Azeda also described her experience as a Rwandan refugee living in Uganda until after the genocide, when she returned to Rwanda in 1998. Her two brothers were part of the RPF. Azeda stated that she used drama as a tool to understand what her brothers were going through and what had happened to Rwanda—the ethnic divide among Tutsi, Hutu and Twa. One of her first productions, *Amashiyiga ya Sehutsitwa* (Firestones of

Sehutsitwa—a made-up word that combined the three ethnic groups), was based on three brothers and drew from the analogy of three firestones and how they need each other to support the cooking pot. The play focused on issues of conflict and mediation. She took the production from Makere University in Uganda, where she was studying, to Kigali as a vehicle to facilitate discussion and debate about the genocide and reconciliation.

After the genocide, Azeda worked for the National Office of Information as the artistic director for the drama section of Radio Rwanda and for the NURC's civic education department. When asked by Hughes about whether drama could be used to discuss sensitive or controversial issues about gacaca, Azeda stated:

> It is a controversial and sensitive issue. That is why drama should be used. It is the role of drama to ask questions, to probe. Drama drives reconciliation. My work with the reconciliation commission was to make people feel as if reconciliation is a natural thing. There were some feelings of my work being compromised or being ethically challenged because I was asked by donors and government officials to change this or that, even if I didn't agree with it. In this way, I've had some problems with my work as an artist working for a donor agency or for the government.

However, Azeda continues to negotiate between official discourse and opportunities 'to discuss issues, to probe'.[28]

To illustrate an instance when theatre was used for debate and discourse, here I give an overview of a workshop on gacaca that I conducted with Azeda.

In 2005, I was invited by the Kigali Institute of Science and Technology (KIST) to give a public lecture. On arrival, I was introduced to several theatre practitioners including Azeda, with whose company, the Mashirika Creative and Performing Arts Group, I subsequently collaborated to explore the use of theatre in a post-genocide context. We exchanged theatre-making techniques in a workshop with company members before determining what contemporary issues could be addressed with interactive theatre in the public lecture at KIST, hoping to include participatory theatre as a vehicle for debate. The workshop focused on gacaca, devising various images that displayed the limitations of gacaca in promoting justice and reconciliation. The use of Image Theatre in Rwanda provided the opportunity for

participants to share responses to gacaca without the potential threat of soliciting genocide stories. The final performance of the images devised by Mashirika members was staged during the KIST public lecture on 20 January 2005, which was attended by university students and lecturers, members of the general public and representatives of the NURC and the SNJG. The audience responded to the images that reflected the problems of gacaca with potential solutions, physically sculpting the 'real' issue or problem to the 'ideal' version followed by a critical discussion of what would need to happen at the government, community and family level for the solutions to be implemented. This first scoping exercise illuminated some limitations of theatre-making in Rwanda, including questions regarding freedom of speech, retraumatization through theatre and transferability of practitioner skills and training.

So far, I have discussed how theatre, radio and television were used to sensitize and educate the population about the upcoming gacaca courts. In the next section, I describe in detail an actual gacaca court proceeding, noting in particular how there may be little aesthetic difference from the fictional staging of gacaca. It is interesting to see through this how the real and the fictional overlap.

## GACACA COURTS: THE TRIAL OF RICHARD MAJYAMBERE IN KIGALI

The gacaca court session of Richard Majyambere, on 23 July 2005 in Rugenge, Nyarugenge district of central Kigali, helps us to analyse the performative aspects of gacaca court proceedings. The trial was held outdoors, under a tin-roofed open structure with wooden benches. When I arrived, the local community members had not yet congregated. Two female prisoners in pink prisoner uniforms sat on a side bench. Several inyangamugayo were present, reviewing the court cases prior to the arrival of the public.

In an interview with me on 23 July 2005, the vice president of the gacaca in that sector stated that the sector trials had begun on 15 March 2005 following the operation of data-collecting pilot courts that had begun in Nyarugenge in 2003.

While the inyangamugayo in most gacaca courts had received limited training (generally a total of four days of instruction), the inyangamugayo in the Rugenge sector had completed three training phases: one included observation of several best-practice gacaca court proceedings and the other

two were based on data collection.[29] As revealed during my interview with the inyangamugayo on 5 November 2005 in Nyarugenge district, the SNJG praised the Nyarugenge court proceedings for demonstrating exemplary skill in retrieving information from the public and conducting trials according to the ordained gacaca laws.

Nyarugenge is located in an area known for several massacres, including a large one that took place over several days at the centrally located Sainte-Famille Church. Lead conspirators of the genocide have been tried in the Nyarugenge gacaca courts, including a major general and an individual who single-handedly killed over 160 people.[30] The real-time scenario of a gacaca court set forth below and descriptive notes of the proceedings provide a detailed account of how an actual trial is conducted. Themes emerge that contrast the scripted narrative of the gacaca plays with the real-time staging of a gacaca. The following timeline documents events as they unfolded in the trial of Majyambere:

09.40   Inyangamugayo enter and read Article 54 of Organic Law No. 16/2004 of 19 June 2004.

09.50   Prisoners stand when their names are called.

09.55   Audience members rise for a moment of silence.

09.57   Majyambere stands before the inyangamugayo and charges against him are read out by the secretary.

10.00   Prisoners who will testify against the accused are led out of the courtroom by a guard, to be called back in later to testify.

10.20   Majyambere is questioned by the president of the gacaca.

11.20   The inyangamugayo question the accused.

11.43   The first prisoner as witness is called to the table to testify against the accused.

12.05   The second prisoner as witness is called to the table to testify against the accused.

12.14   The first community witness provides testimony.

12.21   The second community witness provides testimony.

12.25   The third community witness provides testimony.

12.29   The fourth community witness provides testimony.

12.48   The fifth community witness provides testimony.

12.49   The sixth community witness provides testimony.

12.50   Majyambere responds to accusations.

12.54   The seventh community witness provides testimony.

12.59   The third prisoner stands and asks about his release (his trial was not heard on that day).

13.00   Majyambere stands before the court and the secretary reads the minutes of the trial.

13.10   Majyambere says that he has nothing to add and puts thumb-print on the document. The inyangamugayo deliberate.

13.27   Audience stands. The verdict is read.

The defendant, Majyambere, was found to have been a member of the interahamwe. In a previous court hearing, he had confessed to several killings and had been brought back to court to admit to other crimes found to have been omitted from his former confession.[31]

The perpetrator was brought before the table, his body bent slightly forward in an apologetic stance, shrinking from his natural large build. The secretary read out several articles, including Article 54, stating the requirements for the acceptance of the guilty plea.

The secretary read the first guilty plea of the perpetrator, received on 15 April 2003 (i.e. 27 months ago). It included the names of killers who hunted down the victims, the names of the people killed by Majyambere and the sequence of events. This was followed by the second guilty plea that included crimes he had forgotten in the first confession, among them the killing of François Kirezi, his participation in looting goods and information regarding the death of Kirezi's wife whose body had recently been discovered. According to Majyambere's testimony, the interahamwe had taken Kirezi's wife to the roundabout. Fidel, nicknamed Kisiteri (Hero), a member of the militia, had instructed Grorise, a passer-by whose race they were unable to identify, to beat up Kirezi's wife to death with a stick to prove he was Hutu, which Majyambere alleged he proceeded to do. At this point in the reading of the guilty plea, Majyambere asked for forgiveness and added an alias for one of the killers—Satan. The audience laughed at the irony. Majyambere confessed responsibility for the deaths of several others, including a lecturer from the National University of Rwanda. The confession or guilty plea had not been accepted in the first court hearing because Majyambere had left out the names of accomplices.

A question-and-answer session between the president of the gacaca court and Majyambere ensued to verify the contents of relevant court records; Majyambere's date of birth had been incorrectly recorded in the original documents.[32] The inyangamugayo questioned Majyambere directly, as is common in the gacaca courts.[33]

Majyambere had joined the army in 1993. Cases involving allegations of genocide against soldiers fell within the jurisdiction of military courts. Therefore, one complication in the case of Majyambere was that he had joined the interahamwe while being enlisted as a soldier and a member of MRND. The president of the gacaca court requested that Majyambere provide an account of how he became a part of the interahamwe and whether he worked as a soldier during the genocide. During this period of the inquisition, the president attempted to retrieve information to verify whether Majyambere should be tried by the high court or at the gacaca court.

At the same time, Majyambere provided a detailed account of his actions during the genocide:

> In January of 1994, I was shot in the leg by a co-soldier because of conflict over a Tutsi woman. I got in[to] a fight with someone from my group who wanted to rape a woman. I defended her and was shot in the leg. My nephew Sylveste and other militia members told me to join the interahamwe. When they went to the interahamwe leader Angelina, she told me that I must stay with the militia. I told her that I can't work for them, that I must ask permission from the Kigali Army camp, from Sagahutu who is now in Arusha. I went to the barracks to get an identity card as a soldier. I wasn't given the gun, but had the gun already. When I joined the interahamwe, I didn't join in the work right away because my leg wasn't healed. I was an accomplice, not one of the main leaders.

One of the inyangamugayo interrupted the testimony by asking whether Majyambere had participated in the massacre at Sainte-Famille Church. Majyambere admitted to being a part of the killing after the RPF had left the scene; he had sought out and killed those who remained in hiding. Following a series of questions regarding particular individuals, Majyambere either denied or agreed that the individuals in question were accomplices. The inyangamugayo frequently addressed the audience for verification of his testimony. For instance, Majyambere denied killing a victim named Toto. The inyangamugayo requested the audience to remind Majyambere

how he knew Toto. A community witness stated that Toto came from an area near where Majyambere lived, and so the latter must have known of him. But Majyambere insisted that he was not lying and did not know Toto.

The inquisition continued with the inyangamugayo asking Majyambere if people were killed or burnt in the houses he had set on fire. Majyambere replied in the affirmative. One of the inyangamugayo asked Majyambere whether he was on the front line as a soldier before joining the intera-hamwe. Majyambere stated that he had not fought on the front line but that, in 1993, the year before the nationwide slaughter, he had 'practised' genocide with the army in areas including Ruhengeri and Kigali Ingali. He said that in 1993, the army, having been informed that an imminent Tutsi invasion posed a grave threat to national security, was already rehearsing how they would do their 'work' through initial massacres con-ducted before the mass implementation of the genocide.

Several witnesses, including prisoners, were called to testify. Many discrepancies emerged in their testimonies, including a report from one prisoner that he had originally been released from prison as a soldier but was arrested again for not carrying a driving licence. The prisoner's record stated he had been incarcerated as a génocidaire and had never been released. Another prisoner stated that people were being killed for giving their testimonies, so he had privately testified to the prison director. These two prisoners were cautious about the information they provided, appar-ently fearful of Majyambere's revenge. However, a third prisoner stood in opposition. He stated:

Before, if you tried to tell the truth, they would kill you. They would use poisons that relatives would bring in the food to kill you. Now, it is not as frequent. I have the heart to tell the truth, but there are two groups, one that wants to ask for forgiveness and to tell the truth, the other that doesn't. The group that wants to speak the truth would hide themselves from others. Now, it is the opposite. Those who don't want to tell the truth hide and are ashamed.

It is worth noting that this third prisoner regularly attended that gacaca court, providing eyewitness accounts to crimes.

The script of the actual gacaca court varies from the gacaca play in multiple ways. Unlike the harmony and ease with which the gacaca play

depicted the offer of a confession by the accused and the acceptance of the same by the inyangamugayo, the inquisition 'performed' by the inyanga-mugayo in the real gacaca court setting deliberately searched for inconsistencies in the guilty plea, demonstrating the tension between the defendant's testimony and the inyangamugayo's judgement of authenticity. The gacaca courts I observed consistently and repeatedly sought details from defendants about names of all co-conspirators and where bodies remained buried, as part of the guilty plea. The court case of Majyambere illustrates how geno-cide crimes were dealt with differently, depending on whether the defendant participated in the genocide as a member of the interahamwe or the army, reveals tensions during the genocide among Hutu militia members, provides historical accounts of where and when crimes were committed and highlights the role of the community in providing testimony. Other variations between the gacaca play and the gacaca trial include issues of compensation.

The Majyambere case concluded with the inyangamugayo requesting survivors to seek compensation. A widow requested compensation for her husband who was killed by Majyambere. She sought 7 million Rwandan francs for each of her five children. Her husband had died at the age of 40, earning a monthly salary of 57,000 Rwandan Francs. She requested his salary be paid for 15 years (i.e. 57,000 x 12 x 15) plus an additional 5 million per child, calculated at a request for compensation of 35,280,000 Rwandan francs.

An old woman stood up to claim that, unlike the widow, she could not calculate the worth of her son. She stated that her son would take her to the hospital, fix her house and work for her. 'I don't know how to count his worth for compensation, so the court will have to decide. I have still not recovered his body.' The president of the gacaca court claimed that the old woman's son was dumped into a ditch. 'Those bodies have been taken from their graves and put into a memorial.'

A community witness stood up to ask how his relatives had been killed. The inyangamugayo replied that after the RPF had rescued some people from Sainte-Famille Church, the génocidaires killed the remaining 186. The inyangamugayo asked whether there were any more compensation requests and stated: 'You cannot ask for any kind of compensation during the genocide. It can only be from those who were hunted down and killed, the Tutsi, not just those killed in the war.' He then read from Article 34, Organic Law No. 16/2004 of 19 June 2004: 'A victim referred to is anybody

killed, hunted to be killed but survived, suffered acts of torture against his or her sexual parts, suffered rape, injured or victim of any other form of harassment, plundered, and whose house and property were destroyed because of his or her ethnic background or opinion against the genocide ideology.'[34]

The secretary read the minutes of the court session and Majyambere was asked to put his thumbprint on the document. The inyangamugayo convened for 17 minutes and returned to deliver the final verdict. The president took off his glasses and wiped his brow before stating:

> Richard Majyambere was nicknamed 'Lion' because he was such a fierce killer during the genocide. First of all, he is condemned for being a part of the interahamwe. Secondly, he was involved in the killing of an estimated 70 Tutsi in Sainte-Famille. The militia stole a lot of money, including dollars. The gacaca law says that a soldier cannot be tried in the gacaca courts. Majyambere must be tried in the court of the army, which he will be sent to. According to this court, however, Majyambere [will be] charged as Category One stated in Article 51, Organic Law No. 40/2000 of 26 January 2001.[35]

The court session of 23 July 2005 ended with the inyangamugayo walking in single file back to the district office, gacaca law booklets in hand. The prisoners were put into the back of a pickup and returned to Kigali Central Prison. The community members slowly dispersed down the surrounding dirt tracks.

In this gacaca session alone, inconsistencies were evident in information that could be contained and controlled by the government as scripted in the gacaca plays and the actual gacaca proceedings. There were moments of rupture from the state rhetoric and narrative accounts—a prisoner asked for release from unlawful detainment and spoke out against human rights violations in an open forum;[36] the widow calculated the economic loss of her family due to the genocide, bringing into debate issues of compensation and reparation; and the old woman relayed the inability of gacaca to replace the emotional loss owing to her dependency on her son, the case raising issues of illiteracy and inadequate support for those widowed or stranded. Majyambere provided an account of the Hutu government's role in the genocide, including the rehearsal for the genocide as an army soldier of the MRND. Another survivor requested information about how his

family had been killed when the RPF arrived. It emerged that, often, families sought bodies of kin for burial, only to discover that they had already been buried in mass memorial graves. Personal acts of memorialization and commemoration, therefore, were co-opted by government campaigns, with or without the consent of the families concerned. From these examples, it is evident how multiple narratives are possible within a gacaca court session, and it is important to note that these narratives frequently differ from the overriding and tightly controlled government scripts.

## TROPES OF POST-CONFLICT SOCIETIES: ·TESTIMONY, JUSTICE AND RECONCILIATION

In subsequent sections, I present examples of gacaca in the villages of Gaheneri, Cyarwa and Gahini with a few variations of what might happen at a gacaca in a particular region under particular circumstances. There are differences in the participation and adjudication of gacaca based on local-level variations. Phil Clark remarks on the ability of gacaca to foster discursive community relations, allowing local communities to own the process, thus opening up debate and discourse otherwise controlled by judges that dominate the experiences and perspectives of the community members: 'Survivors in particular can ask questions directly of those who committed crimes, which rarely occurs in more conventional legal settings, and the accused are permitted to respond. Judges may also hear evidence in an open, communal setting that they would not necessarily glean [from] if they were limited to hearing testimony only from witnesses whom they had called' (2010: 164). The benefits of open discourse are directly related to the regional contexts of where the genocide was enacted and gacaca courts adjudicated. Through my research I have observed how grassroots associations foster community interactions and collaborations between survivors, perpetrators and community residents at large, which enhances 'truth telling' and participation in gacaca courts (see Breed 2006).

The following three subsections describe case studies of gacaca courts I attended, highlighting a trajectory of cases emphasizing the role of gacaca in (1) encouraging *testimony*; (2) promoting *reconciliation*; and (3) triggering, inadvertently perhaps, *incrimination*. The isolated events compare and contrast approaches adopted by local communities to negotiate the gacaca laws in various regions, fostering dialogue and ultimately passing judgement on the accused. What do these courts perform? How do they relate to the

overall performance of a national, unified identity? I explore these questions in terms of additional themes that emerge in the performance of gacaca, including performances of forgiveness and reconciliation, of victor's justice and of nationalism. Although complexities are numerous and isolating a few arguments from a handful of case studies does not address how and to what extent the gacaca can be analysed, it does offer a few potential frameworks to illustrate the performativity of the gacaca court sessions.

## GAHENERI GACACA: TESTIMONY

While the potential benefits of testimony for healing have been well documented in the context of the TRC in South Africa, the impact of testimony in the gacaca courts differs considerably. Each citizen is requested to appear in the weekly court proceedings under penalty of law and is obligated to provide any information he or she may have concerning events that took place during the genocide. Thus, an individual's inclination to speak or not to speak, to remain silent or to testify, is not left to free choice under official government policy, although some inevitably elect not to speak even when doing so is punishable by law.

The experience of Seraphine, a trauma counsellor from Gaheneri, is illustrative of the virtues of testifying. Seraphine claimed she had never told her story for fear of being retraumatized. Her story unfolded during my interview with her on 19 July 2005 in Gaheneri. Seraphine had been left for dead under a blanket of corpses and had escaped with her son into banana fields. Eventually, she was discovered and taken to the head of the militia in her area, a former classmate. Although a notorious killer, he spared her life and put her in hiding. While in hiding, she drank her own urine and ate dirt to survive. At one point during the interview she began rocking, fleetingly going back to a particular moment of the genocide. After the interview, she related that she had been retraumatized in narrating her story, yet the telling of the story itself made her feel stronger and more in control.

Advocates of testimony for healing link telling to therapeutic catharsis. In the case of trauma, in which events are shattered into broken narratives, the voicing of the story in a linear structure may provide the physical distancing of the body necessary for healing. Jason Tougaw argues that the unspeakable must be made speakable through narration: 'Trauma, by definition, defies parameters of "normal" [. . .] Testimony provides trauma

with its missing narrative (beginnings, endings, befores, durings, and afters), with conventions all of its own to organize and explain what defies social conventions' (2002: 171). However, there is a difference between producing testimonies of one's volition as opposed to those resulting from judicial obligation. In the case of Rwanda, testimony may in some cases be more of a 'violation' than a channel for healing.

In contrast, an inyangamugayo of the same district, who had lost 20 members of his family during the genocide, stated, in an interview with me on the same date, that repeating his testimony in the gacaca trials had not relieved him of either psychological or physical unease; just as he had long been unable to eat or sleep before testifying at the gacaca court, he continued to suffer from lack of appetite and insomnia. Indeed, he claimed that the telling of the event had worsened his condition. Subsequently, he was asked to provide additional testimonies for case files against other accused perpetrators. Each time, the pain resurfaced. He explained that 'when the survivor tells, he is suffering too much.'[37]

The requirement to provide testimony under legal mandate, rather than for personal or national catharsis, illustrates a considerable difference between the TRC and the gacaca court. Whereas the TRC has sought to promote reconciliation through the Christian premise of forgiveness articulated by Tutu, gacaca has been recognized as a precolonial and traditional Rwandan practice for mediation.

Gacaca court proceedings gave order to the events of the genocide, noting how the genocide was conducted and where bodies were buried. In an interview with me on 11 April 2006 in Kigali, Jeanne Mukamusoni, who was then the psychosocial and medical programme officer of AVEGA, stated that one of the reasons for trauma in Rwandan culture stems from the number of victims' bodies that have never been recovered. 'When you don't bury your relative, then he comes back to your mind,' she said. 'According to tradition, one solution is to build a shrine and put food on the shrine, then usually the trauma diminishes.' According to Mukamusoni, the other solution to ease trauma is to find the bones of the dead. To this end, requiring the guilty plea of the perpetrators to include all available information pertaining to the location of bodies they disposed is quite significant.

In the same interview, she noted that 'the psychological state referred to as trauma has been in Rwandan culture prior to the genocide.' Treatment has traditionally been administered by the *abavuzi ba gihanga* (Rwandan

healers), who are called upon to mediate between the physical and spiritual realms. Thus, Western analysis of trauma and systems for community relations (including gacaca) may not be sufficient when strictly adhering to international norms, which may in some cases negate cultural practices.

CYARWA GACACA: RECONCILIATION

The gacaca trials provided an opportunity for the community to fulfil multiple roles including those of accusers, defendants, witnesses and judges. These roles varied according to the dynamics of each community and the individuals who participated in the gacaca court proceedings. Variation in rates of participation may have been based on how the genocide unfolded in that region, the number of survivors, the number of accused, the number of refugees who returned as well as whether or not sensitization and mobilization campaigns were successfully implemented in the region.

At the information-gathering session I attended in Cyarwa on 14 September 2005, a boy came forward to state that one of the recently released prisoners was spreading genocide ideology. In self-defence, the released prisoner remarked that he did not say '*all* Tutsi are bad' and retaliated by claiming that his fellow villagers had mistreated him when he had returned to the community. Several survivors had asked him why he had not confessed to killing their relatives, blaming him for all the deaths in the village, although he had steadfastly maintained his innocence in the face of the new accusations. One survivor, who had supposedly saved over 1,000 members of the community during the genocide by taking them across the Burundi border, came to his defence. The survivor preached tolerance, maintaining that the villagers must accept the released prisoner and understand that even if the accused had said all Tutsi are bad, it may have been because of mistreatment after spending 12 years in prison. The survivor suggested that the released prisoner should visit people's homes to promote reconciliation and goodwill. Several audience members nodded in agreement.

In this case, the accusation could have prompted further vengeance and division in the community but the survivor's intervention contributed to reconciliation. Although this particular situation prompted a survivor to stand in defence of the accused for justice to include reconciliation, the act required extraordinary courage. The gacaca as a forum provided the opportunity for the demonstration of empathy, but this was dependent on the

personal sense of responsibility and commitment of individual community members. This particular instance highlights the role survivors can play in rebuilding communities. However, placing such responsibility solely on survivors to ensure justice and reconciliation may be too great a risk.

The responsibility for the balance between vengeance and forgiveness lies not only on the national gacaca system but also on each individual. Minow defines vengeance as 'the impulse to retaliate when wrongs are done' and forgiveness as 'a response far from vengeance [. . .] forgive the offender and end the cycle of offence' (1998: 10–14). The balance between vengeance and forgiveness is difficult to negotiate in Rwanda since the gacaca system requires the perpetrator to seek forgiveness and this act of apologizing is therefore driven by the state and may not necessarily prompt remorse. Minow states: 'Forgiveness is a power held by the victimized, not a right to be claimed [. . .] To expect survivors to forgive is to heap yet another burden on them' (ibid.: 17). In this way, the state mandate of forced contrition and forgiveness may impede the healing and reconciliation process. However, establishing shared suffering and contributing towards a community can build alliances between perpetrators and survivors to end the cycle of violence. I discuss this further in Chapter 4.

GAHINI GACACA: INCRIMINATION

The gacaca session I attended in Gahini on 25 October 2005 exhibits how a witness can be incriminated while testifying. A potential reason for not speaking out in the gacaca courts was that further accusations could be made in retaliation to the initial allegation. Article 95 of Organic Law No. 40/2000 of 26 January 2001, established on 15 March 2001, originally protected bystanders who provided testimony of genocide crimes: 'Testimony made on offences of the crime of genocide and crimes against humanity committed between October 1, 1990 and December 31, 1994 can never serve as a basis to take proceedings against its author charging him with the offence of failure to render assistance.' However, Article 95 was deleted from the subsequent Organic Law No. 16/2004 of 19 June 2004, exposing bystanders who testify to potentially be charged as accomplices, for not rendering assistance. The inability to provide testimony anonymously might have promoted vengeance from families or friends of the accused towards those who stood as witness to the crimes. Once a case file had been charged against an individual, it was often difficult to fight. As stated during the

gacaca trial according to Penal Reform International (2010), gacaca defendants have been systemically denied the space to prepare for their defence, either in the actual legal documentation of each defendant's case file or during the gacaca hearings:

> Firstly, in order to facilitate the work of gathering information, the new data collection forms being used contained no space to record testimony for the defence [. . .] As a result of this and other measures designed to speed up the process, defendants faced an uphill struggle in trying to defend themselves. This was one aspect of the damaging impact of the gacaca system on the right of the defendants to a fair trial, and the erosion of the principle of presumption of innocence (ibid.: 28).

I attended several gacaca sessions in which members who gave testimony one week were accused in following sessions. The accused stated their crimes and admitted to: the category charged, sites where the bodies were buried, being a part of the interahamwe and killing people in the hospital where large numbers of Tutsi had sought protection. One perpetrator was asked who was with him when he committed the crimes. He looked out into the sea of onlookers and said: 'I [cannot] tell you who was with me. The number who attacked was about three times the number here today.'[38] Witnesses were called to give testimony. One woman, who worked as a bread-seller in a kiosk, was asked to come forward. After questioning her about the accused, the inquisition suddenly turned to her whereabouts during the time of the genocide. She denied seeing any of the crimes at the hospital but several community members noted seeing her on the premises. Cross-examination by both the inyangamugayo and the community witnesses sought to uncover why she would be at the hospital unless she had been a perpetrator. One of the inyangamugayo took off his sash and testified, then put his sash back on and continued with his inquisition. The trial eventually turned its focus to the original three perpetrators but a file was added for the woman. One of the witnesses said: 'I am worried about someone being called upon as a witness if now she is being questioned as someone who participated.'

Janine Natalya Clark poses the limits of trials when collective crimes become individualized:

> Can guilt ever, therefore, be truly individualized? If trials are necessarily selective, can the guilt that is individualized ever be

complete and comprehensive? If not, can it dispel allegations of collective guilt? The second and perhaps more important issue is the moral question of whether it is appropriate to focus on individual guilt and responsibility when wide-scale crimes have taken place. Is individual responsibility not a 'questionable' concept when applied to large-scale atrocities like the 1994 genocide in Rwanda, which required participation on a vast scale? (2009: 472)

Gacaca proceedings could easily slip from being acts of testimony to incrimination without evidence. Moreover, they had the potential to heighten vengeance and community hostility rather than cultivate reconciliation. Justice could be situated in a delicate balance between vengeance and forgiveness. Minow states: 'Perhaps justice itself "partakes of both revenge and forgiveness"' (1998: 21). In the case of the gacaca courts, there was a possibility for both revenge and forgiveness depending on the state, community and individual.

MAPPING ATROCITY

On our way to a gacaca pre-trial in a remote village in 2004, the driver asked a local resident for directions. The man on the street stated that he didn't know where the gacaca was located: 'Gacaca? I have no job. How am I supposed to go to gacaca? Do you have a job for me?' We found the gacaca located on the grounds of a primary school. Residents of the village were already gathered in front of a wooden table facing the inyangamugayo. Many of the residents shaded themselves from the sun with large colourful umbrellas adorned with images of Kagame. Systematically, the inyanga-mugayo collected data about each household in the cell. The president called out names, to which the residents responded with either 'alive' or 'dead'. Often, pointing to different houses or locations in the surrounding areas, residents provided information about those who lived in the village, those who fled to neighbouring countries following the genocide and those who were killed during the genocide.

Gacaca courts were held locally, most often near the actual sites of genocide crimes. The court proceedings were carried out week after week until the culmination of the gacaca courts. The narration of events through gacaca was intended to create a map of the local area, describing in detail through court testimonies how events transpired, thus creating a collective

memory of the genocide.[39] However, the selective narration of events scripts a particular history, commemorating and memorializing events pertaining to crimes isolated against the extermination of Tutsi. Heidi Grunebaum-Ralph warns against selective memory:

> The containment of a particular history and its emplacement therefore inaugurates a temporal trajectory that is predicated on a before and an after and, hence, excludes those stories that would attest, rather, to individuals' and communities' ongoing struggles with socioeconomic survival, community conflict, trauma, rage, and despair (2001: 200–01).

The exclusion of RPF crimes against Hutu denies the grief and personal narratives of other victims outside gacaca law, which may impede reconciliation. Sarkin provides examples of why the Hutu population at large may resent the gacaca system in light of a legacy of alleged human rights violations falling outside the timetable and jurisdiction of gacaca, including 'ethnic oppression, sixty years of colonial rule, Tutsi rule, and previous massacres perpetrated against them in Rwanda and in neighboring Burundi' (1999: 773).

Considering how the gacaca courts were used to stage nationalism and imprint a particular history, gacaca proceedings at times provided microcosmic illustrations of reconciliation but inevitably linked gacaca to potential concerns that the courts might ultimately work more to fuel renewed conflict than to aid reconciliation. In this case, justice and reconciliation may not go hand in hand. In my interview with Gasibirege on 29 October 2005 in Butare, he stated that forgiveness is a cultural rather than a legal imperative:

> If you go to gacaca, there is an emphasis on confession, to accept that you are guilty. In the law of gacaca, it's important that a person who confesses explains what they have done. After that, he asks pardon from the victims. If in the law of gacaca they share pardon—forgiveness—it is not because it's written in common law but because it's important in Rwandan culture.

Gasibirege's comments reflect some of the tensions between how gacaca was mandated according to law and how it was enacted as a part of Rwandan culture. A confession endorsed by law could obstruct the perpetrator and survivor's experiences of empathetic suffering according to the

memories and experiences of the genocide. Indeed, the legally compelled acts of gacaca might have impeded its cultural significance in moving the nation towards reconciliation.

A 2006 evaluation report conducted by the NURC assessed several potential successes and challenges of the gacaca courts. In an interview with me on 11 November 2005 in Kigali, Theophile Rudahangarwa, the former NURC Research and Evaluation Program Officer, emphasized that the prime challenge in the implementation of gacaca was to address the fear that gacaca represented victor's justice. Rudahangarwa remarked on the evaluation of gacaca:

> Maybe gacaca has a good philosophy and intention, but the imple-
> mentation may be bad, which creates problems. This report is
> intended to correct some of the problems, to give indicators of
> how gacaca is dividing or uniting. In the beginning, everyone
> was afraid that it was the justice of Tutsi against Hutu. In order
> to make the fear disappear, the community must own the process
> of justice, not the authorities.

The weaknesses of gacaca identified by the NURC report included: (1) inadequately trained inyangamugayo or incorrect interpretation of gacaca laws; (2) lack of security for court report material; (3) continuation of genocide ideology; (4) exclusion of RPF war crimes from gacaca juris-diction;  (5) corruption of inyangamugayo; (6) social pressure not to con-fess; (7) passive attendance at the gacaca; (8) intimidation of those who give testimony; (9) bad conditions for the survivors; (10) traumatization of the testifier as well as the witnesses; (11) inadequate sentences imposed on perpetrators; (12) no compensation for survivors; and (13) a perception that the gacaca is intended as a national mourning exercise when the matter really only involves Tutsi.

The report noted a number of successes in the implementation of the gacaca courts, including: (1) good national attendance in gacaca court proceedings; (2) participation of local authorities and leaders; (3) accusa-tions levied and justice meted out to high-level authorities; (4) voluntary pardon being given by survivors to those who confess without pressure from officials; (5) meeting of perpetrators and survivors in a non-violent environment; (6) truthfulness healing survivors; (7) consensus of the com-munity when a perpetrator is sentenced; (8) opportunity for the community

to act as judge and jury; (9) reconciliation associations working with gacaca; and (10) fostering of reconciliation through religious institutions.

The report described some of the judicial, political and social tensions in Rwanda during the implementation of the gacaca. The goals set out—of achieving justice and reconciliation—were enormously ambitious. In an interview with me on 22 July 2005 in Kigali, a gacaca official stated: 'Gacaca is an experiment. There is a 50 per cent chance that it will succeed and a 50 per cent chance that it will fail. In the end, its success or failure will be determined by each individual. Who knows if Rwanda is ready for it yet?'

This chapter has presented several examples of how gacaca can be used to selectively interpret justice and reconciliation but that the adjudication of cases is often influenced by individual experiences and localized politics. Although the premise of Rwandanicity is to create a unified Rwandan identity, gacaca may have exacerbated extant tensions and divisions along ethnic lines. In terms of creating Rwandanicity, the nation is required to commemorate the events of the genocide by re-imagining that time by creating a social, psychological and geographic *mapping* of events that occurred between October 1990 and July 1994. Although it is imperative that the atrocities of genocide are acknowledged and justice is promoted, it is also important to consider that justice can turn into revenge. The gacaca in Cyarwa, for instance, provided an example of another type of justice where a survivor testified on behalf of a perpetrator who was falsely accused. In this way, justice must be addressed not only in terms of resolving crimes of the genocide but also considering human rights in the context of political and social tensions in post-genocide Rwanda.

POSTSCRIPT

The expectation that gacaca should address both justice and reconciliation as *retributive* justice does not take into account the traditional mechanism of gacaca as *restorative* justice, integrating African traditional reconciliation practices as relationship building. Ervin Staub (2002) argues for the need to bring people together. Borrowing from Staub, Janine Natalya Clark comments on the role of shared suffering, a point I discussed in the initial example presented by Lecomte in her 2005 interview with me and her

'competitions of suffering', both discussed in the Introduction, and one I will return to through the grassroots associations in Chapter 4.

Staub's efforts to promote healing and reconciliation in Rwanda recognize that no one group has a monopoly on suffering. As he argues, 'In many instances of mass killing there is some harm done by both sides, if not at the time of the mass killing or genocide, then over a longer historical period' (Staub 2006: 881). If one group sees itself as the sole victim this can fundamentally impede the reconciliation process, as previously argued [. . .] The value of Staub's work is that it seeks to do justice to the suffering of both Hutus and Tutsis on the following basis: 'Consideration of injuries to both sides, *even if substantially unequal*, makes the development of a shared history, of shared collective memories, possible' (ibid.; quoted in Clark 2008; emphasis in the original).

Between 2005 and 2006, I observed how some communities used gacaca as a platform for open discourse, which was inherently connected to creative practices (theatre, dance and music) used by the grassroots associations to create an alternative space for communication and building relations between survivors and perpetrators. However, in 2010, I observed how previous examples of gacaca for truth telling and reconciliation changed to practices that emulated coercion and manipulation of gacaca laws. For instance, a gacaca I attended in 2010 was an appeal trial. The defendant had saved the lives of 97 survivors. Although the trial began with one charge against him, further charges mounted during each appeal hearing. Defence witnesses often had case charges placed against them during the court hearings and thus grew reticent to come forward as the case progressed. The defendant's case closed with a life sentence.

A gacaca official stated in an interview with me in April 2010 in Kigali that it was his belief that the accused was innocent but had been targeted because of his wealth. Reparations for Category Three cases have at times been connected to the accusations and verdicts of Category One and Category Two cases. Since many Category Three criminals did not have the funds for reparations, there were some cases in which landowners had been accused as Category One and Category Two criminals, being sentenced to life imprisonment and having their land auctioned to pay Category Three reparations. In this way, community members with the ability to provide

economic reparations may have been targeted. Penal Reform International states that '[g]iven the economic situation of most of the convicts, there is a real risk of large-scale seizures in the next few years' (2009: 60).

Although the Rwandan Organic Law creates a state-driven ordinance that scripts a particular narrative towards sculpting formations of identities and communities following the genocide, the narrative is often disrupted, reinterpreted or improvised. Some flaws in the implementation of gacaca for justice and reconciliation may be caused by a lack of inyangamugayo training, the speeding up of trials, the subjective interpretation of categorization and the manipulation of court procedures for varied political, economic and personal objectives.

After gacaca, what are its implications? Although several years have been committed to remembering, documenting and adjudicating crimes of the genocide through local-level courts, what are the ramifications of the varied interpersonal rivalries or revenge tactics acted out through gacaca? How will these discourses be mediated? In terms of post-gacaca Rwanda, although the government has controlled diverse narratives through gacaca laws, those narratives still exist as hidden transcripts. Although gacaca courts officially ended in 2012, the impact of gacaca will continue to be felt.

In the next chapter, I illustrate the use of culture not only to promote the stated aims of justice and reconciliation but also to create a space for perpetrators, survivors and community members to develop new relationships. In particular, I note the possible link between processes that encourage 'an attitudinal and behavioral shift from a prelinguistic state to the point where they can begin to articulate their experiences in words and ritual' (Villa-Vicencio 2009: 134) to varied grassroots associations that encourage participation in the gacaca courts.

## Notes

1  An important distinction between the ICTR and gacaca was the temporal jurisdiction: gacaca addressed genocide crimes between 1 October 1990 and 31 December 1994 whereas the ICTR adressed crimes between 1 January and 31 December 1994. Although the Rwandan government was one of the initiators for the ICTR, the tribunal was voted against in the end because it did not include the period between 1990 and 1993 as inclusive

of the genocide. Also, it did not allow the death penalty (abolished in 2007) and was located outside Rwanda.

2　Gacaca plays were listed as an activity funded by the Johns Hopkins Bloomberg School of Public Health in partnership with the Ministry of Justice, Center for Conflict Management, ORINFOR (Rwandan National Information Office), IBUKA, CLADHO and the Muslim Association of Rwanda, available at: http://www.jhuccp.org/africa/rwanda/gacaca.shtml (last accessed on 24 April 2009).

3　Susan Thomson and Rosemary Nagy write: '[E]ven if *gacaca* is *legally* acceptable in a harmonized way, it is nevertheless a state-run legal system that reinforces a particular version of reconciliation and, as such, not only renders most Rwandans largely powerless in individual processes of reconciliation but also serves to maintain a climate of fear and insecurity in their everyday lives' (2010: 11; emphasis in the original). For other references based on the limitations of gacaca, see Allison Corey and Sandra F. Joireman (2004), Alana Erin Tiemessen (2004), Barbara Oomen (2005) and Erin Daly (2002), Lars Waldorf (2010) and Bert Ingeleare (2012).

4　On 13 August 2008, a constitutional amendment added the term Tutsi to read: 'Emphasizing the necessity to strengthen and promote national unity and reconciliation which were seriously shaken by the 1994 Tutsi genocide and its consequences' (Republic of Rwanda 2008).

5　The documented number of prisoners ranges between 100,000 to 120,000 in most publications. The figure of 120,000 inmates in November 1999 was recorded by the Republic of Rwanda National Service of Gacaca Courts' *Report on Activities of Gacaca Courts in the Pilot Phase* (2005b: 3). The report notes a forum to discuss gacaca as an alternative form of justice.

6　Jeremy Sarkin notes that '[a] significant number of those in detention may be blameless' (1999: 794).

7　Historically, Rwanda's legal system is based on Belgian and German civil law. However, there have been various alterations. According to Sarkin, 'in 1940 the Congo Penal System was extended to Rwanda, and a specifically Rwandan penal code was adopted in 1977, taking effect on 1 January 1980' (1999: 793). The Penal Code allows for pre-trial detention. Beyond the precursory Belgian and German laws, Rwanda's Organic Law was established to try the crimes of the genocide, and the Genocide Law categorized genocidal crimes.

8　The role of the inyangamugayo was to administer the gacaca court sessions and pass judgement upon Category Two and Category Three crimes. They attended a training session before formally taking up their duties.

Beginning in April 2002, over 250,000 inyangamugayo were trained with support from the Coopération Technique Belge (Belgian Technical Cooperation, CTB). Since then, some inyangamugayo have been removed from their positions following accusations of participation in the genocide or tampering with case files. Subsequent training sessions and elections of inyangamugayo have occurred to replace them or to fill understaffed cell-level gacaca courts.

9  See www.inkiko-gacaca.gov.rw (last accessed on 25 August 2007).

10 Prunier notes that Rwandan society is highly structured due to authoritarian rule (1995: 3).

11 Organic Law No. 28/2006 of 27 June 2006. Several adjustments have been made to the Organic Law since its implementation, including the reclassification of offences from four categories to three and the provision for 9 inyangamugayo and 5 deputies per court in place of the initial requirement of 19 members for each court bench in Organic Law No. 16/2004 of 19 June 2004. However, the number of inyangamugayo was reduced to 7.

12 In an interview with me on 6 April 2010 in Kigali, Denis Bikesha, who was then the director of Training, Mobilisation, and Sensibilisation for the National Service of Gacaca Courts in Rwanda, stated that 1,210,368 files were received as of 1 April 2010.

13 Lars Waldorf notes the coerced attendance at gacaca courts, emphasizing the economic impact of losing one day of work each week for a largely peasant population (2010: 190).

14 Organic Law No. 16/2004 of 19 June 2004 establishing the organization, competence and functioning of gacaca courts charged with prosecuting and trying the perpetrators of genocide and other crimes against humanity, committed between 1 October 1990 and 31 December 1994. Article 54, p. 15.

15 Martien Schotsmans provides an account of how donor agencies did not sufficiently support recommendations from international non-governmental organizations (INGOs) that monitored gacaca, thus limiting their effectiveness to address human rights violations (2011: 390).

16 For varied motives behind public confessions that shape these performances, see Leigh A. Payne (2008).

17 I witnessed the gacaca court proceedings between July and December 2005 in Butare, Kigali, Gahini, Gaheneri, Nyamasheke and Kigarama among other locations. Additional observations were made in 2004, 2006 and 2010.

18  Malkki (1995) uses the term 'moral community', relating the building of nationalism for Hutu refugees in Tanzania as creating a 'moral community', purged from the impurity of Tutsi contamination.

19  Though the genocide was predominantly based on ethnic cleansing of Tutsi, fuelled by Hutu militia, a large portion of the Hutu population did not participate in the genocide. According to Daly, 'The large numbers of perpetrators should not be taken to imply that "everyone" was culpable. While the numbers are undeniably large, participation of about 650,000 people in the killing means that about one-tenth of the Hutu population did not kill. As a societal norm, this is intolerable, but the difference between one-tenth and everyone is critical in terms of developing a response' (2002: 364).

Research by Giorgia Doná citing Straus (2004) states: '[o]ut of a population of 7 million Rwandans, it is estimated that approximately 1 million individuals were killed during the genocide. This leaves 6 million people unaccounted for [. . .]. Straus [. . .] calculated that a small number of individuals, ranging between 170,000 and 210,000, committed most of the killings, an estimate that is congruent with approximately 200,000 individuals imprisoned on genocide charges' (2012: 236–7).

20  The church has played a primary role in Rwanda as an agent of colonization. According to the CIA World Factbook, in Rwanda in 2001, 56.5 per cent were Roman Catholic, 26 per cent Protestant, 11.1 per cent Adventist, 4.6 per cent Muslim, 0.1 per cent indigenous faiths, 1.7 per cent none, available at: https://www.cia.gov/library/publications/the-world-factbook/-geos/rw.html (last accessed on 26 April 2009). Thus, religious doctrine has affected acts of forgiveness and contrition in gacaca.

21  To learn about the roles prisoners performed in prison and the bartering of crimes for reduced sentences, see Carina Tertsakian (2008).

22  In terms of the performance of confession, I have observed an etiquette of repentance at the gacaca. Although not considered legally binding, there is an assumed mode of delivery and behaviour for the defendant's confession seeking an apology to be 'truthful'. The defendant's demeanour, body language, tone and even the choice of words become elements of the 'performance' of the confession which play a role in the judges' decision about whether to accept it and the reaction of the community in attendance.

23  In the interview, Busingye states that gacaca 'may be' rooted in Rwanda's own culture, illustrating possible equivocation of the legitimacy of gacaca.

24  See http://wiki.comminit.com/en/node/117450 (last accessed on 11 October 2011).

25  According to the report, 5.4 per cent anticipated negative responses to the gacaca before the theatrical performance, rising to 11 per cent after the performance.

26  It took two vehicles to climb to the top of one of the hills where the performance was being staged. One of the bridges had been washed away by rain several months ago and we had to cross wooden planks to reach a jeep awaiting us on the opposite side. The road twisted to the top of one of Rwanda's tallest peaks, passing through small villages until we reached the clearing at the top, looking down at the hills below. The limited access to the area demonstrated the potential necessity for theatre for sensitization.

27  MRND or the National Republican Movement for Democracy and Development was the ruling political party of Rwanda from 1975 to 1994, under President Habyarimana.

28  During the development of *The Liberating Truth*, there were varied instances in which official discourse concerning forgiveness and Azeda's ontological understanding of forgiveness were in conflict. For more information on Azeda and *The Liberating Truth* and the tension between artistic freedom and government control of narratives, see Thompson, Hughes and Balfour (2009: 222–6).

29  Although the inyangamugayo of the district did not state why there was a variation in training in relation to other districts, my assumption is that the gacaca was held in Kigali and was most frequented by international observers.

30  The leaders of the genocide were tried in the high courts as Category One criminals. However, several cases were heard first in the sector-level gacaca and once the verdict indicated that the case was a Category One, it was passed on to the high court. Political leaders responsible for the genocide and other major catalysts (including musician Simon Bikindi whose songs were used as anti-Tutsi propaganda and to incite genocide) were being tried at Arusha (Tanzania) in the ICTR. Bikindi was on trial at the ICTR for crimes of war and was convicted for incitement to genocide in 2008.

31  A guilty plea was not accepted if one did not identify all crimes and provide the names of all the accomplices.

Since the first wave of releases by presidential decree in 2003, those who pleaded guilty were the first to be released, followed by the ill and elderly, underage perpetrators and, finally, those who were innocent and had no case file brought against them while they were imprisoned.

32 Legal court documents were generally transcribed by the inyangamugayo, but because of a high illiteracy rate in Rwanda incorrect reporting was a common occurrence.

33 The gacaca has been criticized for the inaccuracy of many court records and has raised human rights concerns for not following the due process of law because the defendant is not represented by a lawyer or defence but is left solely to represent himself pro se.

34 Organic Law No. 16/2004 of 19 June 2004 establishing the organization, competence and functioning of gacaca courts charged with prosecuting and trying the perpetrators of the crime of genocide and other crimes against humanity, committed between 1 October 1990 and 31 December 1994. Article 34, p. 11.

35 The accused classified as Category One were considered 'planners' of the genocide and faced ultimate punishment, including life imprisonment.

36 The case was not immediately dealt with, nor was there notable public reaction. Potentially, the rupture was a common occurrence. Basically, the complaint was merely recorded and dismissed, to be dealt with in an upcoming session. Here, the power of the court to accept or decline testimonies is noteworthy.

37 Symptoms of trauma in various perpetrators and survivors I interviewed included recurring nightmares, lack of sleep, inability to eat and body pain.

38 Approximately 200 people were in attendance at the gacaca in Gahini on 25 October 2005.

39 The limited jurisdiction of gacaca courts meant that not all events and allegations were heard in court. In particular, RPF crimes associated with the civil war between 1990 and 1994 and war crimes committed between 1994 and the present were not heard in gacaca.

## RECONCILIATION AND THE LIMITS OF EMPATHY:
## GRASSROOTS ASSOCIATIONS

Theatre serves as a vehicle for reconciliation but it can also be used for incrimination. Although theatre has been one way of fostering moral communities through perpetrator and survivor associations, as will be evidenced through several case studies, the use of theatre when connected to justice may not inherently aid reconciliation. In this chapter, I use in-depth descriptions of grassroots associations to analyse how government campaigns of justice and reconciliation—including overarching strategies to instil Rwandanicity—are disseminated and instances where there may be divergent or concurrent discourses at a grassroots level.

Theatre in Rwanda activated memories of the genocide to promote confessions in support of the gacaca trials. In one of my interviews with a perpetrator, the interviewee stated that while watching a theatre production about the genocide, he had a flashback. The story came out like a book, unfolding events and characters previously forgotten or consciously suppressed from memory. Following the performance, he testified in gacaca and revealed the names of perpetrators who he remembered had committed atrocities. In another interview, a perpetrator conveyed that the play had evoked memories of several other killings. He too confessed his crimes in gacaca.

I visited several grassroots associations to understand how national campaigns of justice and reconciliation were incorporated into the arts at a local level.[1] One of them was the association Les Jeunes Accolies Contre les Impacts du Chômage (JACOC, Young Schoolchildren Against Impact of Unemployment), which conducts weekly theatre rehearsals in a cement-block building on top of a high hill overlooking the Nyungwe Forest. As I

was driven there (on 21 July 2005) by the gacaca coordinator of Cyangugu, he told me about the gacaca statistics from the area: 284 inyangamugayo were charged with genocide; 635 local leaders and 2,732 members of the community confessed to participating in the genocide. In that sector alone, over 45,000 corpses were recovered and given a proper burial. Participation in the genocide was particularly high in this region of Western Rwanda, along the DRC border.[2] He also said that, in this sector, 74 per cent of those who are accused confessed their crimes, compared with the national average of 35 per cent. When asked why the confession rate was considerably higher in Cyangugu, he replied, 'theatre.'

Founded on 17 July 2003 by Peter Ndayishimiye, JACOC employs theatre to elicit confessions to be utilized in gacaca. The group started with seven classmates graduating from secondary school. After completing their studies, they anticipated getting government jobs but discovered that they could not find employment. JACOC was created as a form of self-employment, using theatre to spread government policies about unity and reconciliation. The association now has 34 members. In an interview with me on 21 July 2005, Ndayishimiye said that there was a large percentage of confessions in this area, especially because of the evocative use of theatre. The association staged 'true to life' events, integrating characters and events from the history of genocide in the area, but with fictionalized names. Ndayishimiye stated: 'They know who they are. When we stage the events, people in the audience can recognize themselves in the drama. We have had people self-confess to inyangamugayo planted in the audience, or people give testimony.'

In this chapter, three categories of grassroots association case studies have been presented to illustrate the varying objectives of the associations. The first case study category examines Abiyunze as a community-initiated, perpetrator-and-survivor-driven association for reconciliation. The second category of case studies is devoted to youth associations—Association des Jeunes pour la Promotion du Développement et de la Lutte Contre la Ségrégation (AJDS, Youth Association for the Promotion of Development and the Fight Against Segregation), which promotes sensitization and mobilization, and JACOC, which uses theatre to evoke memories of the genocide, in part to increase the number of gacaca testimonials. The youth associations promote discourse whereas associations like Abiyunze seek to integrate survivors and perpetrators back into the community.

The third case study category considers the Forum des Jeunes Artistes du Rwanda (FOJAR, Forum of Young Artists of Rwanda), a government-sponsored association that links local initiatives to government justice and reconciliation campaigns. These examples present stories of reconciliation, but also highlight complexities regarding how theatre for reconciliation, which emerged from a local desire to create alternative spaces between the victims of genocide (perpetrators, survivors and community members), can be co-opted into national campaigns of justice, potentially limiting the effectiveness of empathy.

## RECONCILIATION AND MORAL COMMUNITIES

Reconciliation is a nebulous term, often used as a palliative in post-conflict times to muffle moans of discontent. John Borneman defines reconciliation as a project of departure from violence rather than permanent peace or harmony (2002: 282) whereas John Paul Lederach considers 'reconciliation -as-encounter' as a place of encounter between the past and future to reframe the present (1997: 27). I use the term to illustrate a negotiation of alternative spaces between perpetrators and survivors who use artistic approaches to create moral communities.

The use of the term moral community varies widely with regard to how communities respond to conflict by creating a moral order, as explored by Veena Das (1995), Liisa H. Malkki (1995), Carolyn Nordstrom (1997) and Martha Minow (1998). Malkki employs the term to describe the Hutu refugee population in Tanzania establishing a sense of racial purity through culture. Minow uses it to represent stages between vengeance and reconciliation, thereby dealing with mass atrocity through a moral and judicial national response. I use 'moral community' to contextualize what is being formed in the grassroots associations as the quest to understand otherness and the empathetic response to suffering between perpetrators and survivors. It is through the state of empathetic response that reconciliation can be understood in terms of shared suffering, thus building a moral community.

Reconciliation necessitates fractured communities to be co-creators, recognizing the function of politics following conflict and the fragility of communities in transition. In this way, reconciliation is a process marked by individual acts of negotiation that affirms discourse and discord versus adhering to a consensualized narrative.

In recent years in Rwanda, perpetrators have been released by presidential decree, with tens of thousands returning to their villages after spending a decade or more in prison. Survivors have responded with fear at the prospect of meeting face to face the murderers of their families and neighbours. At the same time, perpetrators have often found their wives or husbands in new marriages and their homes occupied. Within this context of mutual distrust, associations create an alternative space for communities to interact and to establish relationships. Several associations have been created by survivors, perpetrators and community members as a vehicle to build trust and community connections between individuals who uniformly express fear, distrust and grief at the outset.

The numerous interviews I conducted with association members revealed that they all shared similar stories of experiencing isolation and bodily pain until they joined an association. In an interview with me on 15 April 2010, a perpetrator from the association Umuhanzi w'u Rwanda declared that prior to joining the association he regularly had nightmares and shook uncontrollably during the day. Likewise, a survivor said that she had lost all hope of living after her whole family was massacred in the genocide. After joining the association, both claimed that art gave them some measure of happiness and that the physical symptoms of their trauma had begun to subside. The role of the arts in the context of grassroots associations can be to mend or remake the world according to a new order, fostering a new sense of moral community.[3]

The opening example in the Introduction illustrates the importance of community interactions to forge new relationships based on principles of reconciliation that provide opportunities for encounter, building towards a 'we' that constitutes both individual and community identities in transition. As described in the Introduction, a survivor and a perpetrator from Umuhanzi w'u Rwanda stated that art provided an alternative space to forge new relationships. The perpetrator had killed the survivor's five children during the genocide. The survivor had another child after the genocide. When the child was admitted to the hospital following an injury, the perpetrator paid the hospital bills, visited the survivor with food and tended to her crops. In this case, the value of forgiveness and friendship is embedded in their renewed relationship, fostered through their involvement in the grassroots association. In his act of reparation, the perpetrator acknowledged the economic impact of genocide crimes.

In an interview with me on 12 November 2005 in Gitarama, Rwanda, Oswald Rutimburana, a project coordinator of the NURC, acknowledged that it is 'the community that is vital in building their own reconciliation'. Associations that have been created as an outgrowth of both survivors and perpetrators seeking solace through their shared emotions, provide a space for participants to give their testimonies and to stand witness to one another. However, the practice of providing testimony may be intended to serve as reconciliation for its own sake for the in-group of perpetrators and survivors within the association as opposed to delivering it as testimony for justice (as indicated by the case study at the beginning of the chapter).

In response to my question on the role of the arts following the genocide, Odile Gakire Katese stated in an interview with me on 13 April 2010 in Butare:

> The arts can be used in many ways. It plays a big role in therapy, especially for children. During the act, people are happy and are doing the same thing, sharing emotions to speak their mind while using art, drawing, theatre or poetry. When they use the arts together, they feel the same. In this way, there is not much difference between a perpetrator and a survivor. There should be more creative arts for healing.

Although the arts can be one way of opening up multiple narratives outside state-driven campaigns of justice and reconciliation, they also have the potential to evoke memories to inform gacaca proceedings.[4] Thus, the arts in post-genocide Rwanda have various objectives and outcomes that must be considered in relation to wider politics.

## GERMINATING CULTURE FROM THE BOTTOM-UP

According to the NURC, by 2005, over 300 associations in Rwanda developed from a grassroots level. Several of the associations I observed were first established as the result of local initiatives, offering alternative community-generated narratives in contrast to the centrally constructed national narrative. More recently, however, local initiatives have been integrated into the jurisdiction of the NURC, thus potentially shifting the direction of narratives from individual acts of reconciliation into a top-down model managed by the central government. An inventory of associations conducted by NURC in 2007 recorded 600 associations. The increase

in number between 2005 and 2007 was largely attributed to NURC unity and reconciliation campaigns.

Reconciliation plays by grassroots associations emerge from multiple strands of Rwanda's cultural traditions, from celebratory performances to the use of proverbs and symbolic imagery in theatrical performances. Rwandan cultural events have historically included a performative dimension, whether through role-play enactments for wedding ceremonies or dances depicting various scenes from agricultural life at harvest celebrations. Similarly, Rwandans frequently use many and markedly varied proverbs in everyday communication and Kinyarwanda is exceptionally rich in symbolism and metaphorical imagery.

Joseph Nsengimana, Rwandan theatre scholar and advisor to President Kagame, has noted the historical background of theatre in Rwanda as an integral aspect of community life, and its evolution over time:

> Rwanda's traditional theatre is rooted in community ritual and principally connects to the cult of *Imandwa* (followers of *Ryangombe*), which celebrates the spirits of the dead and follows the rituals of *Inzira* (rites connected to the seasonal life of the land). More secular but still enormously important rituals are the *Imisango* (ceremonies relating to marriage) and *Ibitarame* (ceremonies connected to weaponry). After 1970, these traditions were taken up by the modern western-style theatre in the country and used as sources of inspiration and creativity (2000: 237).

The use of theatre by grassroots associations as a response to the genocide has its cultural roots also in Western constructs of theatre in the form of dramatic plays influenced by university and missionary institutions, though to a lesser degree. Western-style drama, however, is a more recent addition to Rwanda's culture. Nsengimana contextualizes Western theatre as introduced by missionaries in the 1930s, later to be developed by Rwandan playwrights. Saverio Naigiziki wrote *L'Optimiste* in 1954, the first published play in Rwanda, and Nsengimana created a theatre programme at the National University of Rwanda in 1980 (ibid.). A further impetus for the use of theatre by the associations has been the returning Tutsi exiles from neighbouring countries.[5]

Radio broadcasts play a special role in conveying information and influencing opinion through news reports and radio dramas. The ability

of radio to influence the population has been witnessed in Rwanda prior
to and after the genocide, and members of grassroots associations located
in resource-poor or remote areas have been found to glean production
ideas from such broadcasts. Jody Ranck states:

> The aesthetics of the radio broadcasts are equally important in
> demonstrating how myth and memory worked during the geno-
> cide. As Chrétien notes, singer Simon Bikindi's music was partic-
> ularly effective in blending popular Zairean rhythms and choral
> verses with long passages from divination rituals such that 'one
> could dance to the passionate call to ethnic mobilisation' (Chrétien
> 1995: 342; Quoted in Ranck 2000: 195).

Likewise, radio dramas have the potential to shape the ideology and
behaviour of Rwandans in the direction of reconciliation. Radio dramas
such as *Musekeweya* (New Dawn) by La Benevolencija and *Urunana* reach
wide audiences and some association members act out the programmes.
In this way, radio is a strong vehicle for the dissemination of national
messages, which then come to be enacted through local theatre initiatives.
For example, Ongera Urebe (See Again) produced their gacaca play by
listening to the radio, without ever having attended a gacaca event. Like
the radio, cultural forms have been appropriated after the genocide to
shape Rwandanicity through dance, myth-making and theatre.[6]

The following case studies present community-specific responses to
reconciliation through the formation of grassroots associations. The primary
source material was gathered over the course of several visits to towns in
Eastern Province and Western Province between July and December 2005,
March and June 2006, and April 2010. In each area, I attended several
gacaca courts, visited associations and conducted interviews with association
members as well as local authorities. In many cases, gacaca was linked to
the association, either through messages of sensitization and mobilization
or through the membership of inyangamugayo in the associations.

## COMMUNITY-BASED ASSOCIATIONS

### ABIYUNZE, EASTERN PROVINCE

The Abiyunze performance I witnessed in Eastern Province on 4 August
2005 preceded the gacaca court. The morning's events began with the asso-
ciation members performing reconciliation songs and dances and displaying

wood-carved handicrafts. The members approached the open dirt expanse carrying the sign 'Ishyirahamwe Abiyunze Ry'I Gahini Dushyigikiye Ubumwe N'Ubwiyunge' (Association of Those Who Are United). Three elderly women came to the centre of the space first and were identified as Twa by the president of the gacaca courts. The Twa dances were close to the earth, displaying quick footwork patterns and arm movements. The next dances were identified as Tutsi and the dancers moved more slowly, their arms held high above their heads, resembling cow horns (see Image 9). The Hutu dances comprised leaps. The president of the gacaca court explicitly identified the dances and the members according to their ethnicity.

Locally, the association performs ethnic identities through dance as an illustration of unity through mixed Hutu, Tutsi and Twa membership. In contrast, the national reaction to the display of ethnic differences through dance forms has been an argument of regionalism versus ethnicity, as described by government officials during interviews. Here, two different strategies and discourses towards reconciliation can be observed. While the local strategy has been to overtly display the integration of differences through the acknowledgement of different ethnic forms, the government

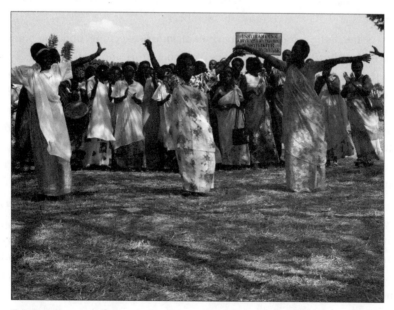

**IMAGE 9** Dance performance by Abiyunze members, Eastern Province, 2005. Courtesy: Ananda Breed.

strategy has been to homogenize cultural forms into a unified national dance (see Breed 2008).

Abiyunze Association (Ishyirahamwe Abiyunze Ry'I Gahini Dushyigikiye Ubumwe N'Ubwiyunge) was initiated by a génocidaire named Emmanuel Kambanda, who approached over 60 neighbours to seek forgiveness on returning home after being released from prison by a 2003 presidential decree. Kambanda felt there was a need for people from different sectors of society to interact on a regular and sustained basis in the practice of reconciliation. Jacqueline Kanyanja, a member who helped to develop the project, was a genocide survivor whose husband had been killed. She had been approached by Emmanuel over 10 times before she agreed to grant him forgiveness. She joined the association 'for unity and reconciliation' because it provided equal representation to the victims, perpetrators and those whose families had relatives in prison. The four main categories of members in the association are: survivors, those released from prison provisionally, those whose relatives are in prison and those who have returned from refugee camps. The association has grown from 22 members to 130 members. There are 20 perpetrators, 40 survivors and 60 members who have family members in prison. The rest of the members are returned refugees and general community members.

Some of the association's activities include beekeeping, building houses for both survivors and the families of perpetrators and craft-making. The SNJG and the NURC have recommended the association's model as an example of 'best practices', commending its democratic style of debate in gacaca and the mixed participation of the three ethnic groups. Abiyunze projects a social model of perpetrators seeking forgiveness, an objective of Rwanda's reconciliation process, but the action stemmed from the perpetrator and survivors who then included others in their atonement as a community endeavour.

Describing the association's activities, Kanyanja said: 'We dance together, we sing, we make handicrafts and we build houses. When they confess, it gives morality.' When asked how art changed her feelings after losing her husband, Kanyanja said: 'When we sing and dance, we feel happy and excited. I no longer see them as enemies, but those that share problems of the survivor.'

Following its formation, Abiyunze received a small degree of fiscal and organizational support. Kambanda received training from Interface

Rwanda on methods to unite families of survivors and perpetrators. Abiyunze extended outreach into prisons, sensitizing released prisoners about the need to confess. NURC provided it with 500,000 Rwandan francs (then 460 GBP). It was registered with the government as an association on 8 January 2004. Abiyunze has built over 50 houses for survivors, funded three young people to attend secondary schools and raised cattle to be equally distributed among association members.

In an interview with me on 4 August 2005, Joy Mukabaranga, trauma counsellor for the region, commented on the importance of Abiyunze:

> Before the association developed, people were suspicious and not at peace. After Abiyunze, people began to interact, to visit each other and began to become friends. It first started as a weekly meeting, then turned into an association of beekeeping. In that process, the association mobilized others to join and then the association started using song and dance. Because people participate in the dance and drama, people begin to testify, to talk to people. People have emotions and cry. While they are doing drama, people feel more comfortable, not traumatized. Traumatization happens when people feel lonely.

Abiyunze illustrates the development of a moral community through the actions of Kambanda and Kanyanja, creating an association through mutual efforts to provide housing and economic assistance to families of both survivors and perpetrators. However, although I have highlighted the impact of individual acts of community members, the differentiated roles of perpetrator and survivor in the association may perpetuate agonistic relationships in the future. In 2010, I visited the association and discovered that Kambanda had been accused of new crimes and had fled the country to escape being tried anew in gacaca. In this case, although he was central to community efforts towards reconciliation and the reintegration of released prisoners, he was vulnerable to ongoing legal procedures.

ONGERA UREBE, EASTERN PROVINCE

Another grassroots association that developed as a community initiative is Ongera Urebe. It was established as a cultural troupe on 12 February 1994, two months before the genocide. Its first staged production *Ongera Urebe Ibyabaye Mu Rwanda* (Once Again See What Happened in Rwanda) was performed in August 1994 following the genocide. Over the years, new

content has been added to the original production, integrating contempo-
rary issues. In this case, theatre is being used primarily as a tool for analysis,
to understand how the genocide happened, and as an educational tool to
prevent it from happening again. *Ongera Urebe Ibyabaye Mu Rwanda* recounts
how the genocide began, how the people participated in the genocide and
how it was stopped. Recent additions to the play integrate gacaca trials
and the consequences of genocide.

Ongera Urebe is led by two people who coordinated the troupe, Vere-
centus Nsengiyumva (director) and François Nzavuganeza (chairperson/
actor). A female elder, who is a survivor of the genocide, acts as the head
of the troupe. The troupe reportedly consults her with regard to the
events of the genocide; her authoritative knowledge about these events
gives her a role in the community. The association started with 12 people
and has grown to 21 members. During my meeting with its members on
12 July 2005, when asked whether they are trained or funded by external
sources, they explained that the techniques come from their inspiration.
They do not receive external funding or advice on what to create but
make plays about topics that concern them, such as reconciliation, street
children, genocide, HIV/AIDS, orphans and gacaca. In addition to their
first production, they have three other plays in their repertoire: *Twugarire
Turugarijwe* (Prevention Because We Are Attacked, focusing on AIDS),
*Hitamo Igikwiye* (Choose What Is Necessary, also highlighting AIDS-related
issues) and *Nawe N'Umwana* (He Is a Child Also, dramatizing the plight of
orphans).

*Ongera Urebe Ibyabaye Mu Rwanda* ends with gacaca. The productions
emerge from local narratives related to the genocide, respond to questions
about regional issues and further debate government policies. The troupe
listened to the radio and attended gacaca meetings, as part of research,
before developing the script. They performed a representation of gacaca
for the public before the community had seen an actual gacaca court. In
this way, theatre fostered critical analysis, research and education. The
plays are rarely performed outside the village because of financial and
transportation constraints, so the productions are performed for the same
audience time and again (see Images 10 and 11).

Abiyunze and Ongera Urebe are examples of local reconciliation
initiatives primarily driven by a community response towards integration
of perpetrators and survivors. The analysis of Abiyunze has positioned

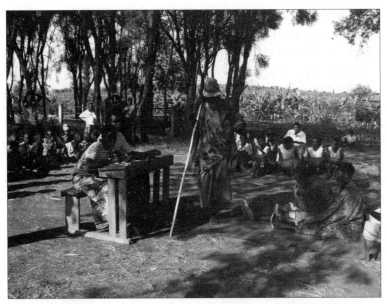

**IMAGE 10** Gacaca scene from *Ongera Urebe Ibyabaye Mu Rwanda*, Eastern Province, 2005. Courtesy: Ananda Breed.

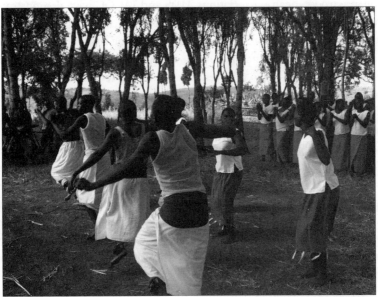

**IMAGE 11** Dance performance by Ongera Urebe, Eastern Province, 2005. Courtesy: Ananda Breed.

grassroots associations as an alternative space for ethnic identities to be performed as an illustration of reconciliation. In the 12 November interview, Rutimburana remarked on the demonstration of ethnicity by associations: 'Maybe what we [the government authorities] teach has put fear into the public not to use the terms Hutu, Tutsi and Twa. People should have no fear of saying those terms, but it is a useless label to use at this time.' Rutimburana suggested that 'grassroots associations should use drama as a method to approach reconciliation, as a method to understand problems affecting the community and expressing issues in a general manner.' While I have questioned the potential co-option of local initiatives into national campaigns, government officials such as Rutimburana note the importance of local initiatives, emphasizing the need for local communities to address specific issues through theatre. The power of the government is not an all-encompassing monolithic force; instead, divergent discourses emerge from specific instances of reconciliation projects.

## YOUTH-BASED ASSOCIATIONS

### AJDS, EASTERN PROVINCE, AND JACOC, WESTERN PROVINCE

The grassroots theatre associations AJDS and JACOC have demonstrated the motivation of Rwandan youth to assist with national campaigns of justice and reconciliation. Many of the youth come from homes of perpetrators and survivors and have been instrumental in motivating family members to confess or to forgive. In several interviews with youth organizations, I found that young people resisted categorizing their peers as Hutu, Tutsi or Twa and disclosing which members come from families of perpetrators or survivors. I gathered information regarding ethnic or political family backgrounds primarily through confidential conversations with either the gacaca district coordinator or adult project mentors. The youth groups have mixed ethnic backgrounds and choose to ignore it to create a united and peaceful future through the ideal of Rwandanicity. In this way, the establishment of the moral community is driven by an altruistic hope for the future based on the performativity of Rwandanicity that downplays ethnicity rather than by highlighting ethnicity and roles of perpetrator and survivor.

AJDS was created in November 2004 in response to reports of resurgent genocide ideology. In interviews I conducted with AJDS members

on 2 August 2005, the director of the association, Frederick Kabanda, described its conception:

> The Parliament and the Ministry of Education did an investigation [revealing] that genocide ideology was [developing] in schools and they broadcast their report over the radio. We thought, 'What can we do as youth and students to stop genocide ideology?' Those of us who are educated know the historical background of this country and that the history taught before the genocide wasn't true, so [we] felt we could make social change [using] theatre and history. We felt that we must participate in rebuilding this country.

Their solution was to stop genocide ideology through the 'correct representation' of history through theatre. The company consists of 15 women and 15 men between the ages of 20 and 30, several of whom are orphans or children of survivors and perpetrators.[7] The company office and rehearsal space are located in the orphanage. Recently, the association has included a few adult members. One member is an inyangamugayo in Rwamagana.

AJDS provides theatre training to young people, facilitating workshops at the local primary, secondary and trade schools. In 2005, AJDS performed an agitprop production, called *Umurage Ukwiye U Rwanda* (The Real Inheritance of Rwanda), about reconciliation for secondary schools, followed by workshops with the students to create their own poetry, songs and plays. A finale was performed for the community and the NURC, a festival bringing together the various student groups to perform for one another. AJDS plans to continue training young people using theatre in schools, hoping to end genocide ideology and work towards a peaceful future. Other productions staged by AJDS in 2005 include *Urubyiruko Dushyigikire Gacaca* (Youth Who Support Gacaca Courts) and *Ibyabaye Byarateguwe* (What Happened Was Planned).

In interviews I conducted with AJDS members on 2 November 2005, they described the first AJDS play. The opening scene in *Umurage Ukwiye U Rwanda* explained that prior to colonization Banyarwandans were one family comprising the Batutsi, Bahutu and Batwa, who lived peacefully with one another. The lesson was followed by a dramatic tale of a young woman from a Hutu family and a young man from a Tutsi family. The Tutsi man suggested that the woman should approach her aunt to seek support regarding their union. The aunt rejected the union, explaining

that her husband, the woman's uncle, was still in prison for genocide and reconciliation could not be forged until his release. The boy approached an NURC member to mediate between the two families. The NURC spokesperson explained that everyone is Rwandan, thus people must learn to be with each other and not to divide. The play ended with the two families offering their consent and reconciling.

In follow-up conversations with me, AJDS members expressed their belief that those who marry an individual from a different ethnic group would be excluded from society. Thus, although there is a common message of reconciliation, an element of stigmatization exists which may not be addressed in reconciliation plays. In addition to performing these plays, AJDS was actively engaged with gacaca courts in sensitizing and mobilizing the population to confess and to reconcile. Company members frequented weekly gacaca court proceedings and transcribed the dialogue. The information was then integrated into gacaca plays, illustrating weaknesses in the proceedings, the guilty who have not confessed and examples of 'truthful' testimonies by perpetrators. According to AJDS, as revealed in the 2 August 2005 interview: 'We were successful because the messages we gave through acting made an impact. Following performances, people stood as witness, and perpetrators told the truth.' In an interview with me, the gacaca coordinator claimed that over 997 members of the community had confessed. In terms of how AJDS has influenced confession rates, he stated that theatre has encouraged the community to attend gacaca courts and to tell the truth.

Similarly, JACOC from Western Province has had an impact on confession rates through sensitization and mobilization. Major Stevens, a military officer residing in the community, has taken on the role of mentor. Stevens trained in theatre while living in Uganda and assisted JACOC with their enterprises. Stevens and several inyangamugayo from the area claimed that theatre has been used to elicit confessions. They told me that, at several performances, inyangamugayo planted themselves strategically in the audience. During and following the performances, there were several confessions triggered by the drama.

One of their plays, *Duharanire Kunga Izatanye* (Let's Try Our Best to Unite Those Who Are Divided), depicts an ill-fated relationship between a young man and woman; the man belongs to a Hutu family that participated in the genocide and the woman belongs to a Tutsi family that had several family members killed. The play's scenario includes a testimony from the

Hutu father in prison, urban myths about a potential double genocide that Tutsi are planning for Hutu and a staging of gacaca. The young couple are crucial in bringing about eventual reconciliation between the two families. When asked why they created the play, several young people stated that it mirrored their lives. According to the actors, another reason for the high confession rate in that area is that young people have mobilized their relatives to confess in gacaca courts. A young man stated that most of them were aged around 11 or 12 at the time of the genocide and knew who participated. He had approached his father about confessing his part in the genocide, which he did. In this way, theatre mirrors the stories of their lives (see Image 12).

## FROM 'BOTTOM-UP' TO 'TOP-DOWN'

While associations developed as 'grassroots initiatives' in the past, today the conflict management department of the NURC provides training in the development of associations and includes the following themes in its curriculum: civic education, peace building and conflict management and

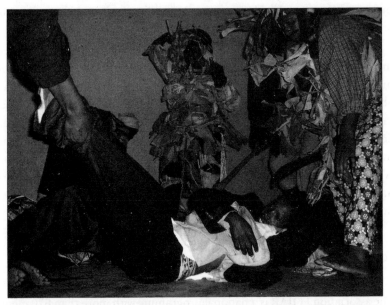

**IMAGE 12** Theatrical enactment of the interahamwe, Rwanda, 2005. Courtesy: Ananda Breed.

the national policy on unity and reconciliation. Associations are provided with a manual and trained to mobilize funds for peace projects. As revealed in an interview with me on 13 April 2010 in Kigali, Laurence Mukayiranga, the acting director of peace building and conflict management, said that the associations have been guided towards creating cooperatives, linking unity and reconciliation with goals of development: 'The development programme for the government commission focused on training associations, but not on poverty reduction. Associations need development; they need to produce as part of the national policy to become a cooperative at a district level.' Although associations previously worked independently, soliciting for individual project grants, the new scheme requires associations to join a forum at a district level to develop a cooperative project plan with other regional associations. To join cooperatives, associations must provide bank statements and demonstrate sufficient funding. Associations such as AJDS claim that the new government cooperative scheme has adversely affected their ability to produce plays based on regional issues due to co-option into larger development schemes rather than concentrating on local issues. Thus, although I have highlighted different grassroots associations that developed as local initiatives, there is a difference between local communities that use the arts as a tool for community building and those that are established under the auspices of the NURC.

Of the 300 associations tracked by the NURC in 2005, 60 were funded through it. In terms of generating grassroots associations throughout the provinces, NURC director of Planning and Programme Management, Shamsi Kazimbaya stated in an interview with me on 18 November 2005, that capacity-building trainings were conducted nationally. The local is then tied to the national and potentially international funding bodies representing the messages generated through a top-down rather than bottom-up process. While I have illustrated some bottom-up approaches to reconciliation through grassroots associations, the final example of FOJAR demonstrates that local initiatives are invariably located within the national framework.

GOVERNMENT-SPONSORED ASSOCIATIONS

FOJAR, KIGALI PROVINCE

The association FOJAR is a national programme with more than 670 members from round the country. Members include soldiers, army personnel,

perpetrators and survivors of mixed ethnicity and age. The association was created in 2004 by army personnel and has worked extensively in prisons across Rwanda. FOJAR is an example of how grassroots associations can be linked to national programmes of reconciliation. Regional FOJAR groups are united under the auspices of a national organization. The messages presented through theatre, dance and music are directly connected to the government, as FOJAR has been primarily funded through government reconciliation campaigns.

The FOJAR production *Umusanzu Ukwiye* (Real Support) was performed at Amahoro Stadium in Kigali on 12 April 2005. The front rows were reserved for government officials and NGO personnel. Surrounding the performance area were bleachers on either side, filled with several hundred audience members. After a speech by the minister of Youth, Sports and Culture, preaching tolerance, the army band performed various songs about justice and reconciliation. Theogene Ntamukunzi, a musician at the time of the genocide and now a member of the band, sang reconciliation songs. Ntamukunzi is a popular musician in Rwanda; thus public association with his music before and after the genocide embodies the ideal of a reformed Rwandan. He has written over 80 songs, the first of which was produced in 1986. In an interview with me on 13 April 2006, Ntamukunzi stated:

> I was first commissioned by NURC in 1998 to sing songs for refugees to come back to this country. I began singing songs in the ingando—to sensitize those from other countries about the peace process in Rwanda. Today, you see ministers going into villages to sensitize people; that's how I got the idea to tell refugees to come back—through the leaders. From 1980 to 1986, I wrote songs, but they were primarily love songs for the radio, although there were other artists who were writing songs for the genocide.

During the production, songs by Ntamukunzi generated singalongs and enthusiastic audience response. Likewise, several reconciliation songs were well known to the audience, eliciting widespread media coverage of Ntamukunzi and FOJAR. Before and after the show and during scene transitions, the band performed with dancers. The dances were a mixture of the modern and traditional, fusing dance styles in a fashion similar to efforts by the National Ballet of Rwanda to integrate forms usually associated with Hutu, Tutsi or Twa. Arm movements shifted between high above the

head (Tutsi, Central Rwanda), level to the shoulders (Hutu, Northern Rwanda) or below shoulder level (Twa, interspersed areas). Characteristically, arm movements begin in the shoulder and twist into the palms of the hands. During the FOJAR performance, the fluid arm movements were often broken with straight symmetric movements, incorporating modern and various pan-African dance forms. Given the mix of dance styles and diversity of performers—army soldiers, ex-FAR soldiers, survivors, perpetrators, youth and elders—the performance illustrated a starkly different symbol of Rwandanicity from that of legendary theatre. Whereas legendary theatre preached Rwandanicity through cultural forms steeped in imagery created by exiled Tutsi, FOJAR performed in stadiums and prisons, reaching vastly different demographic and explicitly cross-integrating cultural forms. In June 2003, FOJAR performed *Cyezamitima* (To Purify the Heart) in seven prisons across Rwanda. In an interview with me on 5 August 2005, FOJAR Director John Ngabonziza acknowledged that several prisoners confessed immediately after the performances. Thus, like grassroots associations such as JACOC, government-sponsored FOJAR has also employed theatre to elicit confessions.

FOJAR replicates grassroots association efforts to integrate survivors and perpetrators by performing reconciliation. Beyond the rural grassroots examples, FOJAR is a national model, performing in large stadiums and integrating entertainment elements for wider consumption, including music bands, dancers and costumes. It also creates a model of collaboration between the government (army personnel) and ex-FAR. In this way, the government and local community (or performers who represent the local community at a national level) perform as a unified company. Messages in the performance highlight government campaigns.

The performance of *Umusanzu Ukwiye* began with ex-FAR soldiers in the Congolese jungle, on the border between Rwanda and the DRC. Following radio sensitization campaigns, several interahamwe were convinced that they should return to Rwanda, including a young man living in the jungle with his parents. The son expressed his desire to go back to Rwanda but his parents were involved in the genocide. 'If you go back to Rwanda, you will be killed directly because you will either face gacaca or be murdered,' said the mother. Eventually, the family was persuaded to return and surrender to RPF soldiers patrolling the border. Following the opening scene, the band performed a reconciliation song:

The white people came to say we were Hutu/Tutsi/Twa, but we have to reconcile to be together. The only medicine I give you is gacaca, back to the roots to stop the war. Let's sit down under the tree and say what happened to be in a peaceful country.

The subsequent scenes illustrate stock messages found in most theatrical performances based on justice and reconciliation: a Tutsi woman joins a women's association for development; her daughter falls in love with the son of the Hutu family (his father was a culprit of genocide crimes against her family). The Hutu woman convinces her husband to confess and eventually the two families are reconciled. Dialogue at various points in the play illustrate government-driven messages:

A SCENE FROM THE PLAY:
*Man enters drunk, singing a war song—changes to a love song when he sees his wife.*
WOMAN. Where have you been? The priest at church asks for one thing—forgiveness.
MAN. I love you so much, but when it comes to Sunday I love you the most.
WOMAN. The three ethnic groups should come together and form one word—love.
MAN. I have one question. If someone talks about unity and reconciliation like the Ministry of Sports, Youth and Culture, how do you see it?
WOMAN. If I tell you about reconciliation, it is when people forgive each other. That's what I understand by reconciliation. Also, our daughter is going to be married.
MAN. Why didn't I know?
WOMAN. You haven't been around. He's a handsome man named Bosco. He's from a Hutu family. Bosco was taught about unity and reconciliation. He went to ingando and wants to marry our daughter.

The dialogue touches on the role of the church, the necessity for reconciliation and forgiveness, and the redemption of perpetrators by going through the indoctrination of Rwandanicity at ingando. At the end of the play, the young Hutu man and the young Tutsi woman speak to one another in private. He discloses a dream he had while in the jungle:

I accepted that I needed to either go back to the fighting or come back to Rwanda. During the war, I had a dream where I didn't know who was fighting with whom. Finally, I understood that it wasn't Hutu or Tutsi, but it was other countries fighting each other.

As one of the closing sentiments of the play, moral and political responsibility for the conflict between the Hutu and Tutsi is put on international powers. During the final scene of the play (i.e. the meeting between both families), the father pleads forgiveness: 'I ask for forgiveness because I didn't think about the wrong that I did. I will ask for forgiveness, like all Rwandans, for what I did. I want all of us to stand up and to fight against genocide ideology.' The audience of more than 600 people stood up and applauded. The performance ended with a speech by the minister of Sports, Youth and Culture. The band played an upbeat reconciliation song, and the audience was invited by the minister to join him for a closing dance. Hundreds of individuals accepted his invitation, dancing and singing along with the band.

The example of FOJAR demonstrates the integration of regional associations into government reconciliation campaigns. The national variation of associations differs from the local context of how individual perpetrators and survivors develop associations within their own communities to create an alternative space of coexistence; thus government-driven associations may potentially alter the impact or effectiveness of empathy that drives the success of local initiatives.

## TELLING MY STORY IS MY MEDICATION

Several grassroots associations emerged in response to the genocide to create a different 'space' for perpetrators, survivors and community members to live side by side. In these, as well as in government-sponsored associations, theatre has been used as a process and a tool for reconciliation, created by individuals and communities who seek answers to the question of how to move forward.

While theatre-making may be, in the words of the Rwandan minister of Culture, a part of the 'explosion of the arts after genocide', theatre is being performed through pre-scripted histories embedded in non-neutral cultural forms. Grassroots associations perform ethnic identities and counter-hegemonies to the prescriptive government version of Rwandanicity,

integrating local narratives and regional forms into their theatre and dance performances. In this way, they use performance as one vehicle to explore differences and to self-identify through the art form itself.

Whereas Abiyunze represents survivor-and-perpetrator associations that use theatre to make coexistence possible after the horrors of the genocide, AJDS and JACOC are youth associations envisioning a new future in which genocide will never happen again. Both associations use personal stories and represent events from the genocide particular to their communities. They primarily perform their reconciliation by actually demonstrating survivors and perpetrators living together peacefully and orphans identifying themselves as the sons and daughters of survivors and perpetrators without differentiating on the basis of who belongs to what category. Frederick Kabanda of AJDS stated in an interview with me on 20 July 2005: 'Telling my story is my medication. My brothers and parents were killed in the genocide. Not enough young people are telling their story, which is a problem.' Asked to identify the orphans of survivors and perpetrators, he said: 'We do not like to say who came from what background; we all move forward together.'

While the apparent impetus and initiative to create these associations have come from the grassroots, I argue that associations are vulnerable to becoming instruments of government propaganda to disseminate political messages. Histories and identities are connected to the cultural forms being used. Thus, performance for reconciliation may hold political tensions. Although some associations have used theatre to mediate relationships between perpetrators, survivors and community members, it has also been used to elicit confessions. In this way, the establishment of moral communities through associations created by perpetrators and survivors can be countered by campaigns of justice-theatre to elicit confessions for gacaca. The case studies depict how theatre is used as a space of encounter to create moral communities through survivor-and-perpetrator-led grassroots associations, as a vehicle for incrimination by youth-led organizations and to perform Rwandanicity at community and national levels. Although I have suggested how local-level practices of reconciliation may be co-opted into government campaigns, it is not to claim that all government-driven campaigns are negative but, rather, that justice and reconciliation might not meet the same objectives to rebuild communities following the genocide.

## Notes

1 I conducted workshops with these associations to exchange theatre games and exercises, observe their plays and interview the participants.

2 Killings began in 1990 and continued until the end of the genocide, in part as a result of the protection provided to Hutu forces by the French military in the region under the auspices of Opération Turquoise.

3 Similar to Elaine Scarry's (1985) concepts of making and unmaking the world, the role of the arts in terms of grassroots associations can be to mend or remake the world through a new moral order.

4 Louis Bickford has given examples of unofficial truth projects including the Ardoyne Commemoration Project (ACP) in Northern Ireland which commemorates 99 residents of Ardoyne who were killed as a result of political violence), publishing 350 testimonies and 50 oral histories: 'The ACP's function was to highlight the hidden history of the conflict in Northern Ireland, as lived by one community, in order to reclaim and commemorate the victims' past from misrepresentation [. . .] Each participant was given complete editorial control over their segment, and allowed to preview other people's contributions for their friend or family member' (2007: 1014–15).

5 Additional influences for grassroots associations engaged in theatre are found in the dramatizations designed for the national gacaca sensitization campaigns, including the widely disseminated gacaca play by Kalisa Rugano as well as *The Liberating Truth*, the screenplay by Hope Azeda.

6 The performativity of a unified Rwanda without ethnic labels has been referred to as Rwandanicity in earlier chapters. See Rusagara (2005).

7 One member, who serves in an advisory capacity, is 38 years old.

## *UKURI MUBINYOMA* (TRUTH IN LIES): THE PERFORMATIVITY OF RAPE AND GENDER-BASED VIOLENCE

> During the gacaca trials, women don't speak openly about rape. They go to the local gacaca district coordinator to give their testimonies. I have heard such horrible stories about rape. There was one case where a woman was ripped wide open from her vagina up through her body. Pepper was put inside her vagina and she was tied to a tree for everyone to see her. There are many stories like this, women being openly tortured and raped for the public to see.
>
> —A gacaca district coordinator

Rape is used as a systemic weapon of war, strategically terrorizing communities, forcing the rapist's ethnic identity upon the victim reproductively and performing the dehumanization and violation of the other as part of a campaign of ethnic cleansing.[1] The performativity of rape in Rwanda is related to its use as a weapon of war. The performative dimension of violence as outlined in the quote above exemplifies the spectacularization of rape during the genocide as a public act of Tutsi annihilation, the encoding of ethnicity (Hutuness) upon the female body through an enactment of power, subverting Tutsi identity through reproductive means.

The UN estimates that over 250,000 women were raped during the genocide. In the wake of this mass rape, legal tools for attempting to achieve justice included the designation in 1998 of rape as a crime against humanity. Pauline Nyiramasuhuko, the ex-minister for family and women's affairs in Rwanda during the genocide, had instructed the militia: 'Before you kill the women, you need to rape them' (in Zimbardo 2007: 13).

In this chapter, I propose that gender-based violence during times of conflict and during times of reconciliation or 'post conflict' should be noted as a continuum of violence embodied and enacted through larger narratives of power discourses concerning gender, identity and nation building—as is the case in post-genocide Rwanda. Though gender-based violence was used as a weapon during the genocide, gender can be 'performed' as a force for unification by elevating women to positions of authority. Between these two, domestic violence continues, exacerbated by residual trauma of the genocide violence and gender-based violence in reaction to the relatively quick emancipation of women to elevated economic and social positions.

I present here an overview of how rape was used as a tool for ethnic cleansing during the genocide, connecting rape to structural violence, followed by an illustration of the continuum of gender-based violence through Ukuri Mubinyoma—a participatory theatre project I co-directed with the Mashirika Creative and Performing Arts Group that toured Rwanda between March and June 2006.

## STAGING SOVEREIGN BODIES

Historically, women have been used during conflict as commodity (the victor taking women for material and sexual gain), for reproductive generation (reproducing the victor's ethnic identity through the woman) and as a symbol of nationalism to humiliate and violate (literally stripping the 'motherland').[2] Rape forces the identity of the aggressor upon the female form, as a conquest of geographic and sovereign spaces. Similarly, the use of extreme sexual violence and the spectacle of rape in Rwanda served a particular function: to create a Hutu nation, cleansed of Tutsi.

Cynthia Cockburn relays the gendered dimension of conflict, including stages of violence as 'the phenomena of economic stress and impoverishment, militarization and divisive shifts in the way identities are represented' (2001: 13). She does not isolate rape in terms of the violent act itself but, rather, lays emphasis on the societal and political factors enacted and performed through rape. Cockburn claims that with economic stress and the growing threat of conflict, gender becomes increasingly differentiated.

One warning sign of impending political violence or armed conflict is divisive shifts in discourse, particularly in media representations. Words chosen, tunes sung and images painted stoke the fires of patriotism and

hatred towards a rival nation, point a finger at 'the enemy within' or deepen the sense of ethnic belonging in opposition to some 'other' or from whom 'we' are different and by whom our culture or our religion, our very existence, is threatened. This divisive discourse is often accompanied by a renewal of a patriarchal familial ideology, deepening the differentiation of men and women, masculinity and femininity (ibid.: 19).

The Hutu Ten Commandments, a widely disseminated manifesto in the newspaper *Kangura*, originally published in December 1990, demonized Tutsi women as whores and called for the abolishment of inter-ethnic marriages or relationships. The first three commandments explicitly targeted Tutsi women as the cause of moral, economic and social decline in Rwanda.

1 Each Hutu man must know that the Tutsi woman, no matter whom, works in solidarity with her Tutsi ethnicity. In consequence, every Hutu man is a traitor: who marries a Tutsi woman, who makes a Tutsi woman his concubine, who makes a Tutsi woman his secretary or protégé.

2 Every Hutu man must know that our Hutu girls are more dignified and more conscientious in their roles as woman, wife, and mother. Aren't they pretty, good secretaries, and more honest!

3 Women, be vigilant and bring your husbands, and sons to reason! (Organization of African Unity 2000)

According to the Human Rights Watch (1996) report, 'Shattered Lives: Sexual Violence during the Rwandan Genocide and Its Aftermath', Tutsi women were blamed for the unemployment of Hutu: 'Another issue of *Kangura* accused Tutsi women of monopolizing positions of employment in both the public and private sectors, hiring their Tutsi sisters on the basis of their thin noses (a stereotypically "Tutsi feature"), thereby contributing to the unemployment rate of the Hutu, particularly Hutu women'. *Kangura* used cartoons to manipulate Tutsi women into sexual subjugation, portraying Hutu men in positions of sexual and political power. Thus, the performativity of rape in Rwanda is also explicitly tied to the propaganda that fuelled the genocide, drawing heavily on the images and iterations of Tutsi women as enemy forces to be dominated and conquered. As such, sexual violence during the genocide was correlated with issues of economy and power. The sexual violence of rape is an act of war, inflicted and performed on the body of a woman.

During the genocide, rape and other forms of gender-based violence were directed primarily against Tutsi women. The extremist propaganda exhorted Hutu to commit the genocide, specifically identifying the sexuality of Tutsi women as a means through which the Tutsi community sought to infiltrate and control the Hutu community, and fuelled sexual violence against Tutsi women as a means of dehumanizing and subjugating all Tutsi (ibid.).[3]

Catharine A. MacKinnon has argued that a connection exists between the sexual subjugation of women and pornography, defining the latter as the sexual exploitation and subordination of women, whether in pictures or in words (see McGowan 2005). The sexualization of Tutsi women in *Kangura* occurred through images and text. MacKinnon has compared rape in war with rape in peace; one is in direct relation to the other (see Niarchos 1995: 651). The explicit degradation of women promotes gender-based violence through authoritative speech acts—the articulation of violence that brings it into being, as imposed by the government or persons of authority.[4] According to Mary Kate McGowan, the connection between pornography and speech acts is that 'authoritative speech is able to enact social facts of gender hierarchy' (2005: 33). In terms of performativity, sexually explicit propaganda that subordinated Tutsi women became part of a larger discourse concerning acts of government officials who used rape as a weapon of genocide, linking to the performative dimension of rape a coming into being of that which is named.

The connection between the sexualized subordination of women and rape can be analysed as a continuum of violence. Besides being used as a tool to physically and emotionally eradicate Tutsi, rape was also used for the economic control of resources. Meredith Turshen (2001) explores rape as political and economic violence. During the genocide, the properties of Tutsi and Hutu moderates were quickly confiscated. In a related way, Hutu militiamen sometimes became the protectors of Tutsi women they raped. The interahamwe, who otherwise may not have been able to afford dowry for a wife, imposed forced marriages on Tutsi women. According to Turshen, these pairings led to a political economy of rape that included the use of women for productive labour, for instance, working on the land for agricultural capital. Turshen also explains: 'The militia disguised rape as sanctioned intercourse between husband and wife by performing bogus weddings; they then used the "marriage" to legitimate

the seizure of land' (ibid.: 63).[5] The spurious ceremony led to a legal fiction in more ways than one: under Rwandan custom, a woman did not possess rights to land and at marriage ownership would have passed to her husband (ibid.: 66).

The political economy of rape involved reproductive labour and land acquisition, but rape as a performative act inflicted Hutu nationalism as a commonly public and communal (gang rape) act of violence. In Rwanda, ethnicity is carried patrilineally. Rape was thus a method to cleanse Rwanda of Tutsi by inflicting Hutu identity as a demonstration of state power. Rape was used not only to impregnate Tutsi women as carriers of Hutu children but also to either dismember their reproductive anatomy (as in the example presented at the beginning of the chapter) or to ensure their social exclusion from their community (ibid.: 62). Rape was institutionalized as a weapon of war. Turshen writes: 'Militarized rape is a distinct act because it is perpetrated in a context of institutional policies and decisions' (ibid.: 63).

The Kinyarwanda word used (ironically) for rape during the genocide was *kubohoza*, which literally means 'to help liberate'. Politicians first used the word to describe the coercion that led people to change political parties; people later applied it to the forcible taking of land and resources (Human Rights Watch 1996: 39).

The following section addresses legal structures that respond to testimonies of rape in Rwanda and raises questions regarding the performativity of rape through subsequent events, including transnational responses to human rights testimonials and witnessing.

## PERFORMATIVITY OF RAPE

The opening quote of this chapter from the gacaca district coordinator explicitly describes the spectacle of rape, a women being ripped apart and pepper being poured into her vagina. The gacaca coordinator verified that her testimony was not unique, as he had often heard similar testimonies. During the genocide, women were brutally raped, for public display at roadblocks or community settings, often with instruments such as wood clubs and machetes. Catherine N. Niarchos generalizes rape as spectacle: 'Many rapes involve the element of spectacle, occurring in the presence of the victim's family, the local population, or other victims. Many victims have suffered multiple rapes' (1995: 657).

The crime of rape had been granted special deference within gacaca procedures and jurisdiction. To begin with, sexual violence was granted prominent mention in the definition of a victim of the genocide. A victim was identified under Article 34 of Organic Law No. 16/2004 of 19 June 2004 as 'anybody killed, hunted to be killed but survived, suffered acts of torture against his or her sexual parts, suffered rape, injured or victim of any other form of harassment, plundered, and whose house and property were destroyed because of his or her ethnic background or opinion against the genocide ideology' (Government of Rwanda 2004).

Rape was also categorized among the most serious crimes of the genocide—Category One—and was tried in the ordinary courts rather than in gacaca courts. For rapists to be categorized and sent to trial, victims provided their testimonies to gacaca coordinators. However, owing to the speeding up of trials in 2007, various Category One crimes were changed to Category Two, which were heard in gacaca courts (Government of Rwanda 2007).

Through the case study of the Ukuri Mubinyoma project, an anti-gender-based-violence programme incorporating theatre as a participatory methodology to engage audience members throughout the (formerly) 12 provinces in Rwanda, I link the performativity of rape with gender-based violence, as part of the continuum of structural violence. The project aimed to engage local populations in dialogues on gender-based violence. As indicated by the NURC (2005) report, 'The Role of Women in Reconciliation and Peacebuilding in Rwanda: Ten Years After Genocide 1994–2004', current issues of violence against women are intricately linked to the genocide:

> Gender-based violence is still a serious problem in Rwanda. Cases of rape of girls and women, assault and defilement are on the increase with the age of the victim getting lower over the years. Most acts of violence against women take place in the home, which sometime makes it difficult for the law enforcement personnel to intervene. [. . .]
>
> Another factor that is of concern is the consequences of the aftermath of the violence committed to women during the genocide (2005: 16).

The report highlights the significance of rape with regard to current socioeconomic reforms in Rwanda. Rape by HIV/AIDS carriers was one strategy for the implementation of genocide: 'Increasing rates of HIV/AIDS

where more than 250,000 women are victims, 66% of women who were raped tested positive and other infectious diseases coupled with limited health facilities further deteriorate their situation' (ibid.: 17). Those infected had difficulty retaining employment and were sometimes ostracized from their communities. Although rape had been categorized as a crime against humanity, obtaining testimonies from the victims could be difficult either because of the victim's fear of being re-traumatized by the violent events or because of intimidation. The NURC report claims:

> It was also found that women, especially widows, are intimidated by some neighbours who were recently released from detention under the presidential pardon order. Much as one of the public facing Gacaca courts, women tend to feel concerned in testifying. They have lost relatives or have husbands in prison or they are married to men from different socio-cultural identities. This phenomenon is of great concern since it poses [a] big threat to the smooth running of Gacaca courts (ibid.: 34–5).

Alternative venues for human rights discourses that stand outside juridical or commemorative practices may be necessary. Ukuri Mubinyoma sought to address contemporary issues of gender-based violence, using theatre as a vehicle to discuss and disseminate information and to address violence beyond the genocide as being potentially interconnected.

## UKURI MUBINYOMA:
### AN ANTI-GENDER-BASED-VIOLENCE PARTICIPATORY THEATRE PRODUCTION

The various dynamics of rape that have been noted in this chapter cannot adequately document the interconnected effects of its political, economic and cultural ramifications. Yet, what are the implications of structural violence in the aftermath of rape during the genocide? Observing conflict and violence as a child contributes significantly to adult crimes including rape and murder (see Davies 1994). Statistics from a UN report state that up to 80 per cent of children witnessed genocide crimes. This raises concerns of how this will relate to future violence and how a population of women and men who participated in the perpetration of genocide and rape can recover from the cycle of violence. This section links the effects of rape during the genocide to contemporary issues of gender-based violence through *Ukuri Mubinyoma*.

The Ukuri Mubinyoma project, funded by the Coopération Technique Belge with the Ministry of Justice in Rwanda, sought to investigate the causes of gender-based violence, to promote the new law against gender-based violence and to receive information from the public about their experiences of gender-based violence through focus groups, interviews and post-show discussions. In collaboration with the Mashirika Creative and Performing Arts Group, the Ministry of Justice promoted a national tour of the play, *Ukuri Mubinyoma*, which was designed, in part, to sensitize the public about Law No. 59/2008 of 10 September 2008. Gender-based violence is defined in Article 2 of the law on Prevention and Punishment of Gender-Based Violence as 'any act that results in a bodily, psychological, sexual and economic harm to somebody just because they are female or male. Such an act results in the deprivation of freedom and negative consequences. This violence may be exercised within or outside households.'[6]

*Ukuri Mubinyoma* was co-directed by Hope Azeda and written by Sam Kyagambiddwa through a series of devising workshops. I wrote the initial funding bid and collected data during the course of research trips to Rwanda from 2005 to 2006 (including previous research that informed the project). The project included two preliminary focus groups, one each in a rural and an urban area. Following each performance, I conducted interviews with community members in each of the 12 provinces. The number of interviewees ranged from 10 to 30 between provinces. I travelled with the tour, observing all performances, and met regularly with the Ministry of Justice to discuss the script, adjusting to feedback and responses from the population.

Each performance included a post-show discussion with the local community to discuss the implications of gender-based violence in their community and connections to potential causes and solutions. The script was devised through initial research provided by local non-governmental health organizations in Kigali, including Urunana, focusing on gender-based violence. Under the directorial guidance of Azeda, actors from Mashirika rehearsed scenes related to the issues presented, eventually creating a production that included moments of audience participation to serve as an evaluative barometer, to test audience attitudes towards gender-based violence and to enlist moments of potential intervention. The strategies of participatory theatre commonly associated with Augusto Boal's

Theatre of the Oppressed techniques encourage the audience or spectators to intervene during moments in which alternative actions or decisions by the protagonist could overcome oppression—to turn spectators into 'spec-tactors' (see Image 13).[7] Here, I provide a detailed description of a per-formance followed by post-show interview data that relates domestic gender-based violence to the genocide, rape and, potentially, the cyclical nature of gender-based violence.

The van carrying nine performers brushed past banana plants along dirt tracks until it arrived at the destination of a community-centre hall. An actor called out the time and place of the upcoming performance through a bullhorn, as a couple of schoolchildren followed the van. After disembarking, the actors changed into the costumes commonly worn in the rural areas and drew crowds with drumming and dance. The perform-ance was primarily based on the plight of a married woman, Anonciata, who seeks to earn money through a women's collective (see Image 14). The husband, Calixte, fearing her new social and economic independence, turns to drinking and womanizing. In the hope of buying a sewing machine to generate additional income, Anonciata hides her money so that it

**Image 13** Audience participation during staging of *Ukuri Mubinyoma*, Rwanda, 2006. Courtesy: Ananda Breed.

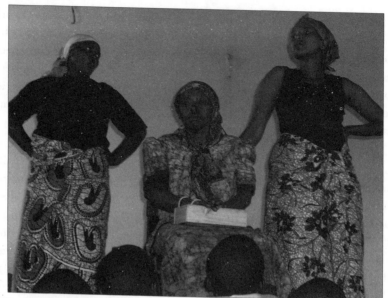

**IMAGE 14** Anonciata (seated) in a scene from *Ukuri Mubinyoma*, Rwanda, 2006. Courtesy: Ananda Breed.

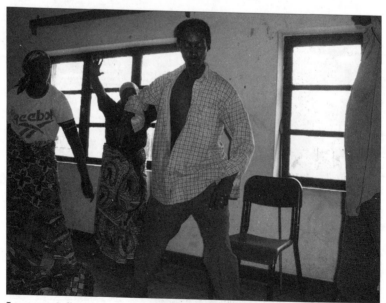

**IMAGE 15** Calixte in a scene from *Ukuri Mubinyoma*, Rwanda, 2006. Courtesy: Ananda Breed.

doesn't get swallowed up by Calixte's alcoholism. One evening, after drink-
ing at the bar, Calixte finds the hidden money and confronts Anonciata.
The skit ends in a climax, the husband about to strike, with the women's
associations just outside the door (see Image 15). One actor, who played
the 'joker' in the performance, stopped the action and asked the audience
what could or should be done about the situation.[8] The reactions from
the community were mixed. Several men announced their disdain of the
woman for disobeying her husband. There were a few women who argued
for the need to earn their own livelihood. Common responses during
post-show discussions included the potential link between the prevalence
of rape during the genocide and the customary witnessing of extreme vio-
lence, and the potential cyclical nature of enacting violence.

Of the 12 provinces that the anti-gender-based-violence project toured,
Byumba was known for epidemic levels of gender-based violence. In Byumba,
the traditional practice of *guterura*, where a man takes a woman by force,
usually in cases where the man is unable to afford the dowry, is a form of
violence against women. Gender-based violence also stems from the residual
trauma of the genocide as well as alcoholism. In an interview with me on 10
July 2005 in London, Rwandan scholar Alice Mukaka explained some of
the causes of gender-based violence stating that conflict arises when men
cling on to the traditional image of the woman as subordinate and women
become aware of their roles in society and gain economic independence:

> Today, in Rwanda, women play a big role in society by holding
> positions of power in government, raising orphans and being the
> heads of household while a large number of men are in prison or
> have been killed in the genocide. The government has responded
> by empowering women by changing laws that give them greater
> rights, rewriting the constitution and giving power in civil society.
> Since the role of women has changed drastically, there is conflict
> between the past and the social and economic changes of today.

Particular to Byumba, audience interventions occasionally sided with
the oppressor, the character of Calixte. However, other audience members
argued against gender-based violence and supported women's associations.
Thus, the project actively engaged the community in debate, with contin-
uous support enforced through the attendance of representatives from
the Ministry of Justice and local government officials. Future performances
were announced on the radio, stating the date, time and venue. Also,

before each performance, the logistics coordinator met with local stake-
holders in the project, including health and safety officials. After the per-
formance, there were discussions regarding issues of gender-based violence
specific to each community. Some of the questions in individual interviews
included the following prompts: 'What do you think are the causes of
gender-based violence? What do you think are solutions to prevent it?
What should happen to Calixte? What suggestions would you give to
Anonciata? How should associations respond in such situations?' Audience
members responded with comments reflecting a range of experiences
and levels of familiarity with the issues, but there were quandaries about
how to use the law in an economically fragile situation. For example, one
audience member stated that even if the husband went to jail for beating
his wife no money would come into the household while he was in jail.
Interventions by the audience focused on the necessity to educate or sen-
sitize men to break away from traditional structures, to support women's
emancipation, and for women's associations to have connections to and
support from the local authorities. Overall solutions depended on societal
and collective sensitization supporting the changing role of women in
society and the support of the local community.

In terms of local support for women's rights, associations have been a
primary vehicle for women's rights and education and for providing assis-
tance to survivors of the genocide. A report by African Rights states:
'Women's associations are, at present, the main source of assistance for
rape victims and women living with HIV/AIDS; both in Rwanda and Burundi
they have proven their value. In terms of education and moral support they
provide a critical link between women and services and must be encouraged
and facilitated' (2004: 88). The associations are often developed by women
who have been affected by the economic and social perils of the genocide
and its aftermath and are keenly sensitized to empathize with one another,
whether a survivor, a wife of a detainee or a widow. For instance, the Asso-
ciation des veuves vulnerables affectees et infectees par le HIV/AIDS
(AVVAIS; Association of Widows Affected by and Infected with HIV/AIDS),
which I visited during a research trip in 2006, comprised 350 widows of the
genocide, 750 women whose husbands were in prison and 750 orphans.
The association works not only towards national goals of unity and recon-
ciliation but also for development. Similar to the dramatic plot of *Ukuri
Mubinyoma*, the association raises funds for sewing machines and breeds

goats to increase the livelihood of women in the local community. However, the number of survivors within this association who were raped or who currently suffer from gender-based violence has not been adequately researched.

## ROLE OF WOMEN IN POST-GENOCIDE RWANDA

Following the genocide, 70 per cent of the Rwandan population was female. The Government of National Unity in Rwanda has dealt with the large number of widows and the dramatic gender disparity by addressing cultural gender inequalities through the empowerment of women, by giving them positions of authority in the public sector and through the support of women's associations. Both the former executive secretary of the NURC, Fatuma Ndangiza, and the former executive secretary of the NSGJ, Domitilla Mukantaganzwa, are women. Rwanda ranks first among all the countries of the world in terms of the number of women elected to parliament (Powley 2008: 154).

Gender plays a vital role in the violent conflicts during and after the genocide, as well as in reconciliation processes in Rwanda. Although I have looked at the performativity of rape through a gendered analysis, there are alternative discourses regarding gender and the role of women before and after genocide. Development initiatives used for recovery from genocide and the vulnerable positions of widows and survivors have affected the fabric of civic life.

Women in Rwanda today figure among many of the inyangamugayo, a distinction traditionally taboo for them. Grassroots associations also promote women as the heads of households and as income generators. Though the performativity of rape during the genocide was to rid Rwanda of Tutsi lineage and the notion of a Tutsi 'motherland', in post-genocide Rwanda, equal rights for women and the acknowledgement of gender-based violence is performed on a national and international scale through theatre, judicial courts and development initiatives to perform a unified Rwanda.

## CONCLUSION

The Ukuri Mubinyoma project was conducted during the same time period as the gacaca courts. Thus, while issues concerning gender-based violence

were debated through the participatory theatre project on a national level, testimonies of rape were presented in juridical courts. In relation to the incrimination of rape on the international stage, Hesford states that 'rape becomes recognized as a human rights violation, women become distinct subjects of international human rights law. They become post-national citizen-subjects in the sense that their identities are now defined in the juridical context of international law rather than exclusively by the nation-state. Their citizens and identities are also not defined solely in terms of suffering and injury' (2004: 124). Hesford highlights the working through of trauma as a 'rhetorical negotiation' between 'available cultural and national scripts and truth telling conventions' (ibid.: 108).

The Ukuri Mubinyoma project sought a different kind of 'rhetorical negotiation' by considering rape as a continuum of violence linked to current violations of gender-based violence to claim that gendered acts of violence are ongoing and may question the notion of Rwanda as a 'post-conflict' zone while violence has increased on a domestic level. By approaching gender-based violence through communal contexts of healing or resistance, it may be possible to expose varied myths and cultural practices that normalize violence.

Myths and legends may have been used to reify Tutsi women as wanton seductresses—the forbidden fruit—but those can also be subverted. An example is presented in the following Rwandan folktale:

A young woman named Ndabaga disguised herself as a young man in order to replace her father who had been forced to grow old in the military because he and his wife had been unable to produce a son. The young woman decided to disguise herself as a man so that she could be admitted in the military camp. She amputated her breasts and dressed in men's clothing to conceal her feminine figure and appearance. In the camp, she acquired the skills of archery and became an accomplished archer, capable of securing first place in the high jump that is so prized in Rwandan military culture. As the days went by, Ndabaga's peers became suspicious of her stubborn search for privacy. They followed her to the little shed she used as a toilet and discovered that the formidable military man was in fact a woman, because she was unable to urinate in a standing position.

Ndabaga's gender was then revealed to the king. Impressed by Ndabaga's exploits, he congratulated her, but at the same time, was compelled to strip her of her military position and cast her out of the military camp. Ndabaga feared that she would not be able to marry because she had been left as a woman without breasts. She was nevertheless saved from ostracism when the king decided to marry her. At the end of the folktale, the king revoked the law requiring soldiers to be replaced by their sons and disbanded the military camp. His action is understood to have been a necessary way of preserving traditional gender boundaries. As he dismissed his army, the king is reputed to have said, 'when a woman goes to war that means things have reached Ndabaga's stage.' The king's utterance has become a part of the collective memory in Rwanda.[ . . .] The English equivalent of the saying is, 'things have gone to the dogs', meaning they have reached the worst state possible (Gallimore 2008: 10–11).

Although this is a well-known folktale in Rwanda, the proverbial meaning was challenged when a group of female ex-combatants formed the Ndabaga Association to find and create possibilities for work (ibid.: 25). The roles of women in Rwanda have challenged traditional notions of gender not just in relation to war but also through an understanding of how structural violence exacerbates gender-based violence.

International law against rape may have created 'post-national citizen subjects' but the increased influx of international rights-based agendas must continue to engage with the cultural specificity of the communities and contexts from which gender-based violence may emerge and question post- or pre-conflict conditions when violence continues to be staged on woman as sovereign bodies.

*Notes*

1  For more information about rape and gender-based violence related to war and post-conflict contexts, see Catharine A. MacKinnon (1998), Tina Sideris (2001) and Meredith Turshen (2001).

2  See Catherine N. Niarchos (1995).

3   In addition to *Kangura*, anti-Tutsi propaganda was disseminated in other media, including in popular songs by musicians such as Simon Bikindi.

4   On speech act theory related to 'performativity', see Austin (1962) and Butler (1990).

5   Rwandan law in this area has been amended following the genocide and can be found in the *Official Gazette of the Republic of Rwanda* 22/99 of 12/11/99. See http://www.migeprof.gov.rw/IMG/pdf/MATRIMONIAL_-REGIMES_LIBERALITIES_AND_SUCCESSIONS-2.pdf (last accessed on 24 December 2013).

6   The inclusion of partners, such as the Ministry of Justice and local health organizations, ensured experiential and factual information within the messages promoted through *Ukuri Mubinyoma*. See http://www.hsph.harvard.edu/population/domesticviolence/rwanda.genderviolence.08.pdf (last accessed on 13 January 2014).

7   Augusto Boal's techniques are used worldwide; community participants enact solutions through theatrical interventions that rehearse for political and social change (see Boal 1992).

8   The term joker refers to the role of a theatrical facilitator in Boal's Theatre of the Oppressed. The joker mediates between the actors and the audience to encourage dialogue.

TRANSNATIONAL APPROACHES TO MEMORIALS
AND COMMEMORATIONS: CRISIS OF WITNESSING

The international community failed to witness the genocide of 1994. At
the height of the genocide, there were only 15 reporters in Rwanda, while
over 2,000 were in South Africa for Nelson Mandela's presidential inaugu-
ration. Although more than 2,000 UN troops were in Rwanda prior to the
genocide, the peacekeeping troops withdrew during the genocide, leaving
only 270 troops (see Power 2002). The failure of international witnessing
(and intervention) in the first instance has led to varied memory projects
and commemorative and memorial acts calling for secondary witnessing
in Rwanda. The Rwandan government's condemnation of the international
community for its failure to witness and to intervene illustrates the political
function of guilt in rebuilding post-genocide Rwanda. Using the genocide
as the traumatic point of departure for secondary witnessing creates a crisis
of witnessing—as memorials and commemorations stage a particular rep-
resentation of the genocide that can be used for political agency. Hesford
uses the phrase 'crisis of witnessing':

> [t]o refer to the risks of representing trauma and violence, rup-
> tures in identification, and the impossibility of empathetic merg-
> ing between witness and testifier, listener and speaker. A critical
> approach to the *crisis of witnessing* as it pertains to the representa-
> tion of human rights violations therefore prompts us to question
> the presuppositions of both legal and dramatic realism that urge
> rhetors (advocates) to *stand in for* the 'other' on the grounds that
> such identifications risk incorporation of the 'other' within the
> self (2004: 107; emphasis in the original).

In the case of legal testimony for gacaca and testimony for healing, it is important to understand the political and social functions that produce the utterance or text.

Notions of justice are bound to witnessing and providing testimony—as is the case with the TRC and gacaca—but testimony to traumatic events is inherently flawed as the traumatic event itself is consistently in a state of recovering its impossibility. Cathy Caruth states:

> Trauma is not experienced as mere repression or defense, but as a temporal delay that carries the individual beyond the shock of the first moment. The trauma is a repeated suffering of the event, but it is also a continual leaving of its site. The traumatic reexperiencing of the event thus *carries with it* what Dori Laub calls the 'collapse of witnessing', the impossibility of knowing out of the empirical event itself, trauma opens up and challenges us to a new kind of listening, the witnessing, precisely, *of impossibility* (1995: 10; emphasis in the original).

This chapter explores the tenuous negotiation between the 'crisis of witnessing' and the 'impossibility' of testimony and justice, in relation to memorials and commemorations in Rwanda. The role of trauma is addressed through the processes of witnessing and providing testimony, triggered by the screen memory of the Holocaust to construct collective (and transnational) memories. Although witnessing may be an integral component for the teller to 'transfer it to another outside oneself and then take it back again, inside' (Laub 1992: 69), the intimate encounter between the teller and the witness becomes distorted when the witnessing is by a mass audience (international) and potentially does not promote the same characteristics of 'telling as healing' as when delivered to an individual witness as listener. Further, testimony and witnessing can be modes of discourse that perpetuate Rwandan tensions and international profiteering from Rwanda.[1]

Memorials and commemorations have been used as political tools not only for reconciliation, which is sometimes the case, but also to fuel a militant state. The horrors of the genocide and the slogan 'never again' are being used to silence political contestation. For instance, President Kagame, in his commemoration speech at the Nyamasheke commemorative event on 7 April 2006 (which I attended; see Image 16), warned the international community against giving 'history and policy lessons', a reminder enforced through his statement: 'The developing world talks about Rwandan

government practices of divisionism.' He then pointed to the memorial in which 153 bodies were placed into the mass grave and said: 'This is divisionism.' While the speech warned against foreign political intrusion, coinciding speeches made by the former president of the survivor foundation Ibuka only raised further alarm concerning current government practices. The president of Ibuka spoke of the need for maximum penalty for all those guilty of the genocide, including bystanders, who stood by and did nothing to stop it.

Every year, a national commemorative event takes place in Rwanda between 7 and 13 April.[2] During this period, new mass graves discovered are dug up and thousands of bodies are excavated and given a burial ceremony. Overnight vigils called *biriyo* provide a space for survivors to give testimonials in the company of fellow survivors.

The theme of the 2006 commemoration was gacaca. The problem with gacaca as a system for both justice and reconciliation is apparent: if over 1 million out of 8 million citizens in Rwanda are currently systemically being accused of the genocide, how does that serve reconciliation? If President Kagame utilizes memorial events such as the commemoration to

**IMAGE 16** At the Nyamasheke commemoration, Rwanda, 2006. Courtesy: Ananda Breed.

send out a message to the international community to not get involved in politics through guilt manipulation, then one must interrogate how and why the memory of the genocide itself is being used to stifle speech and potential human rights abuses.[3] Currently, two official and internationally run memorial sites exist in Rwanda, both funded and operated by the Aegis Trust (UK-based Holocaust centre).

As an observer of the national commemorations in Rwanda, I saw how individuals and groups exhibited traumatic reactions to theatrical re-enactments of the genocide or images from it (photos were often displayed on large screens at Amahoro Stadium during commemorative events). During a performance of *Rwanda My Hope*[4] at Gisozi Genocide Memorial Centre in 2006, a woman had to be carried out from the audience—arms flailing as she screamed, 'She is being dumped in the river! My mother is floating down the Nyabarongo River!'[5] Individual acts of memory are swept into the collective but collective memory is often co-opted towards specific national and political objectives. The memory and embodiment of trauma are staged nationally and reach international audiences and donor communities.

The memorialization and commemoration of atrocities have been embodied and performed through what Diana Taylor has called the 'repertoire' that transmits communal memories and histories: 'The embodied experience and transmission of traumatic memory—the interactions among people in the here and now—make a difference in the way that knowledge is transmitted and incorporated. The type of interaction might range from the individual (one-on-one psychoanalytic session) to the group or state level (demonstrations, human rights trials)' (2002: 155). The enactments of embodied memory are crucial to Rwanda's negotiation of the genocide.[6]

The staging of the genocide and Rwandanicity for an international audience happens on a number of stages beyond those identified in earlier chapters. And it is that international audience and those stages—of commemoration, memorials and life histories of the genocide—that are the main focus of this chapter, to interrogate transnational approaches to memorialization and commemoration, addressing cultural and political practices that circulate discourses of power and visibility (or invisibility).

## TRAUMA AND COMMEMORATION

In 2010, the theme for commemoration week was 'to fight against trauma'. The Ministry of Health reported that 25.58 per cent of the population

suffered from post-traumatic stress disorder (PTSD). In an interview with me on 12 April 2010 in Kigali, Joseph Karangwa, a mental health professional of the National Commission for the Fight Against Genocide, revealed that 280 traumatic episodes were recorded at the national commemoration held at Amahoro Stadium in 2010, in comparison with 100 episodes in 2009, thus almost tripling in frequency. In an interview with me on 21 April 2010 in Kigali, Jane Gatete, who was then the executive secretary of the Rwandan Association of Trauma Counsellors (ARCT), noted that the number of traumatized victims had increased over the years, including trauma cases of youth who never experienced nor witnessed the actual events of the genocide. Patrick Duggan and Mick Wallis write: 'Bearing close witness to a perpetually unresolved trauma can install second-hand memories that are so powerful as to become traumatic in their own right. Moreover, such "collective traumatic memory" can become installed across a culture' (2011: 7). Gatete also remarked that the recitation of graphic descriptions of genocide crimes during gacaca over the years and images displayed during annual commemorations have had severe consequences on the mental and emotional health of Rwandan citizens, resulting in chronic trauma:

> The genocide in Rwanda was different because it was between neighbours, husbands and wives. There are flashbacks, wounds that are still fresh. The cases we get now are much more complicated because the symptoms are chronic since they weren't treated earlier. There is a PTSD crisis in Rwanda. It started with simple trauma that could have been treated earlier but now the cases have become more severe as psychiatric illness. One out of three individuals in Rwanda has trauma.

Various initiatives address trauma, including the training of trauma counsellors. Karangwa explained that, in alignment with the theme 'to fight against trauma', 10 counsellors were trained in 416 sectors, thus 4,160 counsellors were trained in 2010 overall. Staub and Pearlman explain their approach to healing and reconciliation:

> We provide a broader understanding of the psychological aftermath of traumatic experiences, 'beyond PTSD', helping people understand the behavioral, cognitive, emotional, interpersonal, spiritual, and physiological sequelae of violence. We also convey to workshop participants that trauma does not imply

psychopathology or dysfunction. Furthermore, communities can use a neighbor-to-neighbor approach to address trauma: we support people in participating actively in their own recovery. This framework seems to have energized and empowered the people with whom we have worked in Rwanda (2006: 219).

Various arguments have been made against the prevalent diagnosis of PTSD, especially concerning diagnosis in non-Western countries.[7] International intervention for 'psychological trauma' may be one guise to exert control over post-conflict regions and citizens. Social psychology has become endemic to international development, emphasizing the psychological effects of post-conflict trauma and the likelihood of enactments of violence by those exposed to violence, thus the rationalization for international intervention. Although treating PTSD may justify the role of the international community in a post-conflict context, external intervention can be used to manipulate the instability of psychological and social structures inherent to post-conflict scenarios towards alternative political and economic advantages.

## TRAUMATIC EVENT AS A POINT OF DEPARTURE

The history of Rwanda is directly linked to the history of the trauma of the genocide. In my 28 November 2005 interview in Kigali, Straton Nsanzabaganwa wrote the word genocide on a piece of paper. To the left, he drew an arrow with the word past; to the right, he drew an arrow with the word future. The genocide was the epicentre from which history would be rewritten and the future envisioned. Situating history round a traumatic event such as the genocide may create ethical dilemmas if events are recorded to represent singular versus multiple narratives. The events of both 1959 and 1994 are marred not only by violence but also by dramatic shifts linked to the effects of trauma and the necessity for a return to the motherland. The return of the Tutsi exiles under the leadership of Kagame provides a historical narrative in which the RPF saved Rwanda from the genocide.

Writing about trauma as a point of departure, Caruth examines the predicament of situating history in relation to trauma. She uses the example of the Holocaust and the legacy of Jewish migration as 'not so much the return to a freedom of the past as a departure into a newly established future' (1996: 14). Likewise, the post-1994 period in Rwanda marks a new future shaped by the RPF. Here, I draw a parallel to Caruth who applies

Freudian psychoanalysis based on trauma and memory to the exodus of the Jews from Egypt. She comments on Sigmund Freud's 1937 *Moses and Monotheism*, that deals with the subject of the exodus and the return of Israelites constituting history through trauma:

> Centering his story in the nature of the leaving, and returning, constituted by trauma, Freud resituates the very possibility of history in the nature of a traumatic departure. We might say, then, that the central question, by which Freud finally inquires into the relationship between history and its political outcome, is: What does it mean, precisely, for history to be the history of a trauma? (Caruth 1996: 15)

Caruth's theorization of history can be applied to the thousands of Tutsi who fled Rwanda after 1959 (and returned after 1994). Their return to stop the genocide was less a return of the exiles to a period of freedom and more a departure from the past to create a new future.

Genocide as the traumatic point of departure seeps into overarching performances and performatives as various modes of constructing memory to commemorate the genocide in Rwanda, from political speeches to memorials and the narratives of their curators, all function in a highly politicized way. If we were to view the return of Rwandan refugees and the RPF to the history of the trauma of genocide, linked to massacres in 1959, 1973 and the ultimate genocide in 1994, we should also view the repetition as a systemic return to the traumatic event. Duggan and Wallis position trauma's occurrence as 'an experience so extreme as to be inassimilable to existing schemes and is thus unavailable to symbolic manipulation, including narrative. These "unassimilated scraps of overwhelming experience" are consigned instead to other (somatosensory or iconic) neural networks from which they trigger the re-enactments and flashbacks of the trauma-symptom' (2011: 6). They pose the possibility that '[t]he act of re-visioning the experience affords it access to implicit memory and thereby to symbolization and narration. Here, then, is a further aspect in which theatre and performance—this time as a place and space of iterative re-visioning as well as active narration—might have a particular purchase on trauma' (ibid.). Although I critically analyse national commemorative and memorialization practices in Rwanda, varied performances and performatives can be used for 're-visioning' towards symbolization and narration that may lead to healing. However, narration is not necessarily the most appropriate conduit

for personal healing since 'traumatic storytelling' following atrocity is often circulated by larger national and collective narratives connected to justice and reconciliation, as is the case in post-genocide Rwanda.[8] Theatre productions that stage images and events from the genocide might effectively 're-vision' memories, but these memories might trigger narratives that have juridical consequences (as illustrated in Chapter 5).

## ACTS OF MEMORY: COMMEMORATION AND GACACA

The slogan for the 2006 commemoration was: 'Let's remember the genocide while participating in gacaca and have the courage to tell the truth and to fight the consequences of the genocide.' Acts of memory through gacaca and commemoration can be used for justice but it is important to acknowledge that they can also function as tools for vengeance. In a speech at the 2006 commemoration, François Ngarambe, who was then the president of the Ibuka umbrella organization for survivors, warned of the continuing presence of anti-Tutsi genocide ideology in Rwanda and among those who fled abroad, noting that 'there are people who would be happy to finish off any genocide survivors. There is still a war to fight.' He insisted that 'measures should be put in place to speed up justice and to continue the search for genocide sympathizers.' And he demanded the maximum penalty (i.e. life imprisonment) for those who contributed to the genocide.

The speech by Ngarambe was followed by testimonies of survivors. The commemoration ceremony ended with a speech by President Kagame during which he switched from Kinyarwanda to English, clearly in order to deliver a message to the international community in attendance and television viewers.

The commemoration speeches I heard drew clear connections between memory and justice, with both linked to national politics. According to David Lowenthal, '[t]he heritage of tragedy may well be more effective than that of triumph: "suffering in common unifies more than joy does," wrote Renan over a century ago. "Where national memories are concerned, griefs are of more value than triumphs, for they impose duties, and require a common effort"' (1994: 50). Such performative enactments are represented by actual memorials, which function as literal or concretized statements of Rwanda's relationship to the 1994 genocide.

Although numerous memorials and shrines exist throughout Rwanda, there are two internationally funded memorials open to the public, often the first sites visited by tourists and international visitors.[9] Both Gisozi Genocide Memorial Centre in Kigali and Murambi Genocide Memorial Centre in Gikongoro were established by the UK-based Aegis Trust. The trust's construction of a genocide memorial in Rwanda and their continued response to genocide following the establishment of the Holocaust Centre in the UK automatically links the two genocides into a master narrative about the representation of genocide for international audiences. Although erected in the heart of the Rwandan capital, Gisozi Genocide Memorial Centre has been disparaged as a 'Western' construct in part because it was designed and erected by the Aegis Trust (see Laville 2006). Linking memorialization and trauma with international donor aid, I recount my observations based on a tour of Murambi Genocide Memorial Centre.[10]

To understand how this site functions, it is worth sketching my experience of 16 July 2005. On arrival, we were given a guided tour by Emmanuel Mugenzira, one of four survivors of the over 45,000 who were massacred at Murambi Technical School from 21 April 1994 onwards (see Image 17).

**IMAGE 17** Clothes of genocide victims on display at Murambi Genocide Memorial Centre, Rwanda, 2006. Courtesy: Ananda Breed

Mugenzira functions as living proof of the atrocities of the genocide. He showed the dent in his head where he was pounded with the butt of a rifle. Left for dead, he eventually emerged from underneath the corpses and fled by night to Burundi where he was taken to a hospital by soldiers. He lost his wife and five children during the massacre. Mugenzira enunciates his testimony as proof of the genocide, by showing scars and informing visitors of his tribulations. In my interview with him on the same day, he said that he provides the guided tours of Murambi to be closer to his family and so that people 'never forget'. This staged 'repertoire' of trauma serves as living proof of the genocide through the curation of the memorial. It made me question my role as witness to the first-person testimonies of Mugenzira. Rob Baum notes the chasm between testifying and witnessing:

> [A]s one observes and hears testimony (in the ontological presence of one who testifies), the testimony is transferred, in this way constructing its own witness; this occurs with or without the volition of the observer. Thus trauma and its memory, this memory that issues from living bodies as if landscapes, becomes secondary to testimony and its action: witnessing. In that distance between testimony and witness (where the artefact of trauma may never actually venture) lies a chasm into which notions of faith, belief, recognition and transference tumble (2010: 44).

The memorials are intimately connected to commemoration as a repetitive and continuous return to the traumatic event. What are the politics of the 'keepers of memory', the survivors who serve as tour guides in memorial sites? How does trauma become alleviated or embedded through the repetition of their narratives of suffering? Has the consumption of such narratives and atrocity tourism created an economy that places these individuals, who need to repeatedly narrate their traumatic experiences for economic survival, at risk? How do their testimonies dramatize the 'real' in support of larger government campaigns?

In an interview with me on 10 April 2006 in Kigali, a senior official at Ibuka explained: 'Commemoration week is a target for the government to explain to the world what happened. Commemorations and memorials are to communicate information.' He noted that some of the controversies regarding commemoration were because of the fact that the genocide was conducted in the name of Hutu, prompted by a Hutu-dominated political elite, and the commemoration brought back former identities that the

government has been trying to abolish. He also said that memory affects each social group of Rwandans differently and that memorials and commemorations might create frustration. He used the example of a young man attending a commemoration event:

> There may be frustration if a young man has a father in prison; somehow he won't be at ease. It could lead to further division— but it depends on how it is managed—for instance, if you don't give rights to that person. You must speak to him, even if his parents committed genocide. It is important to make him feel at ease.

The statement exposes some of the inherent problems related to how individuals may react to commemoration events, and the distinction between Hutu as perpetrator and Tutsi as survivor, furthering social divisions that remain, after genocide, along ethnic lines.

Lemarchand notes that memories may be constructed differently by different ethnic groups, thus the danger of the national exclusion of ethnic identities in Rwanda and the enforcement of a dominant Tutsi narrative in terms of national memory:

> The clash of ethnic memories is an essential component of the process by which the legacy of genocide—the 'memory of the offense'—is being perceived or fabricated by one community or the other: once filtered through the prism of ethnicity, entirely different constructions are imposed on the same ghastly reality— from which emerge strikingly divergent interpretations of why a genocide happened. Not only is the past seen through a different ethnic lens, but there are also major differences *among* Hutu and Tutsi in the way in which it is remembered or forgotten [. . .] The imposition of an official memory, purged of ethnic references, is not just a convenient ploy to mask the brutal realities of ethnic discrimination; it institutionalizes a mode of thought control profoundly antithetical to any kind of interethnic dialogue aimed at a rethinking of the atrocities of mass murder (2009: 101–08).

The link between gacaca as the commemoration theme, the actual commemoration events and the gacaca courts is problematic. The commemorations are used for remembering the genocide but function simultaneously as a mode of forgetting the RPF war crimes. During commemoration, testimonies are given publicly as part of formal ceremonies but also informally

as biriyo next to the fireside. While testimony may be linked to various outcomes such as 'healing', the act of telling also becomes a political and judicial act that can serve to prolong conflict. Public acts of testimony can become linked to gacaca, serving as testimonials for juridical accusations.

Concerning social trauma, testimonies have been used nationally in gacaca courts, which may negate the effectiveness of testimony towards healing. Often, traumatic events cannot be remembered in a linear time frame; thus, the use of testimony for gacaca can be questionable when witnesses, survivors or perpetrators might experience trauma through the reliving or acting out of past events. Laub gives the example of a Holocaust survivor who provided testimony of a Jewish uprising in Auschwitz where four chimneys were blown up, but her testimony was later discredited by historians who argued that the actual number of chimneys was 'one versus four' (1992: 57). Here, we are faced with inherent dilemmas concerning the use of testimony for various purposes. In terms of testimony for healing, the number of chimneys is irrelevant, as the extraordinary event of a Jewish uprising takes precedence. Since the traumatic narrative may not adhere to a 'factual' or linear structure, the narrator may be accused of providing false testimony and is thus susceptible to incrimination in gacaca if they remember or recount events differently owing to the effects of trauma.

Commemoration and memorialization were linked to the larger political agenda of gacaca, weaving narratives that support today's RPF-dominated government by manipulating memory for political purposes. In his speech at Nyamasheke, although President Kagame emphasized the need for the country's problems to be resolved from within, independent of foreign intervention, Rwanda is intricately involved in regional conflicts related to land rights and resource wealth which extend into the DRC (and are still ethnically linked). Thus the implications of justice and reconciliation inherently extend beyond Rwanda's borders. The 20 December 2008 issue of the *Economist* argued for cutting over $1.8 billion in Western aid to Rwanda until Kagame withdrew his political and military support of a Congolese Tutsi militia, led by General Laurent Nkunda, which has rendered thousands dead and over 250,000 homeless in Eastern Congo. Lemarchand states: 'Again, the systemic extermination by Rwandan troops in eastern DRC of tens of thousands of Hutu refugees—conveniently lumped together as "génocidaires"—has been virtually "airbrushed out of history", to use Milan Kundera's phrase' (2009: 104).

Kagame's speech, while cautioning the international community against getting involved in 'politics' concerning divisionism, avoids larger controversial issues such as his backing of the ongoing ethnic violence in the DRC related to the extortion of mining, the possible channelling of international funding towards this conflict and the exclusion of ethnic memories based on the genocide.[11] However, while the Rwandan government may not want intervention, it relies heavily on international support for its security and economic development. Kagame's claim for Rwandan independence from external 'lessons' is thus in conflict with the country's gain from international funding.

AIDING NARRATIVES

Peter Uvin, in his article on the international community in Rwanda after the genocide states:

> Since the genocide, development agencies have spent tens of millions of dollars in Rwanda on justice, governance, security and reconciliation—issues they used to consider far beyond their mandate until very recently. As a result, Rwanda has emerged as one of the countries where the new post-conflict agenda is being most strongly implemented, under extremely difficult conditions (2001: 177).

International bodies have provided substantial support to the post-genocide regime. In a 2009 article, Catherine Philp from the *Times* (London) stated: 'Since the genocide, Rwanda has relied on foreign aid for half its national budget. Britain is its single largest donor, committed to a disbursement of at least £46 million a year until 2015.' Donation by international agencies may be motivated by a number of agendas, not least a sense of responsibility for not having intervened to stop the violence in 1994, but this money may paradoxically support programmes or government strategies that could further entrench ethnic divisions, exacerbate interethnic tensions and ultimately foster the possibility of violence.[12] However, the political agenda of donor countries may also be connected to less reputable objectives, including access to the vast mineral resources in the Great Lakes region, most significantly in the DRC. According to Philp, '[t]he proxy war in Congo has been enormously profitable—for individuals, not the national budget, well cushioned by foreign aid. Rwandan customs accounting regularly show it exporting tonnes of minerals that it does not

even produce—but which are mined feverishly over the border in Congo' (ibid.; see also Pottier 2002).

Foreign investment has rebuilt the economic infrastructure, aiding narratives connected to justice and reconciliation campaigns. Uvin states: 'The donor community [has] invested heavily in the promotion of justice in post-genocide Rwanda. In total, donors [have by 2001] funded more than 100 justice-related projects, costing more than $100 million' (2001: 182). Uvin's analysis highlights the very profound impact of international aid (both direct and indirect) on systems of governance in Rwanda. Some of the most visible sites for 'staging' the new Rwanda, particularly for international communities, are the official commemorative and memorial activities.

## BANANA LEAVES AT DUSK

The permutation of transnational frames for representing the genocide transcends to a local level. Communities conduct their own commemorations to mark the genocide regionally, digging up bodies and conducting formal burial services. Testimonies and speeches are delivered under purple and white tarps, where coffins containing photos and flowers are kept in preparation for burial as vigils are held.[13] Through the proceedings, often, a mix of poetry, testimony and songs establishes 'never again' as memories are shared between community members. I attended one such event in Eastern Province where AJDS performed a play about the genocide (see Image 18).

Under the canopy of nightfall, actors dressed as interahamwe, in military uniform and banana leaves, approached the audience. The performance space was lit by fires and lanterns and was surrounded by wooden benches on all four sides. The intimate space between the actors and audience held a palpable tension, as the actors carried props that resembled weapons. The play began with the commander of the interahamwe inciting the others to join in the 'work', claiming that the country was under attack from the RPF and that it was their duty to work for the government. 'We've finished digging out mass graves. The remaining work to do is to throw the Tutsi in. We can do it. We are strong and energetic. Just count on us,' said the commander. A neighbour entered with his Tutsi friend and was immediately questioned about his alliances. Although he justified their relationship (that they had been friends since childhood and went to

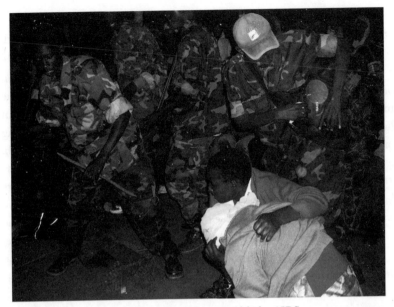

IMAGE 18 Theatrical performance of the genocide by AJDS at a commemoration, Eastern Province, 2006. Courtesy: Ananda Breed.

school together), the commander negated such ties and taunted the Tutsi about resembling a snake. In the next scene, the Tutsi returned home to his family and was met by his two children who shared stories about being ridiculed at school. They were instructed to pray, as similar evil had prevailed in the past and they must ask God for protection. The family knelt on the dirt surface as they sang the following verse:

> *Mana nkuko wafashaga ba Sogokuruza,*
> *Natwe niko uzadufasha mu myaka iri mbere*
> *Umuyaga w'ishuheri, urawuturinda*
> *Tugufite ntitwifuza undi murengezi.*

> God, the way you used to help our ancestors,
> That's how we want you to help us in the years to come
> When there is a storm, you protect us,
> Since you are with us, we don't need any saviour other than you.

The performance transitioned into a church scene as the interahamwe entered with a pastor and religious representatives. The interahamwe sang slogans to boost morale and the pastor quoted biblical verses based on the

oppression of Israelites by the enemies who would attack from a Northern border: 'Many shepherds will ruin my vineyard and trample down my field: they will turn my pleasant field into a desolate wasteland' (Jeremy 12:10).

The next scene demonstrated the training of the RPF in preparation for their attack. They also sang songs to build enthusiasm and discipline through military drills. The army commander informed the soldiers about the mass killing, that devils have overtaken Rwanda: 'Our people are being tortured, burnt alive, pregnant women killed with their babies in the womb, heads are cut with machetes . . . priests have become devils and the government army, whose mission is to protect people, are the ones who are slaughtering them.' As if to make the speech explicit, the interahamwe gestured movements associated with rape, while making jokes about the taste of Tutsi women. The RPF entered the scene and stopped the genocide.

The play ended with survivors joining a widows' association that created income-generating activities and working as a community towards solidarity. Following the play, the audience moved from the performance space to the open graves where the mass burial was conducted.

The performance left a nagging residue. Although it ended with the RPF victory and message to restore communal ties through associations, I was uncomfortable with enactments of genocide at the commemoration site. During the performance, some audience members diverted their gaze. Although there were varied moments in which the interahamwe provided comic relief, I question the immediacy of memory and the temporal proximity to the actual events. How might commemorations and commemorative acts (or theatrical performances) unearth the past as much as they may seek to bury the dead? The representation of genocide requires an alternative response outside the post-violent depiction of violence.

## OUTSIDE THE POST-VIOLENT DEPICTION OF VIOLENCE

In the Rwandan context, one crucial question is: how have individuals been able to respond to the violence that occurred outside the government-prescribed 'master narrative' of the genocide. Master narratives are created within a structure that Allen Feldman has identified as the trauma-aesthetic, which '[i]nstalls and smuggles into the human rights discourse a visual genealogy of witnessing and testimony giving that sorts victim and witness into positions of hierarchical observation, compulsory visibility and

non-reciprocal appropriation of the body in pain' (2004: 186). Feldman has noted the complexity of post-violent witnessing and the constraints of human rights discourse by arguing that some narratives of suffering may need to stand outside the normalization of witnessing and documenting violence. He has questioned national juridical and commemorative practices that may ultimately frame violence into digestible and transferable representations for mass consumption by international audiences at the exclusion of counter-narratives.

The post-conflict paradigm of justice and reconciliation includes juridical, social and commemorative acts articulating the atrocities of the genocide but also connects those acts to other atrocities and narratives of suffering. Although commemorations and theatrical representations of the genocide may document and account for genocide crimes that can acknowledge the complicity of international communities, narratives of suffering can be used to foster collective guilt that may deter the witnessing of present-day human rights violations. Without understanding the individual narratives outside the predominant discourse, collective guilt can drown out alternative narratives. The form in which testimonies are heard, repeated or disseminated is crucial to the act of witnessing, in which testimony may be used as an agent for healing or towards public or social agendas.

Feldman, in his study of memory theatres, virtual witnessing and the trauma-aesthetic has claimed that '[t]o enclave the human rights violation story at a primordial scene of violence is already to preselect the restorative powers of legal, medical, media, and textual rationalities as post-violent. There is a normative and moralizing periodization built into the post-violent depiction of violence' (ibid.: 164). He has emphasized the need to understand the conditions through which life histories of human rights violations circulate to develop dialogical opportunities outside those master narratives. Strategies for justice and reconciliation must be inclusive of multiple life stories and histories.

Commemoration and memorialization create a universalization of suffering and integrate secondary witnessing on an international scale that often does not foster mutual understanding between the individual perpetrator and survivor for what I would call empathetic response or shared suffering, as evidenced through grassroots associations.

Personal acts of memory and remembrance must have alternative outlets other than testimonial discourse to stand outside the post-violent

depiction of violence. The traumatic event of genocide as the point of departure must be regarded critically when the vast majority of civic acts—from gacaca to grassroots associations—are used to inculcate the new Rwandan identity. If this identity remains fractured or adversely dominated by the RPF (and predominantly Tutsi) recollections, Rwanda will inevitably be caught between conflicting narratives of public versus hidden transcripts. Thus, the re-imaging project and the performativity of Rwandanicity will be incomplete, with iterations of Rwandanicity stated as public transcripts but potentially disavowed as hidden transcripts when in the company of one's in-group. The artists of Rwanda—with the integration of diverse ethnic, geographical, regional and economic backgrounds of its citizens—play a vital role in providing alternative outlets for expression towards a future of coexistence.

*Notes*

1   Christopher J. Colvin critiques the political economy of 'traumatic story-telling' which he identifies as a kind of storytelling about trauma that does not admit the unspectacular and is framed by psychodynamic stages of trauma, and can be traumatic for the teller (2006: 171).

2   In 2004, the UN declared 7 April as the 'International Day of Reflection on the 1994 Genocide in Rwanda', marking the 10th commemoration of the Rwandan genocide.

3   Patrick Duggan and Mick Wallis comment on political trauma and post-traumatic closure, 'where healing the nation often abuses traumatized individuals: a refurbished national narrative traduces that of its subjects, dis-locating one from the other' (2011: 15).

4   Created by the Mashirika Creative and Performance Arts Group.

5   According to Duggan and Wallis, 'the survivor-sufferer performs the symptoms of their suffering, repeatedly and compulsively "acting out" words, situations and action from the trauma-event' (ibid.: 6).

6   Rob Baum expands on how the body performs as testimony, 'and the conduit (social, ethical) from testimonial body to witnessing body' (2010: 43).

7   While Vanessa Pupavac (2001) has debated the role of PTSD in post-conflict contexts, arguing that it originated from Vietnam War veteran lobbying and is specific to the political and social milieu of USA during that time, Patrick

J. Bracken (2001) has established an association between PTSD and postmodernity, a breakdown of the social fabric that gives meaning to life events.

8   James Thompson (2009) has argued against the international practice of therapeutic storytelling and narrative imperative to alleviate trauma and PTSD, a Western practice often imposed on other cultures and contexts in an inappropriate, ineffectual and potentially damaging way.

9   Laurie Beth Clark explores trauma tourism to understand how they 'draw tourists because of the persistent and seemingly irresolvable traumas that appear to be fundamental to human society' (2011: 68).

10   For an analysis of Murambi Genocide Memorial Centre as a politics of affect, see Thompson (2009). He claims the bodily effect of interpretation's failure: 'Murambi was breathed then exhaled—it was not read. The only clarity was the guide, who said he kept coming back because his family was there and that the bodies should stay to remind people' (ibid.: 93). Thompson asserts the idea that the physical effect of Murambi might resist simple narration, but I argue that the emotional and affective curation of the memorial by survivors, called 'keepers of memory' in Rwanda, inherently politicizes and subverts the ontological into the epistemological, consumed into the national discourse.

11   The 20 December 2008 issue of the *Economist* expands on the December 2008 release of a UN report concerning conflict in Eastern Congo: 'The report also shows that both General Nkunda's lot and the main Congolese-backed Hutu militia, the Democratic Forces for the Liberation of Rwanda, have links with mining companies. Both extort large sums of money from mines they control. They also do illegal mining, from which Rwanda profits as well. The booty helps pay the militias to fight, giving them good reason to carry on the conflict' (ibid.: 18).

12   Furthermore, although the international community did little to stop the genocide, humanitarian aid money supported the post-genocide refugee crisis. Samantha Power writes, 'President Clinton requested $320 million in emergency relief funds from Congress and announced the deployment of 4,000 US troops to aid refugees in the camps in Zaire' (2002: 381).

13   The colours were purple and white at the time of research but changed in 2013 to grey in order to keep with Rwandan versus Catholic symbolism (wood ash was traditionally used to cover the head of mourners).

AFTERWORD

Never before has a justice system required every citizen, by law, to attend national courts in relation to genocide crimes—nor for the period of time required—every week for seven years. Thus, it is important to address gacaca as a national performance in terms of how the implementation of the courts between 2005 and 2012 created juridical subjectivity. I believe that the correlation between the performance of gacaca and the construction of the new Rwandan subject, embedding Rwandanicity through legal mechanisms, will have a longstanding worldwide impact and influence in relation to human rights, justice and reconciliation. Although the kind of impact and influence gacaca might have is yet to be determined, the magnitude of the project has yet to be paralleled and needs further research regarding its effect. This book has examined the macro and micro layers of the construction and performance of gacaca, emphasizing the negotiation between how memory and testimony relate to personal and collective functions— spanning grassroots, national and international performances—between performatives like gacaca courts and commemorations and theatrical performances. To date, no other project has examined the correlation between performance and gacaca in Rwanda. Thus, this research is an attempt to contribute to wider disciplines including transitional justice, genocide studies and human rights.

Within the messy context of post-conflict reconstruction, speech often falters. Articulations of identities and speech acts become disjointed between personal and collective memories and identities, but have been forced into the construction of juridical speech for gacaca courts. Scott refers to the imbalance of power as faltered speech when 'one party [person] has a severe speech impediment induced by power relations' (1990: 138). During the several gacaca proceedings I attended between 2004

(information gathering), 2005, 2006 and 2010, I observed layers of social performances being played out within the overarching legal gacaca framework. Jeffrey C. Alexander claims that every social performance combines some or all of the following six components: actor, collective representations, means of symbolic productions, *mise en scène*, social power and audience (2011: 83–4).

Both the constructed legal space of the gacaca courts and the theatrical space of performance contain or hold transformative power and the possibility for resistant acts. Erika Fischer-Lichte (2008) notes the transformative power of empathy within the co-presence of the performance space, deriving from an encounter with otherness (see also Reynolds and Reason 2012: 182). Similarly, the theatrical space offers critical distance to evaluate the political, emotional and juridical frames of the genocide, and, in and of itself, can enable an important political and social event.

My research project, culminating in this book, has addressed how theatre and the arts have been used at a delicate stage of Rwanda's reimagining project, between the period of genocide and the national implementation of justice. I hope that subsequent studies will be able to further illuminate how the arts can be used beyond government-driven campaigns of justice and reconciliation towards coexistence in the land of a thousand hills, creating another kind of myth or legend.

Although I have framed gacaca as a social performance, it is difficult for performances to actually manifest the new Rwandan identity without suppressing underlying ethnic and political identities. Alexander states: 'To be really powerful means that social actors, no matter what resources and capacities they possess, must find a way to make their audiences believe them' (2011: 89). But, what happens if the performative is incomplete? Resistant performatives emerge as counter-performances. Performances contain archival traces of historical identities and the formation of emergent ones. Borrowing from Scott (1990), 'faltered speech' requires a more rigorous analysis of divergent discourses to learn the nuanced dialects and codes within a dominant structure. Several examples of moments when resistant performatives emerged as counter-performances to dominant structures have been presented throughout this book: grassroots association members performed their ethnic identities through dance; a prisoner performed his innocence by providing names (as ordained for provisional release) in gacaca of those whom he had supposedly killed but who proclaimed their

'aliveness' in court as their names were read out; and a theatre director staged a production to provide a venue for open discourse about gacaca through the fictional frame of theatre in relation to the Frankfurt Auschwitz trials.

The resistant performatives are important to document, to learn the nuanced dialects and codes. This is why performance and performance studies contribute significantly to the understanding of overriding legal structures such as gacaca and transitional justice systems. According to Harvey M. Weinstein, 'over the last 20 years, these goals [of judicial mechanisms] have expanded to encompass the elusive ideas of "reconciliation" and "closure" in order to move countries toward a broader vision of reconstituted societies based upon democratic principles, rule of law and observance of human rights norms' (2011: 2). Although often extolling the virtue of locality for transitional justice systems like gacaca, these systems can be used to enforce state power through a nostalgic quest for past traditions rather than by analysing the power dynamics at play. Other virtues of transitional justice systems such as providing testimony as healing have been rebuffed in recent years through empirical studies that illustrate the traumatic effects of both telling and witnessing unless the safety of the individual survivor and other potential victims have been secured. Thus, we need to question the legacy of justice after the genocide: that is, after gacaca, what are its ramifications?

# WORKS CITED

African Rights. 2004. 'Rwanda. Broken Bodies, Torn Spirits: Living with Genocide, Rape and HIV/AIDS'. Unpublished report. April.

Alexander, Jeffrey C. 2011. *Performance and Power*. Cambridge, UK: Polity Press.

Anderson, Patrick, and Jisha Menon. 2009. *Violence Performed: Local Roots and Global Routes of Conflict*. New York: Palgrave Macmillan.

Austin, John Langshaw. 1962. *How to Do Things with Words: The William James Lectures Delivered in Harvard University in 1955* (J. O. Urmson and Marina Sbisà eds). Oxford: Clarendon Press.

Bale, John. 2002. *Imagined Olympians: Body Culture and Colonial Representation in Rwanda*. Minneapolis: University of Minnesota Press.

Baum, Rob. 2010. 'The Mark, the *Gestus*, and the Moment of Witnessing'. *Theatre Research International* 35(1): 43–53.

Bharucha, Rustom. 2007. 'Dimensions of Conflict in Globalization and Cultural Practice: A Critical Perspective' in Helmut Anheier and Yudhishthir Raj Isar (introd. and eds), *Conflicts and Tensions*. London: Sage, pp. 51–65.

Bickford, Louis. 2007. 'Unofficial Truth Projects'. *Human Rights Quarterly* 29: 994–1035.

Bikesha, Denis. 2010. 'The Genocide Perpetrated Against Tutsis: Handling the Aftermath of Gacaca'. Unpublished paper presented at the International Symposium of the National Commission for the Fight against Genocide: '16 Years after the Genocide Perpetrated against Tutsi: Handling Its Consequences', Kigali, Rwanda, 4–6 April.

Billington, Michael. 2007. 'The Investigation'. *The Guardian*, 2 November.

Boal, Augusto. 1979. *Theatre of the Oppressed*. New York: Urizen Books.

———. 1992. *Games for Actors and Non-Actors*. London: Routledge.

BORNEMAN, John. 2002. 'Reconciliation after Ethnic Cleansing. Listening, Retribution, Affiliation'. *Public Culture* 14(2): 281–304.

BRACKEN, Patrick J. 2001. 'Post-Modernity and Post-Traumatic Stress Disorder'. *Social Science & Medicine* 53: 733–43.

BREED, Ananda. 2006. 'Performing Reconciliation in Rwanda'. *Peace Review: A Journal of Social Science* 18(4): 507–13.

———. 2007. 'Performing Gacaca in Rwanda: Local Culture for Justice and Reconciliation' in Helmut K. Anheier and Yudhishthir Raj Isar (introd. and eds), *Conflicts and Tensions*. London: Sage, pp. 306–12.

———. 2008. 'Performing the Nation: Theatre in Post-Genocide Rwanda'. *The Drama Review* 52(1): 32–50.

BROOK, Peter. 1968. *The Empty Space*. New York: Touchstone.

BROUNÉUS, Karen. 2008. 'Truth-Telling as Talking Cure? Insecurity and Retraumatization in the Rwandan Gacaca Courts'. *Security Dialogue* 39(1): 55–76.

BURNET, Jennie E. 2009. 'Whose Genocide? Whose Truth? Representations of Victim and Perpetrator in Rwanda' in Alexander Laban Hinton and Kevin Lewis O'Neill (eds), *Genocide: Truth, Memory, and Representation*. Durham, NC: Duke University Press, pp. 80–112.

BUTLER, Judith. 1990. *Gender Trouble: Feminism and the Subversion of Identity*. New York: Routledge.

———. 1993. 'Extracts from *Gender as Performance: An Interview with Judith Butler*'. Interview by Peter Osborne and Lynne Segal, London. Available at: http://www.theory.org.uk/but-int1.htm (last accessed on 1 September 2007).

———. 2000. 'Critically Queer' in Paul du Gay, Jessica Evans and Peter Redman (eds), *Identity: A Reader*. London: Sage, pp. 108–19.

CARUTH, Cathy. 1995. 'Introduction: Trauma and Experience' in Cathy Caruth (introd. and ed.), *Trauma: Explorations in Memory*. Baltimore, MD: The Johns Hopkins University Press, pp. 3–12.

———. 1996. *Unclaimed Experience: Trauma, Narrative, and History*. Baltimore, MD: The Johns Hopkins University Press.

CHRÉTIEN, Jean-Pierre. 1995. *Rwanda: Les médias du génocide*. Paris: Karthala.

CLARK, Janine Natalya. 2008. 'The Three Rs: Retributive Justice, Restorative Justice, and Reconciliation'. *Contemporary Justice Review* 11(4): 331–50.

———. 2009. 'The Limits of Retributive Justice: Findings of an Empirical Study in Bosnia and Herzegovina'. *Journal of International Criminal Justice* 7(3): 463–87.

CLARK, Laurie Beth. 2011. 'Never Again and Its Discontents'. *Performance Research: A Journal of the Performing Arts* 16(1): 68–79.

CLARK, Phil. 2010. *The Gacaca Courts and Post-Genocide Justice and Reconciliation in Rwanda: Justice Without Lawyers*. Cambridge: Cambridge University Press.

——, and Zachary D. Kaufman. 2009. *After Genocide: Transitional Justice, Post-Conflict Reconstruction and Reconciliation in Rwanda and Beyond*. London: Columbia University Press.

COCKBURN, Cynthia. 2001. 'The Gendered Dynamics of Armed Conflict and Political Violence' in Caroline O. N. Moser and Fiona Clark (eds), *Victims, Perpetrators or Actors? Gender, Armed Conflict and Political Violence*. London: Zed Books, pp. 13–29.

COLE, Catherine. 2010. *Performing South Africa's Truth Commission: Stages of Transition*. Bloomington: Indiana University Press.

COLVIN, Christopher J. 2006. 'Trafficking Trauma: Intellectual Property Rights and the Political Economy of Traumatic Storytelling'. *Critical Arts* 20(1): 171–82.

CONNERTON, Paul. 1989. *How Societies Remember*. Cambridge: Cambridge University Press.

COREY, Allison, and Sandra F. Joireman. 2004. 'Retributive Justice: The *Gacaca* Courts in Rwanda'. *African Affairs* 103: 73–89.

COWLEY, Jason. 2005. 'Rebirth of a Nation'. *The Guardian*, 27 February. Available at: http://www.theguardian.com/film/2005/feb/27/features.review (last accessed on 17 July 2013).

DALY, Erin. 2002. 'Between Punitive and Reconstructive Justice: The *Gacaca* Courts in Rwanda'. *International Law and Politics* 34: 355–96.

DAS, Veena. 1995. *Critical Events: An Anthropological Perspective on Contemporary India*. Oxford: Oxford University Press.

DAVIES, Miranda. 1994. *Women and Violence: Realities and Responses Worldwide*. London: Zed Books.

DEBORD, Guy. 1994. *The Society of the Spectacle* (Donald Nicholson-Smith trans.). New York: Zone Books.

DERRIDA, Jacques. 2003. *On Cosmopolitanism and Forgiveness*. London: Routledge.

DES FORGES, Alison. 1999. *Leave None to Tell the Story: Genocide in Rwanda*. New York: Human Rights Watch.

——. 2007. 'Call to Genocide: Radio in Rwanda, 1994' in Allan Thompson (ed.), *The Media and the Rwanda Genocide*. London: Pluto Press, pp. 41–54.

DONÁ, Giorgia. 2012. 'Interconnected Modernities, Ethnic Relations, and Violence'. *Current Sociology* 61(2): 226–43.

DUGGAN, Patrick, and Mick Wallis. 2011. 'Trauma and Performance: Maps, Narratives and Folds'. *Performance Research: A Journal of the Performing Arts* 16(1): 4–17.

ECONOMIST, THE. 2003. 'Kagame Won, a Little Too Well'. 28 August. Available at: http://www.economist.com/node/2023062 (last accessed on 3 January 2006).

———. 2008. 'Stop Paying for Murder'. 20 December. Available at: http://www.economist.com/opinion/displaystory.cfm?story_id=12817705 (last accessed on 4 March 2009).

EDMONDSON, Laura. 2005. 'Marketing Trauma and the Theatre of War in Northern Uganda'. *Theatre Journal* 57: 451–74.

———. 2009. 'The Poetics of Displacement and the Politics of Genocide in Three Plays about Rwanda' in Patrick Anderson and Jisha Menon (eds), *Violence Performed: Local Roots and Global Routes of Conflict*. New York: Palgrave Macmillan, pp. 54–78.

ELTRINGHAM, Nigel. 2004. *Accounting for Horror: Post-Genocide Debates in Rwanda*. London: Pluto Press.

EYE MAGAZINE, THE. *The Insider's Guide to Rwanda*. 2005–06. 'Discover Rwanda', November–January, p. 6.

FANON, Frantz. 1963. *The Wretched of the Earth* (Constance Farrington trans.). New York: Grove Press.

FELDMAN, Allen. 1991. *Formations of Violence: The Narrative of the Body and Political Terror in Northern Ireland*. Chicago, IL: University of Chicago Press.

———. 2004. 'Memory Theaters, Virtual Witnessing, and the Trauma Aesthetic'. *Biography* 27(1): 163–202.

FISCHER-LICHTE, Erika. 2008. The Transformative Power of Performance: A New Aesthetics (Saskya Jain trans.). New York: Routledge.

FOUCAULT, Michel. 1977. 'Nietzsche, Genealogy, History' in Donald F. Bouchard (ed. and introd.), *Language, Counter-Memory, Practice: Selected Essays and Interviews by Michel Foucault*. Ithaca, NY: Cornell University Press, pp. 139–64.

———. 1990. 'Part Three: Scientia Sexualis' in *The History of Sexuality, Volume 1: An Introduction* (Robert Hurley trans.). New York: Vintage.

FUJII, Lee Ann. 2009. *Killing Neighbors: Webs of Violence in Rwanda*. London and Ithaca, NY: Cornell University Press.

GALLIMORE, Béa Rangira. 2008. 'Militarism, Conflict and Women's Activism'. *Feminist Africa* 10: 9–30.

GOFFMAN, Erving. 1974. *Frame Analysis: An Essay on the Organization of Experience*. New York: Harper Colophon Books.

GOVERNMENT OF RWANDA. 2002. 'Law No. 47/2001 of 18 December 2001', Article 1 in *Official Gazette of the Republic of Rwanda. Year No. 41 Special of February 1, 2002*. Available at: http://www.genevaacademy.ch/RULAC/-pdf_state/Law-47-2001-crime-discrimination-sectraianism.pdf (last accessed on 13 March 2013).

——. 2004. 'Organic Law No. 16/2004 of 19/6/2004', Article 34 in *Official Gazette of the Republic of Rwanda. Year No. 43 Special of June 19, 2004*. Available at: http://repositories.lib.utexas.edu/bitstream/handle/2152/4582/3677.pdf?-sequence=1 (last accessed on 5 March 2013).

——. 2007. 'Law No. 10/2007 of 1 March 2007' in *Official Gazette of the Republic of Rwanda. Year No. 5*. Available at: http://www.primature.gov.rw/-publications/pointer/0.html?tx_mmdamfilelist_pi1%5BgetSubFolders%5D=fileadmin%2Fuser_upload%2Fdocuments%2FOfficial%20Gazettes%2F2007%20Official%20Gazettes%2F&tx_mmdamfilelist_pi1%5Bgetsubfolders%5D=fileadmin%2Fuser_upload%2Fdocuments%2FOfficial%20Gazettes%2F&cHash=0e1511116c032c1c3d1531ed6a561463 (last accessed on 17 July 2013).

GRAYBILL, Lyn S. 2002. *Truth and Reconciliation in South Africa: Miracle or Model?* London: Lynne Rienner Publishers.

GRUNEBAUM-RALPH, Heidi. 2001. 'Re-Placing Pasts, Forgetting Presents: Narrative, Place, and Memory in the Time of the Truth and Reconciliation Commission'. *Research in African Literatures* 32(3): 198–212.

HAMERA, Judith. 2002. 'An Answerability of Memory: "Saving" Khmer Classical Dance'. *The Drama Review* 46(4): 65–85.

HESFORD, Wendy S. 2004. 'Documenting Violations: Rhetorical Witnessing and the Spectacle of Distant Suffering'. *Biography* 27: 104–44. Available at: http://www.bupedu.com/lms/admin/uploded_article/eA.238.pdf (last accessed on 9 May 2013).

HIRONDELLE NEWS AGENCY (LAUSANNE). 2011. 'Rwanda: Gacaca to Wind Up by Year-End Despite 22 Cases Outstanding'. *allAfrica*, 10 November. Available at: http://allafrica.com/stories/201111110362.html (last accessed on 30 January 2011).

HUMAN RIGHTS WATCH. 1996. 'Shattered Lives: Sexual Violence during the Rwandan Genocide and Its Aftermath'. Human Rights Watch Women's

Rights Project. Available at: http://www.hrw.org/reports/1996/Rwanda.htm (last accessed on 3 June 2008).

———. 2005. *World Report 2005: Rwanda*. Available at: http://www.hrw.org/-legacy/english/docs/2005/01/13/rwanda9860.htm (last accessed on 31 May 2009).

———. 2007. *World Report 2007: Rwanda*. Available at: http://www.hrw.org/-legacy/wr2k7/wr2007master.pdf (last accessed on 31 May 2009).

HUMPHREY, Michael. 2002. *The Politics of Atrocity and Reconciliation: From Terror to Trauma*. London: Routledge.

HUTCHISON, Yvette. 2005. 'Truth or Bust: Consensualising a Historic Narrative or Provoking through Theatre. The Place of the Personal Narrative in the Truth and Reconciliation Commission'. *Contemporary Theatre Review* 15(3): 354–62.

———. 2010. 'Post-1990s Verbatim Theatre in South Africa: Exploring an African Concept of "Truth"' in Carol Martin (ed.), *Dramaturgy of the Real on the World Stage*. Basingstoke and New York: Palgrave Macmillan, pp. 61–71.

INGELAERE, Bert. 2012. 'From model to practice: Researching and representing Rwanda's "modernized" gacaca courts'. *Critique of Anthropology* 32(4): 388–414.

JACKSON, Michael. 2002. *The Politics of Storytelling: Violence, Transgression and Intersubjectivity*. Copenhagen: Museum Tusculanum Press.

JEFFERS, Alison. 2011. *Refugees, Theatre and Crisis: Performing Global Identities*. London: Palgrave Macmillan.

JONES, Amelia. 1998. *Body Art / Performing the Subject*. Minneapolis: University of Minnesota Press.

KURATH, Gertrude. 1977. *Iroquois Music and Dance: Ceremonial Arts of Two Seneca Longhouses*. St Clair Shores, MI: Scholarly Press.

LANEGRAN, Kimberly. 2005. 'Truth Commissions, Human Rights Trials, and the Politics of Memory'. *Comparative Studies of South Asia, Africa and the Middle East* 25(1): 111–21.

LAUB, Dori. 1992. 'Bearing Witness, or the Vicissitudes of Listening' in Shoshana Felman and Dori Laub (eds), *Testimony: Crises of Witnessing in Literature, Psychoanalysis, and History*. New York: Routledge, pp. 57–74.

LAVILLE, Sandra. 2006. 'Two Years Late and Mired in Controversy: The British Memorial to Rwanda's Past'. *The Guardian*, 13 November. Available at: http://www.guardian.co.uk/world/2006/nov/13/rwanda.sandralaville (last accessed on 4 March 2009).

LAYIWOLA, Dele. 2003. 'Conceptualizing African Dance Theatre'. Paper presented at the CODESRIA 30th Anniversary Conference on Canonical Works and Continuing Innovation in African Arts and Humanities, Panel X: Foundation Works in African Dance & Music, Accra, Ghana, 17–19 September, p. 2. Available at: http://www.codesria.org/IMG/pdf/layiwola.pdf (last accessed on 11 March 2009).

LEDERACH, John Paul. 1997. *Building Peace: Sustainable Reconciliation in Divided Societies*. Washington, DC: United States Institute of Peace Press.

LEMARCHAND, René. 1970. *Rwanda and Burundi*. London: Pall Mall Press.

———. 2009. *The Dynamics of Violence in Central Africa*. Philadelphia: University of Pennsylvania Press.

LEMERT, Charles, and Ann Branaman. 1997. *The Goffman Reader*. Oxford: Blackwell Publishers Ltd.

LONGMAN, Timothy. 2006. 'Justice at the Grassroots? Gacaca Trials in Rwanda' in Naomi Roht-Arriaza and Javier Mariezcurrena (eds), *Transitional Justice in the Twenty-First Century: Beyond Truth versus Justice*. Cambridge: Cambridge University Press, pp. 206–28.

LOWENTHAL, David. 1994. 'Identity, Heritage, and History' in John R. Gillis (ed.), *Commemorations: The Politics of National Identity*. Princeton, NJ: Princeton University Press, pp. 41–60.

MACKINNON, Catharine A. 1998. 'Rape, Genocide, and Women's Human Rights' in Stanley G. French, Wanda Teays and Laura M. Purdy (eds), *Violence against Women: Philosophical Perspectives*. London: Cornell University Press, pp. 43–56.

MALKKI, Liisa H. 1995. *Purity and Exile: Violence, Memory, and National Cosmology Among Hutu Refugees in Tanzania*. Chicago, IL: University of Chicago Press.

MAMDANI, Mahmood. 2001. *When Victims Become Killers: Colonialism, Nativism, and the Genocide in Rwanda*. Princeton, NJ: Princeton University Press.

———. 2004. 'Race and Ethnicity as Political Identities in the African Context' in Nadia Tazi (ed.), *Keywords/Identity: For a Different Kind of Globalization*. New York: Other Press, pp. 20–1.

MARTIN, Carol. 2010. 'Introduction: Dramaturgy of the Real' in Carol Martin (ed.), *Dramaturgy of the Real on the World Stage*. Basingstoke and New York: Palgrave Macmillan, pp. 1–14.

McGOWAN, Mary Kate. 2005. 'On Pornography: MacKinnon, Speech Acts, and "False" Construction'. *Hypatia* 20(3): 23–49.

McGreal, Chris. 2008. 'Bush Shaken by Memorial to 800,000 Rwanda Dead'. *The Guardian*, 20 February. Available at: http://www.theguardian.com/world/-2008/feb/20/rwanda.usa (last accessed on 9 May 2013).

——, Xan Rice and Lizzy Davies. 2010. 'Delayed UN Report Links Rwanda to Congo Genocide'. *The Guardian*, 1 October. Available at: http://www.-guardian.co.uk /world/2010/oct/01/un-report-rwanda-congo-genocide (last accessed on 9 May 2013).

Mgbako, Chi. 2005. '*Ingando* Solidarity Camps: Reconciliation and Political Indoctrination in Post-Genocide Rwanda'. *Harvard Human Rights Journal* 18: 201–24.

Middleton, David, and Derek Edwards. 1990. 'Introduction' in David Middleton and Derek Edwards (eds), *Collective Remembering*. London: Sage, pp. 1–22.

Miessen, Markus. 2010. *The Nightmare of Participation* (*Crossbench Praxis as a Mode of Criticality*). Berlin: Sternberg Press.

Ministry of Justice. 2004. *Evaluation Report for* 'Gacaca *Play*'. Kigali, Rwanda, 16 September.

Minow, Martha. 1998. *Between Vengeance and Forgiveness: Facing History after Genocide and Mass Violence*. Boston, MA: Beacon Press.

Misago, Célestin Kanimba, and Thierry Mesas. 2000. *Regards sur le Rwanda: Collections du Musée National*. Paris: Maisonneuve et Larose.

Mukaka, Alice. 2005. 'Revivifying Rituals as the Engine for Drama Development in Rwanda: A Socio-Critical Approach'. Unpublished undergraduate thesis. Rwanda: National University of Rwanda.

National Curriculum Development Centre. 2005. 'The Teaching of History of Rwanda: A Participatory Approach. A Resource Book for Teachers, for Secondary Schools in Rwanda'. Unpublished report. Rwanda: National Curriculum Development Centre, pp. 120–4.

National Unity and Reconciliation Commission (NURC). 2005. *Report on the Role of Women in Reconciliation and Peacebuilding in Rwanda: Ten Years after Genocide, 1994–2004; Contributions, Challenges and Way Forward*. Kigali: NURC.

Newbury, Catherine. 1988. *The Cohesion of Oppression*. New York: Columbia University Press.

Niarchos, Catherine N. 1995. 'Women, War, and Rape: Challenges Facing the International Tribunal for the Former Yugoslavia'. *Human Rights Quarterly* 17(4): 649–90.

NKULIKIYINKA, Jean-Baptiste. 2002. 'Introduction à la dance Rwandaise Traditionnelle Musée royal d'Afrique centrale'. *Annales sciences humaines* 166: 234–8.

NORDSTROM, Carolyn. 1997. *A Different Kind of War Story*. Philadelphia: University of Pennsylvania Press.

———. 2004. *Shadows of War: Violence, Power, and International Profiteering in the Twenty-First Century*. Berkeley: University of California Press.

NORWEGIAN HELSINKI COMMITTEE (NHC). 2002 [November]. Prosecuting Genocide in Rwanda: The Gacaca System and the International Criminal Tribunal for Rwanda. Report II/2002. Oslo: NHC. Available at: http://www.donika.com/RWANDA.PDF (last accessed on 21 May 2013).

NSENGIMANA, Joseph. 2000. 'Rwanda' in Ousmane Diakhate, Hansel Ndumbe Eyoh and Don Rubin (eds), *World Encyclopedia of Contemporary Theatre: Africa*, VOL. 3. London: Routledge, pp. 236–9.

OOMEN, Barbara. 2005. 'Donor-Driven Justice and Its Discontents: The Case of Rwanda'. *Development and Change* 36(5): 887–910.

ORGANIZATION OF AFRICAN UNITY (OAU). 2000. 'Rwanda: The Preventable Genocide'. The Report of the International Panel of Eminent Personalities (IPEP) to Investigate the 1994 Genocide in Rwanda and the Surrounding Events. Rwanda: IPEP. Available at: http://www.aegistrust.org/images/stories/oaureport.pdf (last acessed on 17 July 2013).

PATRAKA, Vivian M. 1999. *Spectacular Suffering: Theatre, Fascism, and the Holocaust*. Bloomington: Indiana University Press.

PAVIS, Patrice. 1992. *Theatre at the Crossroads of Culture*. London: Routledge.

PAYNE, Leigh A. 2008. *Unsettling Accounts: Neither Truth nor Reconciliation in Confessions of State Violence*. Durham, NC: Duke University Press.

PELLS, Kirrily. 2011. 'Building a Rwanda "Fit for Children"' in Scott Strauss and Lars Waldorf (eds), *Remaking Rwanda: State Building and Human Rights after Mass Violence*. Wisconsin: University of Wisconsin Press, pp. 79–86.

PENAL REFORM INTERNATIONAL. 2003. *PRI Research on Gacaca Report: Report IV. The Guilty Plea Procedure, Cornerstone of the Rwandan Justice System*. Rwanda: Penal Reform International. Available at: http://www.essex.ac.uk/armedcon/story_id/000870.pdf (last accessed on 21 May 2013).

———. 2004. *PRI Research Report on the Gacaca: Report VI. From Camp to Hill, the Reintegration of Released Prisoners*. Rwanda: Penal Reform International. Available at: http://www.essex.ac.uk/armedcon/story_id/000872.pdf (last accessed on 9 May 2013).

——. 2009. *Gacaca Research Report No. 12: Settlement of Property Offence Cases.* Rwanda: Penal Reform International. Available at: http://www.penalre-form.org/-publications/gacaca-research-report-no12-settlement-property-offence-cases (last accessed on 21 May 2013).

——. 2010. *Eight Years On . . . A Record of* Gacaca *Monitoring in Rwanda.* Rwanda: Penal Reform International. Available at: http://www.penalre-form.org/publications/eight-years-ona-record-gacaca-monitoring-rwanda (last accessed on 21 May 2013).

PENDAS, Devin O. 2010. *The Frankfurt Auschwitz Trial, 1963–1965: Genocide, History, and the Limits of the Law.* New York: Cambridge University Press.

PHILP, Catherine. 2009. 'Yesterday a Victim, Today an Oppressor: How Aid Funds War in Congo'. *The Times,* 7 April. Available at: http://www.thetimes.-co.uk/tto/news/world/africa/article2594191.ece (last accessed on 23 July 2013).

POTTIER, Johan. 2002. *Re-Imagining Rwanda: Conflict, Survival and Disinformation in the Late Twentieth Century.* Cambridge: Cambridge University Press.

POWER, Samantha. 2002. *A Problem from Hell: America and the Age of Genocide.* New York: Basic Books.

POWLEY, Elizabeth. 2008. 'Rwanda: Women Hold Up Half the Parliament'. Available at: www.idea.int/publications/wip2/upload/Rwanda.pdf (last accessed on 17 July 2008).

PRUNIER, Gérard. 1995. *The Rwanda Crisis: History of a Genocide.* London: Hurst and Company.

——. 1998. 'The Rwandan Patriotic Front' in Christopher Clapham (ed.), *African Guerrillas.* Oxford: James Currey, pp. 119–33.

——. 2009. *Africa's World War: Congo, the Rwandan Genocide, and the Making of a Continental Catastrophe.* Oxford: Oxford University Press.

PUPAVAC, Vanessa. 2001. 'Therapeutic Governance: Psycho-social Intervention and Trauma Risk Management'. *Disasters* 25(3): 358–72.

RANCK, Jody. 2000. 'Beyond Reconciliation: Memory and Alterity in Post-Genocide Rwanda' in Roger I. Simon, Sharon Rosenberg and Claudia Eppert (eds), *Between Hope and Despair: Pedagogy and the Remembrance of Historical Trauma.* New York: Rowman & Littlefield, pp. 187–212.

REPUBLIC OF RWANDA. 2008. *The Constitution of the Republic of Rwanda.* Kigali, Rwanda: Government of the Republic of Rwanda. Available at: http://www.-mod.gov.rw/?Constitution-of-the-Republic-of (last accessed on 9 May 2013).

REPUBLIC OF RWANDA NATIONAL SERVICE OF GACACA COURTS. 2005a [January]. *Trial Procedure in Gacaca Courts.* Kigali: National Service of Gacaca Courts.

——. 2005b [June]. *Report on Activities of Gacaca Courts in the Pilot Phase*. Kigali: National Service of Gacaca Courts.

REYNOLDS, Dee, and Matthew Reason. 2012. *Kinesthetic Empathy in Creative and Cultural Practices*. Bristol, UK: Intellect Books.

REYNTJENS, Filip. 2001. *Again at the Crossroads: Rwanda and Burundi, 2000–2001*. *Current African Issues*. Burundi and Rwanda: Nordiska Africainstitutet, 25pp.

——. 2010. 'Constructing the Truth, Dealing with Dissent, Domesticating the World: Governance in Post-Genocide Rwanda'. *African Affairs* 110(438): 1–34.

——, and Stef Vandeginste. 2005. 'Rwanda: An Atypical Transition' in Elin Skaar, Siri Gloppen and Astri Suhrke (eds), *Roads to Reconciliation*. Lanham, MD: Lexington Books, pp. 101–28.

ROSS, Will. 2006. 'Translating the Truth about Apartheid'. *BBC News* (South Africa), 8 November. Available at: http://news.bbc.co.uk/1/hi/world/africa/-6122014.stm (last accessed on 18 October 2010).

ROTHBERG, Michael. 2009. *Multidirectional Memory: Remembering the Holocaust in the Age of Decolonization*. Stanford, CA: Stanford University Press.

RUSAGARA, Frank K. 2005. '*Gacaca*: Rwanda's Truth and Reconciliation Authority'. *New Times*, 16 May. Available at: http://allafrica.com/stories/200505-170174.html (last accessed on 9 May 2013).

SARKIN, Jeremy. 1999. 'The Necessity and Challenges of Establishing a Truth and Reconciliation Commission in Rwanda'. *Human Rights Quarterly* 21(3): 767–823.

SCARRY, Elaine. 1985. *The Body in Pain: The Making and Unmaking of the World*. Oxford: Oxford University Press.

SCHECHNER, Richard. 1985. *Between Theatre and Anthropology*. London: Routledge.

——. 2002. *Performance Studies: An Introduction*. London: Routledge.

——. 2009. '9/11 as Avant-Garde Art?' *Publications of the Modern Language Association of America* 124(5): 18209.

SCHNEIDER, Rebecca. 2011. *Performing Remains: Art and War in Times of Theatrical Reenactment*. New York: Routledge.

SCHOTSMANS, Martien. 2011. '"But We Also Support Monitoring": INGO Monitoring and Donor Support to Gacaca Justice in Rwanda'. *The International Journal of Transitional Justice* 5: 390–411.

SCOTT, James C. 1990. *Domination and the Arts of Resistance: Hidden Transcripts*. London: Yale University Press.

SIDERIS, Tina. 2001. 'Rape in War and Peace: Social Context, Gender, Power and Identity' in Sheila Meintjies, Anu Pillay and Meredeth Turshen (eds), *The Aftermath: Women in Post-Conflict Transformation*. London: Zed, pp. 142–58.

STAUB, Ervin. 2002. 'Genocide and Mass Killing: Origins, Prevention, Healing and Reconciliation'. *Political Psychology* 21(2): 367–82.

———. 2006. 'Reconciliation after Genocide, Mass Killing, or Intractable Conflict: Understanding the Roots of Violence, Psychological Recovery, and Steps toward a General Theory'. *Political Psychology* 27(6): 867–94.

———, and Laurie Ann Pearlman. 2006. 'Advancing Healing and Reconciliation' in Laura Barbanel and Robert Sternberg (eds), *Psychological Interventions in Times of Crisis*. New York: Springer, pp. 213–44.

STOCKMAN, Farah. 2000. 'The People's Court: Crime and Punishment in Rwanda'. *Transitions* 9(4): 20–41.

STRAUS, Scott. 2004. 'How Many Perpetrators Were There in the Rwandan Genocide? An Estimate.' *Journal of Genocide Research* 6(1): 85–98.

———. 2006. *The Order of Genocide: Race, Power, and War in Rwanda*. London: Cornell University Press.

———, and Lars Waldorf. 2011. 'Introduction: Seeing Like a Post-Colonial State' in Scot Straus and Lars Waldorf (eds), *Remaking Rwanda: State Building and Human Rights after Mass Violence*. Wisconsin: University of Wisconsin Press, pp. 3–24.

TAYLOR, Diana. 2002. 'You Are Here: The DNA of Performance'. *The Drama Review* 46(1): 149–69.

TAYLOR, Jane. 1998. *Ubu and the Truth Commission*. Cape Town: University of Cape Town Press.

TERTSAKIAN, Carina. 2008. *Le Chateau: The Lives of Prisoners in Rwanda*. London: Arves Books.

THIRD WORLD INSTITUTE, THE. 2003. *The World Guide 2003/2004*. Oxford: New Internationalist Publications Ltd.

THOMPSON, James. 2009. *Performance Affects: Applied Theatre and the End of Effect*. London: Palgrave Macmillan.

———, Jenny Hughes and Michael Balfour. 2009. *Performance in Place of War*. London, New York, Calcutta: Seagull Books.

THOMSON, Susan. 2011. 'Reeducation for Reconciliation: Participant Observations on *Ingando*' in Scott Strauss and Lars Waldorf (eds), *Remaking Rwanda: State Building and Human Rights after Mass Violence*. Wisconsin: University of Wisconsin Press, pp. 331–42.

——, and Rosemary Nagy. 2010. 'Law, Power and Justice: What Legalism Fails to Address in the Functioning of Rwanda's *Gacaca* Courts'. *The International Journal of Transitional Justice* 5(1): 11–30.

TIEMESSEN, Alana Erin. 2004. 'After Arusha: Gacaca Justice in Post-Genocide Rwanda', *African Studies Quarterly* 8(1). Available at: http://www.africa.-ufl.edu/asq/v8/v8i1a4.htm (last accessed on 13 December 2013).

TIEROU, Alphonse. 1992. *Doople: Eternal Law of African Dance*. New York: Routledge.

TOUGAW, Jason. 2002. 'Testimony and the Subjects of AIDS Memoirs' in Nancy K. Miller and Jason Tougaw (eds), *Extremities: Trauma, Testimony and Community*. Chicago: University of Illinois Press, pp. 166–85.

TRAN, Mark. 2008. 'Rwandan President Kagame Threatens French Nationals with Arrest'. *The Guardian*, 12 November.

TURNER, Victor Witter. 1982. *From Ritual to Theatre: The Human Seriousness of Play*. New York: PAJ Publications.

TURSHEN, Meredith. 2001. 'The Political Economy of Rape: An Analysis of Systemic Rape and Sexual Abuse of Women during Armed Conflict in Africa' in Caroline O. N. Moser and Fiona Clark (eds), *Victims, Perpetrators or Actors? Gender, Armed Conflict and Political Violence*. London: Zed Books, pp. 55–68.

TUTU, Desmond. 1999. *No Future without Forgiveness*. London: Rider.

UKALA, Sam. 2000 'Impersonation in Some African Ritual and Festival Performances'. *New Theatre Quarterly* 16(61): 76–87.

UN HIGH COMMISSIONER FOR HUMAN RIGHTS (UNCHR). 2010. *Democratic Republic of the Congo, 1993–2003: Report of the Mapping Exercise Documenting the Most Serious Violations of Human Rights and International Humanitarian Law Committed within the Territory of the Democratic Republic of Congo Between March 1993 and June 2003*. Geneva: UN High Commissioner for Human Rights.

UVIN, Peter. 1995. *Aiding Violence: The Development Enterprise in Rwanda*. West Hartford, CT: Kumarian Press.

——. 2000. 'The Introduction of a Modernized Gacaca for Judging Suspects of Participation in the Genocide and the Massacres of 1994 in Rwanda'. Unpublished discussion paper prepared for the Belgian Secretary of State for Development Cooperation.

——. 2001. 'Difficult Choices in the New Post Conflict Agenda: The International Community in Rwanda after the Genocide'. *Third World Quarterly* 22(2): 177–89.

VAN GENNEP, Arnold. 1960. *The Rites of Passage*. London: Routledge & Kegan Paul.

VANSINA, Jan. 2000. 'Historical Tales (Ibiteekerezo) and the History of Rwanda'. *History in Africa* 27: 375–414.

VILLA-VICENCIO, Charles. 2009. *Walk with Us and Listen: Political Reconciliation in Africa*. Washington, DC: Georgetown University Press.

WA THIONG'O, Ngũgĩ. 1998. *Penpoints, Gunpoints, and Dreams: Towards a Critical Theory of the Arts and the State in Africa*. Oxford: Clarendon Press.

WALDORF, Lars. 2010. 'Like Jews Waiting for Jesus. Posthumous Justice in Post-Genocide Rwanda' in Rosalind Shaw, Pierre Hazen and Lars Waldorf (eds), *Localizing Transitional Justice: Interventions and Priorities after Mass Violence*. Stanford, CA: Stanford University Press, pp. 183–202.

WEINSTEIN, Harvey M. 2011. 'Editorial Note: The Myth of Closure, the Illusion of Reconciliation. Final Thoughts on Five Years as Co-Editor-in-Chief'. *International Journal of Transitional Justice* 5(1): 1–10.

WEISS, Peter. 2010. *The Investigation: Oratorio in 11 Cantos* (Alexander Gross trans.). London: Marion Boyars Publishers Ltd.

WITZ, Leslie. 2003. *Apartheid's Festival: Contesting South Africa's National Pasts*. Bloomington: Indiana University Press.

ZIMBARDO, Pauline. 2007. *The Lucifer Effect: Understanding How Good People Turn Evil*. New York: Random House.

ZORBAS, Eugenia. 2004. 'Reconciliation in Post-Genocide Rwanda'. *African Journal of Legal Studies* 1(1): 29–52.

——. 2009. 'What Does Reconciliation after Genocide Mean? Public Transcripts and Hidden Transcripts in Post-Genocide Rwanda'. *Journal of Genocide Research* 11(1): 127–47.

## FURTHER READING

ANDERSON, Benedict. 1991. *Imagined Communities: Reflections on the Origin and Spread of Nationalism*. London: Verso.

BARAHONA DE BRITO, A., Carmen Gonzaléz-Enríquez and Paloma Aguilar. 2001. *The Politics of Memory: Transitional Justice in Democratizing Societies*. Oxford: Oxford University Press.

BENNETT, Jill, and Rosanne Kennedy. 2003. *World Memory: Personal Trajectories in Global Time*. London: Palgrave Macmillan.

BUTLER, JUDITH. 1993. *Bodies That Matter: On the Discursive Limits of Sex*. New York: Routledge.

ELTRINGHAM, Nigel. 2001. 'Representing Rwanda: Questions and Challenges'. *Anthropology Matters* 3(1). Available at: http://www.anthropologymatters.com-/index.php?journal=anth_matters&page=article&op=view&path%5B%5D =137&path%5B%5D=264 (last accessed on 16 February 2009).

GOVERNMENT OF RWANDA. 1999. 'Law No. 22/29 of 12 November 1999' in *Official Gazette of the Republic of Rwanda. Year No. 22*. Available at: http://www.mige-prof.gov.rw/IMG/pdf/MATRIMONIAL_REGIMES_LIBERALITIES_AND_ SUCCESSIONS-2.pdf (last accessed on 17 July 2013).

HARROW, Kenneth W. 2005. '"Un train peut en cacher un autre": Narrating the Rwandan Genocide and Hotel Rwanda'. *Research in African Literatures* 36(4): 223–32.

HOBSBAWM, Eric, and Terence Ranger (eds). 1983. *The Invention of Tradition*. Cambridge: Cambridge University Press.

HUMAN RIGHTS WATCH. 2011. 'Justice Compromised: The Legacy of Rwanda's Community-Based *Gacaca* Courts'. Human Rights Watch Women's Rights Project. Available at: http://www.hrw.org/sites/default/files/reports/rwanda-0511webwcover_0.pdf (last accessed on 11 February 2014).

MOSER, Caroline O. N., and Fiona Clark (eds). 2001. *Victims, Perpetrators or Actors? Gender, Armed Conflict and Political Violence*. London: Zed Books

SCHAFFER, Kay, and Sidonie Smith. 2004a. 'Conjunctions: Life Narratives in the Field of Human Rights'. *Biography* 27(1): 1–24.

——. 2004b. *Human Rights and Narrated Lives: The Ethics of Recognition*. New York: Palgrave Macmillan.

SCHECHNER, Richard. 2002. 'Theatre in Times/Places of Crisis: A Theoretical Perspective' in B. Claudio, M. Dragone and G. Schinina (eds), *War Theatres and Actions for Peace*. Milan: Euresis Edizioni, pp. 155–70.

STOVER, Eric, and Harvey M. Weinstein (eds). 2004. *My Neighbor, My Enemy: Justice and Community in the Aftermath of Mass Atrocity*. Cambridge: Cambridge University Press.

TAYLOR, Diana. 1997. *Disappearing Acts: Spectacles of Gender and Nationalism in Argentina's 'Dirty War'*. London: Duke University Press.

——. 2003. *The Archive and the Repertoire: Performing Cultural Memory in the Americas*. London: Duke University Press.

UVIN, Peter, and Charles Mironko. 2003. 'Western and Local Approaches to Justice in Rwanda'. *Global Governance* 9: 219–31.

## INGANDO SYLLABUS

| No. | Kinyarwanda | French | English |
| --- | --- | --- | --- |
| 1 | Umusogongero ku ngando zigamije kwimakaza umuco w'amahoro, ubwiyunge n'ubuyobozi bwiza | Introduction aux forums de formation en paix, réconciliation et bonne gouvernance | Introduction to peace, reconciliation and good governance forums |
| 2 | Umusogongero ku masomo y'ubwirinzi | Introduction à la science militaire | Introduction to military science |
| 3 | Umusogongero kuri Politiki | Introduction à la Politique | Introduction to politics |
| 4 | Umusogongero ku mibereho n'imibanire y'umuryango w'abantu mu mateka | Introduction à la Philosophie | Introduction to philosophy |
| 5 | Kamere y'Isi n'Isura zitandukanye igenda ifata | L'Essence du monde et les formes différentes de son existence | The essence of the world and its forms of existence |
| 6 | Inkomoko y'isi, ubuzima, umuntu n'umutimanama | L'origine du monde, de la vie, de l'homme et de la conscience | The origin of the world, life, the human being and the consciousness |

| 7 | Amategeko agenga imiterere y'isi n'inzira y'amajyambere | Les lois de la Dialectique | The laws of dialectics |
|---|---|---|---|
| 8 | Inkomoko n'iterambere ry'umuryango w'abantu mu mateka yabo | Origine et développement de la société humaine | Origin and development of human society |
| 9 | Amahame remezo agenga ubukungu bw'umuryango w'abantu mu mateka yabo, inkomoko y'inzego n'amakimbirane mu muryango w'abantu | Introduction à l'économie politique. Origine et développement des classes sociales et des contradictions au sein de la société humaine | Principles of political economy, class formation and class struggles |
| 10 | Uburyo bwo kugera ku bumenyi nyakuri | Le processus de la Connaissance | The process of cognition |
| 11 | Imyumvire y'Umuryango w'Abantu n'impindura-matwara | Conscience sociale et révolution sociale | Social consciousness and social revolution |
| 12 | Ubunyarwanda:<br>•Igihugu cy'u Rwanda<br>•Ubwenegihugu nyarwanda<br>•Umuco nyarwanda: ubupfura, ubugabo n'ubwangamugayo.<br>•Ubumenyi n'ubuvanganzo nyarwanda | Identité et citoyenneté rwandaises:<br>•L'Etat-Nation<br>•La citoyenneté rwandaise<br>•L'éthique et la culture rwandaises (virilité, équité, probité, résilience<br>•Science et art rwandais (l'expression de l'âme rwandaise) | The Rwandan identity and citizenship issue:<br>•The nation<br>•Rwandan citizenship<br>•Rwandan ethics and culture<br>•Rwandese expression |

| 13 | Ikibazo cy'amoko mu Rwanda no mu karere k'Ibiyaga bigari by'Afurika | La question ethnique au Rwanda et dans la Région des Grands Lacs Africains : •Origine •Développement •Tentatives de résolution et de prévention | The ethnic issue in Rwanda and in the African Great Lakes region: •Origin •Progression •Tentatives of resolution and prevention |
|---|---|---|---|
| 14 | Amateka y'u Rwanda: •mbere y'ubukoloni •mu gihe cy'ubukoloni •nyuma y'ubwigenge | Histoire du Rwanda •Avant la colonisation •Pendant la colonisation •Après l'indépendance. | The history of Rwanda: •Before colonization •Colonial era •After independence |
| 15 | Itsembabwoko mu Rwanda n'uko ikibazo cy'ingengabiterezo ya Jenoside kifashe mu Rwanda n'ahandi: •amateka ya Jenoside mu isi •jenoside mu Rwanda •ibikorwa mu guhangana n'ingaruka za Jenoside mu Rwanda no mu karere k'Ibiyaga bigari by'Afurika | Le génocide et l'idéologie génocidaire au Rwanda et ailleurs: •origine et développement du concept •le génocide au Rwanda •les stratégies appropriées | Genocide and its concept: •Context •Actual status of the issue •Appropriate strategies |
| 16 | Gukumira, guhosha no gukemura amakimbirane mu muryango w'abantu : •Ingero z'ukuntu byifashe hirya no hino •Ubu hari ngamba ki? •Umwihariko w'u Rwanda? | Prevention, résolution et gestion des conflits dans la société humaine: •Exemples •Stratégies actuelles | Prevention, resolution and management of conflicts in human society: •Examples •Strategies |

| 17 | Muri iyi nkubiri y'iku-sanyabukungu n'iko-ranabuhanga rigezweho, u Rwanda ruhagaze he? | La place du Rwanda dans le village mondial de développement | Rwanda in globalization |
|---|---|---|---|
| 18 | Politiki y'ubuyobozi bwiza mu Rwanda | La politique de la bonne gouvernance au Rwanda | The policy of good governance in Rwanda |
| 19 | Politiki y'ubumwe n'ub-wiyunge mu Rwanda | La politique de l'unité et réconcilia-tion au Rwanda | The policy of unity and recon-ciliation in Rwanda |
| 20 | Politiki y'umurimo mu Rwanda | | |
| 21 | U Rwanda mu miryango mpuzamahanga : kuba intangarugero mu mubano mpuzamahanga (COMESA, East African community, African Union, United Nations) | La place du Rwanda dans les organisa-tions internationales (COMESA, la com-munauté Est-africaine, l'Union africaine, ONU) | Rwanda in international organizations (COMESA, East African commu-nity, African Union, United Nations) |
| 22 | Politiki y'ishoramari mu Rwanda | La politique de l'in-vestissement au Rwanda | The policy of investment in Rwanda |
| 23 | Ukwegurira ibigo bya Leta abikorera ku giti cyabo mu Rwanda | La politique de la privatisation au Rwanda | The policy of privatization in Rwanda |
| 24 | Politiki y'Ubukeraru-gendo mu Rwanda | La politique tourisme au Rwanda | The policy of tourism in Rwanda |
| 25 | Politiki y'ubucuruzi mu Rwanda (ibihingwa ngan-durarugo, ngengabukungu, am-abuye | La politique du com-merce au Rwanda (les cultures vivrières et industrielles, les | The commerce policy in Rwanda (food crops, cash crops, industrial crops, minerals, |

| | | | |
|---|---|---|---|
| | y'agaciro, inganda n'ubukorikori | mines et les carrières, usines et artisanat, import export) | soil materials factories, arts and crafts, import–export) |
| 26 | Imari ya Leta mu Rwanda:<br>•Aho u Rwanda rukura amafaranga (imisoro n'amahoro, imfashanyo n'inguzanyo z'abagi-raneza n'ibigega mpuzamahanga)<br>•Uko imari y'u Rwanda isaranganywa<br>•Uko imari y'u Rwanda ihagaze ubu | Le budget de l'Etat rwandais:<br>•Les sources de revenues<br>•Le partage du patrimoine national<br>•L' état actuel des finances de l'Etat Rwandais | Rwandan budget:<br>•Resources<br>•Budget and wealth sharing<br>•Present status of Rwandan resources |
| 27 | Politiki yo kurwanya ubukene mu Rwanda (ubudehe, inguzanyo, FDC, HIMO) | La politique de la lutte contre la pau-vreté au Rwanda (ubudehe, crédits, FDC, HIMO) | The policy of poverty reduction in Rwanda (ubudehe, credits, CDF, HIMO) |
| 28 | Itegeko nshinga n'andi mategeko mu Rwanda: kubaka igihugu cyubahi-riza uburenganzira bw'ibanze bwa muntu, kurwanya akarengane | La constitution, l'état de droit et l'esprit de lois au Rwanda | The Rwandan constitution, 'rights rule', and the spirit of laws |
| 29 | Inkiko gacaca n'imirimo nsimburagifungo yagirira igihugu akamaro mu Rwanda | Les juridictions populaires gacaca et les travaux d'intérêt général (TIG) au Rwanda | Gacaca jurisdictions and communal work (TIG) |
| 30 | Urwego rw'umuvunyi mu Rwanda | L'ombudsman au Rwanda | The ombudsman institution in Rwanda |

| 31 | Inteko ishinga amategeko y'u Rwanda: Umutwe w'Abadepite na Sena | Le parlement rwandais: la chambre des députés et le sénat | Rwanda parliament: Congress and Senate |
|---|---|---|---|
| 32 | Ikigo cy'Ubugenzuzi bukuru bw'Imari ya Leta mu Rwanda | L'Office de l'Auditeur Général au Rwanda | Auditor general's office |
| 33 | Urwego rw'abunzi mu Rwanda | Les collèges des conciliateurs au Rwanda | Abunzi institution |
| 34 | Inzego z'abagore n'iz'urubyiruko mu Rwanda | Les structures organisationnelles des femmes et des jeunes au Rwanda | Organizational structures of women and youth in Rwanda |
| 35 | Uruhare rw'amadini mu isanamitima n'isanagihugu mu Rwanda | Le rôle des confessions religieuses dans la réhabilitation spirituelle et dans le développement | The role of religious confessions in healing and development |
| 36 | Ubutaka, gutura neza, ingufu no kurengera ibidukikije mu Rwanda | Le sol, l'habitat, l'énergie et la protection de l'environnement au Rwanda | Policy of land, shelter, energy and environment protection in Rwanda |
| 37 | Gukunda igihugu n'imikorere ya kijyambere mu Rwanda | Le patriotisme et la méthode scientifique de travail | Patriotism and scientific method of work |
| 38 | Uburezi n'uburere bibereye u Rwanda: <br>•Mu muryango <br>•Mu mashuri abanza n'ayisumbuye <br>•Mu mashuri makuru bwiza | Enseignement et éducation au Rwanda: <br>•Dans le ménage <br>•Dans les cycles primaire et secondaire <br>•Dans les Instituts d'enseignement supérieur | Education policy in Rwanda: <br>•In family <br>•In primary and secondary levels <br>•In higher educational institutions |

| | | | | |
|---|---|---|---|---|
| | • Ahandi Abanyarwanda bakura umuco n'uburere bwiza | • Education informelle et para-scolaire | • Informal education | |
| 39 | Ibirango by'Igihugu cy'u Rwanda:<br>• Amateka yabyo<br>• Ibiriho ubu<br>• Akamaro k'ibirango | Les insignes et les emblèmes nationaux:<br>• Historique<br>• Les emblèmes actuels<br>• Le rôle des emlèmes et insignes nationaux | National emblems:<br>• Historical background<br>• Present emblems<br>• Role of national emblems | |
| 40 | Indwara z'ibyorezo cyane cyane SIDA mu Rwanda | Les épidémies dont le SIDA | Epidemic diseases including AIDS | |
| 41 | Umutekano mu Rwanda, mu karere k'Ibiyaga bigari by'Afurika, muri Afurika no mu isi | La sécurité au Rwanda, dans la sous-région des Grands lacs, en Afrique et dans le monde | Security in Rwanda, in the Great Lakes region, in Africa and in the whole world | |
| 42 | Ubuzima bw'imyororo-kere | La santé reproductive | Reproductive health | |
| 43 | Ihungabana n'ihahamuka | Le traumatisme et son traitement | Trauma and its treatment | |
| 44 | Gahunda ya Leta y'u Rwanda mu myaka 7 (2003–10). | Le programme du Gouvernement rwandais dans le septennat 2003–10 | Government programme in the 7-year period (2003–10) | |
| 45 | Icyerekezo cy'imyaka 2020 mu Rwanda | La vision 2020 | Vision 2020 | |
| 46 | Uruharerw'uburinganire n'ubwuzuzanye mw'iter-ambere ry'Igihugu | | | |
| 47 | Guganga no gucunga imishinga iciriritse ibyara inyungu. | | | |

# INDEX

Abiyunze Association (Ishyirahamwe Abiyunze Ry'I Gahini Dushyigikiye Ubumwe N'Ubwiyunge) 1, 28, 30, 33n2, 131, 136–9, 140–2, 151; *see also* community-based grassroots associations

Aegis Trust 172, 177

AJDS (Association des Jeunes pour la Promotion du Developpement et de la Lutte Contre la Segregation) 131, 142–4, 146, 151, 182–4; *see also* youth-based grassroots associations

  *Ibyabaye Byarateguwe* 143

  *Umurage Ukwiye U Rwanda* 143

  *Urubyiruko Dushyigikire Gacaca* 143

alternative discourse(s)/narrative(s) 26, 29, 67–8, 134, 165, 185

alternative juridical frames 79–80

alternative space/s 3, 25, 27, 58, 123, 132, 133, 141–3, 150

amnesty (ies) 65, 77, 79, 80–1, 82–3, 96, 97

Amnesty Committee hearings 79

Arusha Peace Talks / Arusha Peace Accords 5, 6, 47, 61n7

AVEGA (Association des Veuves du Genocide) 104; *see also* widows' grassroots association(s)

AVVAIS (Association des veuves vulnerables affectees et infectees par le HIV/AIDS) 164–5; *see also* widows' grassroots association(s)

Bahutu manifesto 46

*biriyo* 171, 179–80

Bizimungu, Pasteur 6

Burundi 8–9, 16, 17, 38, 41, 48–9, 53, 60n1, 120, 164

Busingye, Johnston 98–9, 127n23

Church 44–5, 127n20, 149, 183–4

civic education 4, 9, 25–6, 145–6

commemoration 1, 3, 4, 7, 14, 22, 27–8, 103, 113, 169, 170–1, 172, 173–4, 176–81, 182, *183*, 184, 185, 186n3, 188; *see also* Nyamasheke Commemoration

conciliation 23, 30, 32

confession(s) 2, 14, 18, 80, 89, 91, 92, 93, 95–6, 97–8, 100, 108, 110–11, 120–1, 127n22, 130, 131, 144, 145,